ROMAN PORTRAITS IN THE GETTY MUSEUM

By Jiří Frel

in collaboration with Sandra Knudsen Morgan

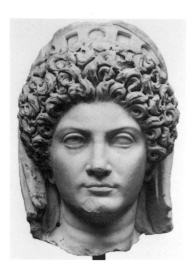

36. Julia, daughter of the emperor Titus

The perfectly preserved head is perhaps the most charming female portrait in the collection. About 90.

A catalogue prepared for the special loan exhibition "Caesars and Citizens"
Philbrook Art Center, Tulsa, Oklahoma, April 26–July 12, 1981
Archer M. Huntington Art Gallery, The University of Texas at Austin

Photography by Donald Hull and Penny Potter
Design by John Anselmo Design Associates, Santa Monica
Art Direction, Tom Lombardi
Typography by Freedmen's Organization, Los Angeles
Printing by Jeffries Banknote Company

© Philbrook Art Center and The J. Paul Getty Museum
Library of Congress Catalog No. 81-50775
ISBN 0-86659-004-8

This exhibition was made possible by grants from Getty Oil Company, Getty Refining and Marketing Company, The Oklahoma Humanities Committee and the National Endowment for the Humanities.

TABLE OF CONTENTS

MR. GETTY'S ROMANS

One day before World War II, J. Paul Getty was walking through the Vatican Museum in Rome and paused in a little-frequented gallery. He told the story later of how he was surprised to see a Roman portrait that looked uncannily like W. G. Skelly, founder and president of Skelly Oil, his friend and rival in the oil business. It is no wonder that in his collecting of ancient art, which Mr. Getty began at this time, Roman portraits were among his first acquisitions, and throughout his buying years an expressively individual Roman character could often seduce him into a purchase.

Mr. Getty was not the only one to feel this way. In her introduction to the collection of Roman portraits in the Metropolitan Museum of Art, Gisela M. A. Richter noted that many venerable Roman Republicans looked to her like successful American businessmen. This spiritual observation does not hold up under deeper analysis, but it may explain well one of the fascinations which Roman portraits have for modern Americans. Another reason for their popularity is that they provide human likenesses for the familiar great names of history, from Caesar to Costantine. And due to the response of the museum's founder, Mr. Getty's Romans now number nearly one hundred examples, showing a large spectrum of personalities, art, times, and evolution, a mirror of the past in which we can often see ourselves.

The present publication introduces all of the one hundred portraits in the Getty collection today, with an emphasis on the seventy-odd pieces which are actually visiting the Philbrook Art Center in Tulsa in 1981. Tulsa is a city Mr. Getty always remembered with a soft spot in his heart, for it was there that he took his first steps in the oil business.

The thanks of the authors are due to the trustees of the J. Paul Getty Museum who authorized this enterprise and to all friends who in many different ways helped with the realization of the show and of the catalogue. The text was read by Faya Causey Frel, and much valued assistance was rendered by Katherine Kiefer and Lucinda Costin.

J. F.

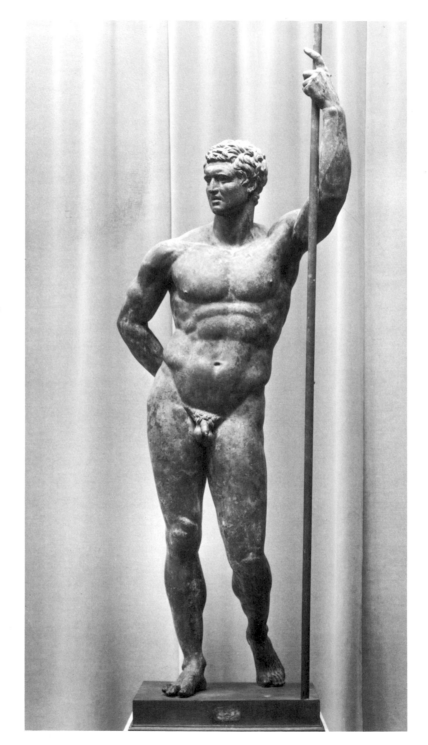

Figure 1. *Bronze statue, called a ruler, but representing a victorious Roman general in the Hellenistic tradition. Beginning of the first century B.C. Rome, Museo Nazionale.*

ROMAN PORTRAITS

The ancient Greeks were the real pioneers of individuality as we perceive it today and of the artistic vision of the individual, realized in the art of the portrait. However, the Greeks tolerated public monuments, even for their ranking citizens, rather reluctantly and only after their death—at times the direct result of community action, the most illustrious case being the Athenian democracy that first forced Socrates to drink hemlock and later erected a statue of him in repentance.

In the fifth and fourth centuries B.C., the great age of the Greek city states, portrait sculptors greatly enhanced the actual appearance of famous people by avoiding the trivial, the momentary, signs of aging, emotion, or psychology. Such marks were restricted to socially less acceptable figures, both mythological and real—satyrs, centaurs, ghosts, barbarians, slaves—sometimes reflecting the darker side of the Greek soul. The image of a Greek citizen, in public monuments dedicated by the community or by descendants, was heroized and ennobled by comparison with the immortal gods. It was Alexander the Great (356–323 B.C.) who first adopted the Near Eastern tradition of erecting godlike images of himself, often colossal in scale, in order to foster propagandistic legends of divine legitimacy. His successors and later the Roman imitators (fig.1) followed this example. Also from Alexander's time on, the declining Greek cities permitted a multiplication and accompanying devaluation of public honorific images, together with an increase of monuments to the illustrious men of the past. But even though the interest in individual appearance thus increased in the Hellenistic era, the monumental and idealized character of Greek portraits remained basically the same.

Greek sculpture may seem cold, distant, and in a way threatening to the modern viewer. At its best, it calls forth the identification of the viewer and the viewed: the victorious athlete the Getty Bronze can, in a good moment, communicate the feelings that it was you, too, who won at Olympia. Roman portraits seem just the opposite, partly because they look so much like real people we see every day. This man (no. 9) reminds me of the secretary of the museum, and that lady (no. 13) is the aunt who was not an intellectual but who made wonderful Christmas cookies. They are framed in their time by fashions of hair and beards, but with today's variety of hair styles and beard lengths, even this is not an insurmountable obstacle for awakening a spontaneous feeling of intimacy with them.

It is, nevertheless, a wrong sensation. Although to some extent Roman portraits are personal and individual, to a much larger degree they perpetuate the social and fashion stereotypes of their times. We remember how individual our friends were in high school, but a glance at another's school yearbook will im-

1

Figure 2. *Lid of an Etruscan cinerary urn with reclining man. Limestone, style of Volterra. Second century B.C. The head is much more a generic image than a portrait. Getty Museum, 71.AA.262.*

Figure 3. *Head of an old fisherman. Roman replica after a Hellenistic prototype. The strongly characterized features show how the Hellenistic genre statues were a starting point for Roman portraits. In the Renaissance, the piece was often used as a representation of the dying Seneca. Vatican Museum.*

mediately reveal how everyone looks the same. It is an effect of the same time and the same photographer. What we actually see in Roman portraits is, of course, not the likeness of a real individual of flesh and blood but a social stereotype transmitted by the sculptor. The traditions of workmanship and the style and fashions of a generation provide the appearance which attracts us as actual likeness. However, this does not mean that our fascination is wrong. It helps us to establish human contact by the vehicle of art. Right or wrong, it nourishes the feeling that humanity remains one in the changing kaleidoscope of history.

THE ROMAN REPUBLIC

The private portrait as we understand it was first developed by the Romans. Literary sources relate how when a prominent Roman died, he was escorted by a funeral procession to the Rostra in the Forum, where a son or other relative delivered a public eulogy recounting his virtues.

> *After this, having buried him and performed the customary rites, they place a portrait of the deceased in the most prominent part of the house, enclosing it in a small wooden aedicular shrine. The portrait is a mask which is wrought with the utmost attention being paid to preserving a likeness in regard to both its shape and contour. Displaying these portraits at public sacrifices, they honor them in a spirit of emulation, and when a prominent member of the family dies, they carry them in the funeral procession, putting them on men who seem most like the deceased in size and build. . . .One could not easily find a sight finer than this for a young man who was in love with fame and goodness. For is there anyone who would not be edified by seeing these portraits of men who were renowned for their excellence and by having them all present as if they were living and breathing?*

Amazingly, this is the account of a Greek, Polybios (VI, 53) the great historian of the second century B.C. who came to Rome as a hostage and became a sincere admirer of Rome and Roman customs. The educational side of this practice was extended in the Empire to all great men of the past, Greek or Roman, and statues of them, with tablets recording their deeds were set up on the sides of the Forum of Augustus (31 B.C.–A.D. 14) and later, in the Forum Transitorium by Alexander Severus (222–235).

Funerary images had long existed in different parts of Italy, especially among the Etruscans who exercised a deep influence on early Rome (see fig. 2, nos. 3, 4). Under the influence of the Greek Hellenistic world, the Romans raised their sepulchral images to the level of artistic portraits. The craftsmen-sculptors serving the Romans were mostly of Greek origin, but they did not take their inspiration from the idealizing Greek portrait tradition but rather from the repertoire of genre characters popular since the late third century B.C. (fig. 3). Such sculptures, often slightly humorous, could emphasize age, occupation, strong movement, and emo-

tions of their lower class subjects. Roman patrons did not desire classical beauty in their portraits: more important to them was expression of their concern for the *res publica*, the welfare of the state, combined with a naked admission of their aspiration for power. This characterization may occasionally appear under the idealized features borrowed from Hellenistic rulers (no. 1), but is more often seen under a rude, toothless face mercilessly exposing a rustic shrewdness (see nos. 9, 11). Indeed, the noble Romans of the Republic seem to have preferred this almost crude type of depiction not only for themselves but even for their wives (no. 12).

Because of this character, one might be inclined to view Roman portraits as private creations. Nothing is farther from the truth. Their function was basically social and their audience the entire city. For example, the statue of a man from the late first century B.C. in the Museo Capitolino Nuovo in Rome wears the *toga candida* (fig. 4) to show that he is seeking election to public office and holds busts of his father and his grandfather to help establish the legitimacy of his claim. This preference for the most veristic trend in Roman portraiture can also be traced in Roman coins of the first century B.C., where ancestral images of the old families of the establishment are reproduced. Indeed, this corresponds well to a statement in Pliny that the aristocracy in Rome had a special privilege—*ius honorum et imaginum*—the right to supreme offices and to possession of ancestral images, the latter justifying the former. The same author adds *sed plebs non habet gentes*, "but the common people lack venerable ancestry."

However, by the later first century B.C., the use of funerary portraits was widespread by all strata of the Roman population. These often mass-produced images all share a standard craftsmanlike level, but the repetition of similar features belics the apparent concern for real likeness. Inscriptions reveal that not only the plebian citizens but even foreigners settled in Rome and freedmen, former slaves, were made to look like the most respectable senators (no. 10). The unifying factor is their *civismus*, their dedication, whether real or fictitious, to the *res publica*. Some archaeologists label this harvest of funerary reliefs with stereotyped portraits as the plebeian trend in Roman art. Such a sociological approach may be interesting, but it seems to neglect the fact that the roots of the movement are in the veristic portraits of the old nobility. Rather than a new trend, there seems instead to be a wider diffusion of established values down the social scale at this time. The trend continued in the early Empire, but its ethos became more and more an empty schema. Instead portraits, particularly ones with artistic pretensions, appear less as citizens and more as private individuals.

The vogue of portraits in the Roman Republic was not limited to funerary images. Following a well-established Greek tradition, images were set up by individuals themselves, by their heirs, or by any kind of private

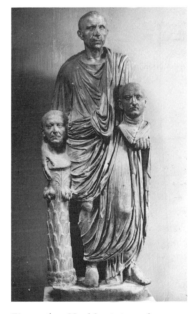

Figure 4. *Marble statue of a Roman (head ancient but alien) in the* toga candida, *holding the busts of his father and grandfather. The work belongs to the end of the first century B.C. Rome, Museo Capitolino Nuovo. Photo: German Archaeological Institute, Rome.*

or public institution—religious, commercial, or legal authorities—in countless public places. The pretext was usually votive, but the intention was really honorary, denoting the status of the represented and his family. As early as 158 B.C., the crowd of statues in the Roman Forum was so great that the censors decreed that any not dedicated by the Senate must be removed. At the same time, other centers in Italy, even minor ones, followed the example of Rome in the proliferation of both funerary and honorary portraiture. Thus some scholars detect the influence of Roman art's ruthless verism even in late Etruscan art. There is also no doubt that the last century of the Roman Republic, with its intricate network of ties with the Greek world, produced complex relationships in art production. Most of the sculptors of Roman portraits must have been of Greek or Greek-educated origin, as was true for most other artists and craftsmen in Rome.

The artists themselves undoubtedly followed different traditions. A neoclassical revival before the middle of the first century is associated with the sculptor Pasiteles, who was originally from Magna Graecia, and is one example of a trend that clearly continued into early imperial times. Other features link Roman art, even in portraiture, with another type of neoclassical production from the so-called Attic school. Another school of art, via the island of Delos, may point toward origins in Asia Minor or Rhodes. There are even occasional striking affinities with the art of Alexandria, which enhanced its version of Hellenism with the achievements of the perennial Egyptian tradition (for example, no. 31) and may, according to some specialists, have produced fruitful connections with late Republican Roman portraits.

While it is universally recognized that imperial portraits survive in many copies, and even in copies of copies of varying quality, it may be surprising to note that very few originals of Republican portraits are known. Most of these venerable effigies are known only in first or second century A.D. replicas. This should emphasize the fact that the main function of the portrait was as part of ancestor galleries. As the great Roman families grew and intermarried, there was a constant need to renew and duplicate portraits of ancestors. Sometimes a definite hint of this procedure is apparent as the shape of a bust is modified to suit new fashions. More often one can only guess at the duplication on the basis of subtle changes in the style as a portrait was modified by the copyist in the light of his own time.

IMPERIAL PORTRAITS

The establishment of the Empire created a new category in Roman portraiture, the images of the emperor and his family. Today in traditional democracies the changing of the chief executive is marked in official buildings by the replacement of one modest photograph by another. Under different skies, countless overwhelming portraits of charismatic leaders are considered necessary for the enthusiasm of the masses. In a few

surviving monarchies, the image of the ruler continues the tradition of the annointed kings. All these customs are not new. They reach far back into antiquity, where effigies of divine pharaohs and Near Eastern rulers were an important part of the religious framework of the whole social system, while the emperors of Rome achieved such superhuman status only with the decline of the Empire.

Even at the dawn of the Roman Republic, victorious generals and ambitious men are recorded to have dedicated their images in sanctuaries and public places. By the last years of the Republic in the first century B.C., the countless statues of the dictator Caesar were the subject of polemics and public execration when they were adorned with royal insignia. Caesar's successor, Augustus, accepted the cult of himself associated with the goddess Roma in the eastern provinces, where the worship of the ruler was already established in the old Hellenistic kingdoms. Over the next century, the imperial cult spread across the Empire. Augustus deified Caesar and received the same honor himself after his passing. The portraits of emperors who were deified continued to be venerated, forming a kind of pantheon of the Empire. As a group and as individuals, they received supplementary adornment and even special priesthoods charged with the imperial cult (like no. 7).

The backbone of the Pax Romana was, of course, the Roman army, which carried the image of the ruling emperor as part of its military regalia. A statue, or at least a bust, often of precious metal, was housed in the sanctuary of each legion. Military decorations and insignia often included a medallion miniature bust of the ruler. Thus, in the case of a rebellion, the first thing to happen in the barracks was to tear down the images of the ruling emperor and erect the image of the pretender. For symbolic reasons, sacrifices were made to the image of the emperor before the opening of courts of law or official activities, and on the frontiers a barbarian leader fell on his knees in ceremonial adoration before the image of the emperor as a sign of submission.

All over the Empire, the portraits of the ruling emperor and sometimes those of his illustrious predecessors were erected in public places. This honor was not limited to the emperor himself; it included to a lesser degree his family, wife, and children, and especially the heir apparent. Such statues were not usually erected by official decree but most often by the voluntary activity of civic groups, guilds, or veterans associations that would adorn a square, a basilica, or a library with sculptures of the emperor and his family as a gesture of loyalty. The administration might then reduce taxes or donate public money to build an aqueduct or listen to some specific grievances, but nevertheless the core of the gesture was spontaneous. The number of portraits in public places must therefore have been enormous. In the late second century A.D., M. Fronto wrote his former pupil Marcus Aurelius (no. 61)) that he must be tired if not annoyed to be constantly meeting with his

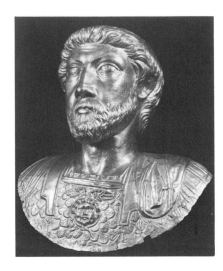

Figure 5. *The emperor Marcus Aurelius. Gold bust of provincial workmanship. Late 170's. Avenches, Museum (Switzerland).*

Figure 6. *Portrait of the very old emperor Trajan on a bronze shield image. 117–118. Ankara, Archaeological Museum.*

own likeness everywhere. The philosopher-emperor replied with true stoic acceptance.

Dissemination of the official prototype gave the Empire not only the image of the emperor and the way he should be venerated but also official court art, which then influenced local artistic production in many fields, especially in private portraiture. In this way, the influence of the imperial effigy went much deeper than the art itself. The loyal subject wanted to look like the emperor or his wife, which included not only the hairstyle and fashion of beard but also the presentation of personality (see especially no. 80). The influence of female portraits of the imperial house may have gone still deeper, as they represented the height of contemporary fashion in their hairstyle and general appearance. These fashions can aid the archaeologists in establishing chronology, but they provide their own difficulties; a third century man can wear a beard popular in the second century and one should not be confused by it (see for example, the difference of two generations in no. 66). A lady, however, could be faithful to the intricate hairstyle of her youth more than half a century later (as perhaps nos. 13 and 81).

How were the imperial portraits made? A court sculptor may have had free access to the emperor and his family on occasion, but this does not presuppose a sitting in the modern sense. Sight and memory were honed stronger and sharper in antiquity, as among certain tribes living closer to nature than Western man. So the artist would catch the essence of his subject and express it within the framework of artistic tradition and ideology of the time. The result would be officially approved in Rome, possibly even by the emperor himself, and then replicas would be dispersed throughout the provinces of the Empire. The barbarian West and central Europe received a good many effigies directly from Italy, particularly bronzes but also marbles carved either in local Italian Carrara or imported Pentelic marble from Attica, or, later in Asia Minor marble. Some crude copies were produced in local stone or bronze in the West, but in the civilized East, with its centuries of Hellenized life, local workshops produced most of the countless replicas for themselves and even for some neighboring areas like the South Balkans. The techniques involved are described with a valued unfinished portrait, no. 34. Of course, the most important portraits were in precious metal. Certain megalomaniac emperors are recorded, like Domitian (Suetonius, XIII, 2) as permitting "no statues to be set up in his honor unless they were of gold or silver and were of a certified weight." Very, very few of them survive, for obvious reasons. There is, however, a bust of Lucius Verus in silver, clearly the product of a skilled workshop in Rome itself but found in North Italy, and a gold bust of Marcus Aurelius from Switzerland (fig. 5), indisputably executed by a local craftsman.

The portrait sculptor considered himself much less an artist than an artisan, like the other stonecutters and bronze founders who reproduced the imperial image in countless replicas. This is why most of the numerous

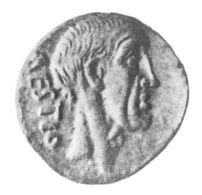

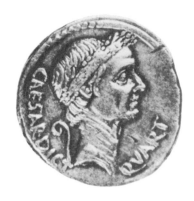

surviving imperial portraits are of lesser quality than contemporary private portraits. The latter are originals, the former mostly copies. Only a few rare originals of imperial portraits survive; they are, however, mostly local products and not necessarily great artistic achievements. The golden bust of Marcus Aurelius from Switzerland is poor both as a work of art and as a portrait, but a bronze tondo in Ankara (fig. 6), a form which the Romans called an *imago clipeata* (shield image), with a bust of Trajan, is a unique and unsurpassed masterpiece. The local sculptor must have been impressed by the sight of the aged emperor and successfully caught his own perception of Trajan's physical presence, impressive and thrilling even for the modern viewer.

COINS

The very first and most numerous category of imperial portraits is coins. In this respect, the Caesars followed the well-established tradition of Hellenistic kings in disseminating the image and message of the ruler. In the last century of the Republic, the magistrates supervising the mint started to include likenesses of their ancestors on the city's coins as an expression of family pride (fig. 7). Julius Caesar was the first individual to assume the prerogative of striking his own profile in his lifetime (fig. 8). He was followed immediately by his assassins, those supposedly deep-seated Republicans, and then by Augustus and all the succeeding emperors. The portraits are usually struck on the obverse of each coin; the reverse has a figural device with an appropriate motto of imperial propaganda, often with involuntarily sarcastic overtones (when two imperial brothers proclaim their *concordia*, you can be sure that sooner or later one will murder the other; when the *concordia* of the army is vaunted, the Roman world is on the brink of military rebellion). Coins are an estimable source for Roman history, and the portraits on them provide a well-dated series of official images which aid in the identification of portraits in other media. Here the gradually decreasing importance of actual likeness is clearly documented. In the first two centuries of the Empire, the identification of sculptured portraits of most imperial figures is well established, with the exception of some younger princes. In the third century and later, however, the features of many ephemeral emperors or pretenders are confusing. Often the die with a precursor's profile might be used, especially at a provincial mint, with a simple change of the legend—eloquent sign that the real likeness was quite unimportant. From the fourth century on, even identification is difficult, as the coin portraits propagandize unchanging stability in a world fomented by perpetual and violent transition. The same is true of portraits in all other media.

Figure 7. *Silver denarius with portrait of the tribune Antius Restio, struck by his descendant C. Antius Restio in 46 B.C. Photo: B. Schweitzer,* Bildniskunst, *fig. 87.*

Figure 8. *Silver denarius with portrait of Gaius Julius Caesar, struck in the first half of February 44 B.C. by M. Mettius. Photo: A. Alföldi,* Caesar in 44 v. Chr., *pl. 7.17.*

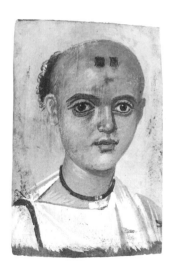

Figure 9. *Mummy portrait of a boy. Encaustic on wood panel. Middle of the second century A.D. Getty Museum, 78.AI.262.*

PAINTED PORTRAITS

Few painted imperial portraits survive, and Roman mural paintings provide only a hint of the quality in private painted portraits. But they must have been nearly as widespread as sculpted ones. One Roman province, Egypt, is unique in furnishing numerous examples of painted images (figs. 9 and 10). Sometime after the beginning of the Roman occupation, the Egyptian way of handling the mummified bodies of the deceased was modified. At first, the traditional plaster and cartonnage masks placed over the head of the mummy were replaced by wooden planks with painted portraiture—either in encaustic technique or, especially later, in tempera. Less often, the image of the deceased was painted directly on the linen shroud. The mummies must have been preserved in some instances for a long period of time in the family home, as evidenced by some excavated mummies which had been damaged by children's scrawls and later repaired. When the emotional interest in the deceased declined, the mummy was discarded more often than properly buried. Good portraits were at this time often removed from the linen wrappings to be hung on the wall. Some of these images seem to have been copied or adapted from previously painted portraits from life, but most must have been done on the occasion of death. All of them are products of local craftsmen: they show competence but little artistic potential. At first glance, these portraits look alive and individual, but on closer examination, the individual and actual likeness is reduced to a kind of expressive stereotype. However, they are the best we have of ancient portrait painting and by their appearance and occasional paraphernalia show the curious syncretism of Egyptian religious traditions: mummy image, Hellenistic painting, and Roman perception of the individual.

STATUES AND BUSTS

There are basically two categories of three dimensional portraits: statues and busts. To the Romans, the head was the real essence of the portrait. This explains the existence of many heads made separately for insertion into nude or draped statue bodies, where the body was seen as just a support and reproduced a standard, often Greek, prototype (see no. 51 where statue and head both survive). How many emperors and private Roman citizens appeared in a Polykleitan scheme? How many Roman ladies were shown as the Large or Small Herculaneum Women? This standardization is essentially un-Greek, for the classical Greek sculptor perceived face and body and pose as a cohesive whole. The shift in attitude reduced the work of Roman portraitists to the head and allowed the client to choose a body that suited his taste. The practice also allowed the combination of different materials: often the drapery of a statue or even of a bust could be of colorful marble to set off the white flesh areas. The changes in hair fashions also found expression: from the second

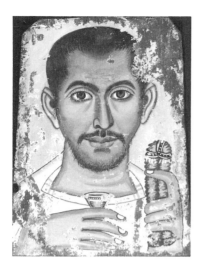

half of the second century A.D. on, we know examples of faces made separately from the hair which could be attached like a stone wig and changed on the arrival of a new fashion (see no. 75).

The most frequent shape used for Roman portraits and the most economical was the bust. They were made to be exhibited mostly in niches or in some architectural frame. The back of the bust itself (even of the head) was often not completely finished because it was not meant to be seen. In the time of the Republic, the bust extended to just below the neck. By the late first century B.C., it commonly included the collarbones (no. 17); and in the first century A.D., a deeper, triangular section (no. 18). About 100, not only the complete shoulders but the tops of the upper arms were shown, and the base followed the contours of the large pectoral muscles. Soon after, busts commonly extended to the navel (no. 65) and the upper arms were clearly modeled, but already in the early third century the lower abdomen and complete arms were sometimes carved. However: earlier types of busts sometimes were used in later times. Their variety reflects basic statue types: the cuirassed bust, draped bust (sometimes with veiled head), and nude bust. Statues were made with portrait heads inserted into idealized bodies of one or another type, which bear no relation to the physique of the individual represented. With no intended humor, emperors and their wives, as well as private individuals, could be represented as gods and goddesses. The same tradition today lets us view with equanimity a modern (eighteenth to twentieth century) statesman with the body of a nude Greek athlete. It is, however, astonishing to modern eyes to see females of the imperial house who had their dignified, middle-aged faces attached to the bodies of youthful, nude Venuses. The assumption of divinity is strong here. Some early emperors chose to appear as godlike statue types, as Jupiter and Herakles (Nero erected a seventy-foot high gilded colossus of himself as Helios), and later on as popular oriental divinities. From the fourth century onwards, the emperors often appeared as the annointed vicars of god on earth.

In the early Empire, imperial portraits were usually life-size, or slightly larger for public monuments or large spaces. Colossal scale was rare in the first century, except for megalomaniac individuals like Nero (no. 30) or Domitian (no. 34), but they became more and more frequent with time. By the end of the third century, statues close to twenty feet tall were not at all uncommon. The portrait of an emperor was characterized as such, be it statue or bust, by several external insignia, some of them reserved exclusively for emperors or heirs apparent, some of them shared with other dignitaries. Thus the preserved *capite velati* (portraits with a fold of the toga over the head) characterize any priest, while the *lituus* (a short stick terminating in a volute) is an insignia of the augurs, a respectable college of seers presided over by the emperor. Cuirass and paludamentum (a triumphal cloak) were reserved to *imperatores*, victorious generals, in the Republic, but during the Empire they were exclusively the garb of the supreme ruler (no. 35). Different crowns existed,

Figure 10. *Mummy portrait of a man holding a flower crown and a chalice. Tempera on wood panel. End of the third century A.D. Getty Museum, 79.AI.142.*

9

from laurel and oak leaves to ears of wheat, designating members of different religious colleges, to the ray crowns originally an attribute of the gods and used from time to time by some tyrannical individuals of the first century like Nero or Domitian. They regularly adorn living emperors from the third century on (see no. 86).

Insertion heads allowed frequent and inexpensive reuse of statues and loyal updating of a long-lived sovereign's image. A few examples even exist of reused portrait heads. It happened, especially in later antiquity, that a portrait, even of a "good" emperor, could be recut to be used under another name for another imperial likeness (see also no. 15). This is not to say anything about the emperors whose memory was officialy cursed (*damnatio memoriae*) like Nero, Domitian, or Elagabalus. Their images were broken and mistreated, and even their names were erased from inscriptions (see also no. 79).

CONCLUSION

Many historical periods and cultures have lived through progressive cycles of interest in the artistic portrait. Others were never interested in it at all, and others, like our own, have replaced it with mechanical means of capturing individual appearance. The Roman portrait developed and flourished in the last two centuries of the Roman Republic. It peaked in the first two centuries A.D., the first two centuries of the Empire. The third century marked its disintegration; the fourth, its decadence. This, of course, does not imply the decadence of Roman art as a whole, but only that the new community consciousness put less and less weight on the individual and his appearance. As late Roman society sought more and more for spiritual values, actual likeness, whether real or fictitious, was taken less into account. The soul being perceived as superior to the body, the portrait was condemned, since it is hard to reflect a man's soul in stone or on panel.

Very often this evolution is connected with the advent of Christianity. It is true that as the heir of some Near Eastern, specifically Jewish, ideas, Christianity did not regard the visual arts favorably at the outset. But the trend toward spirituality in Roman art existed prior to the wide diffusion of Christianity and surely prior to its adoption as the official religion of the late Roman state.

The end of antiquity was not the end of the Roman portrait tradition. Attempts at revivals immediately followed. Imperial images inspired the official iconography of Charlemagne (800–814) and his successors; later, Frederick II Hohenstaufen (1194–1260). The imitation was so close that the portraits of this time may be easily mistaken for Roman. In the fifteenth-century Renaissance in Tuscany, Roman Republican portraits inspired a masterful vision of the new individual, like the so-called Niccolo d'Uzzano by Donatello, and the great Roman public monuments paved the way to his equestrian statue of Gattamelata. Renaissance medals looked consciously backward to the masterpieces of Roman monetary portraiture. This classicizing and

specifically Roman-inspired art continued through the Baroque period. At the end of the eighteenth century, it received new impetus from the French Revolution seeking roots in the Roman Republic and still more from the fascinating personality of Napoleon finding the proper medium for his propaganda in Augustan portraiture. Napoleon's time perhaps also created the image of the very youthful Augustus as a kind of retrospective. Celebrities of the nineteenth century continued this trend, but even recent twentieth-century imagery, while apparently rejecting tradition, often retains the Roman bust shape and emulates the penetrating psychology and irresistible ethos of Republican heroes.

Western history's fascination with Roman portraits thus has a very long tradition. It also has its reverse side. Since the Renaissance, imitations and forgeries of Roman effigies have been current. The word "forgeries" is not really an appropriate designation: early on many collectors desired complete series of the twelve Caesars, according to the canonical set established by Suetonius's biographies, or of great literary figures (no. 96). Missing portraits could be added to genuine ancient heads by contemporary sculptors, and complete sets were manufactured to order (see no. 97) following recognized iconographies. Even the early nineteenth century tried to place its own leaders in the Roman dress of great men of the past, sometimes so accurately that a misunderstanding on the part of a modern archaeologist is possible. The constitution of the art market and widespread museum and private collecting have also produced a need that has been satisfied in more recent years by more or less competent forgeries (see nos. 97–100). When recognized, these works represent not only a tribute to the mastery of Roman portraitists but also present interesting documents on how modern times see the Romans as individuals captured by art. All in all, we still return today with admiration and affection to the images struck in metal or carved in marble, whether anonymous or associated with the great names of antiquity, for the spirit and the grandeur that was Rome.

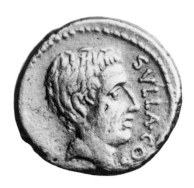

1. Bronze head from a statue

A Roman general, possibly L. Cornelius Sulla. The portrait and the art are so completely in the Greek tradition, going back to the fourth century B.C., that specialists have thought it might represent a Hellenistic ruler. Early first century B.C.

Figure 11. *Silver denarius with the head of Sulla, struck by Q. Pompeius Rufus in 59 B.C., Getty Museum, 78 AI.315.*

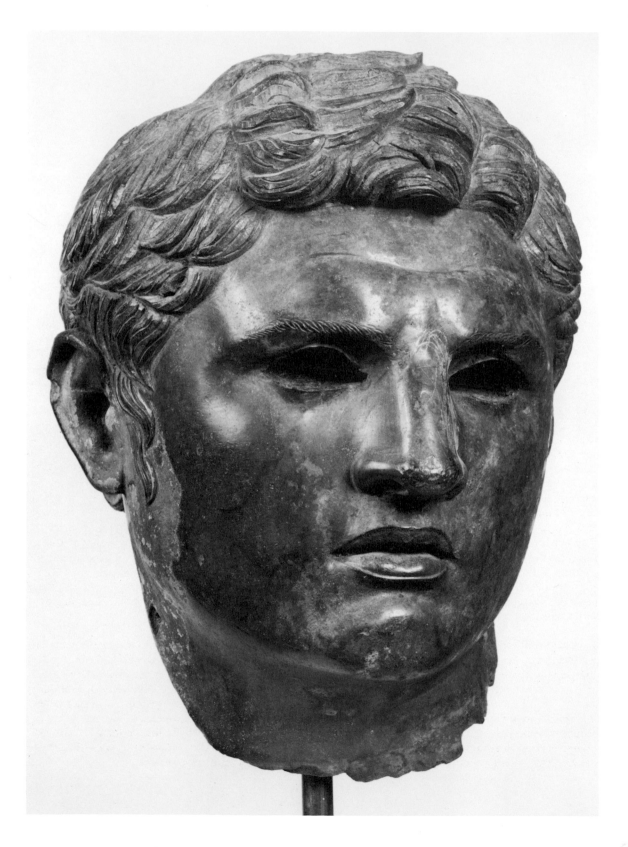

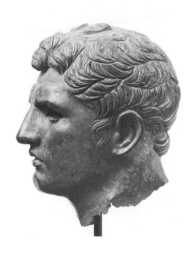

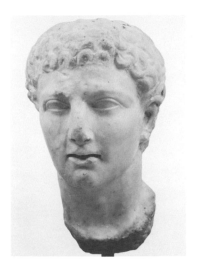

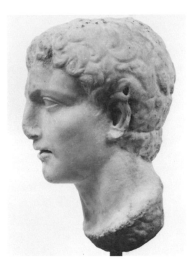

THE GREEK TRADITION

2. Young man from Asia Minor

This is another example of the Hellenistic tradition, but neoclassical elements fashionable in the first century B.C. and later continued in Roman imperial art, are very strong. Early first century B.C.

1 The earliest Roman portrait in the Getty collection is unquestionably a masterpiece. It is overwhelmingly impressive even though the sculptor was not very careful. The casting has the perfection of the best Hellenistic Greek bronze work, but the cold work—the detailed chasing of the eyebrows, hair, and ears—is sketchy and even a little negligent. But what a sensitivity to the nature of bronze! The casting and the modeling go together perfectly. The artist's ability to capture the essence of the sitter is admirable. We do not see much of his real likeness or his complex character, as the man is rejuvenated or rather ageless, in the best Greek tradition. Standard Lysippan proportions are used to build the facial structure. This fact at first led some specialists to believe the head must represent a Hellenistic king. Although the absence of a diadem excludes this possibility, the artist's inspiration must come from such a source. The man radiates the power of his will. Accustomed to command, he inspires submission by his charisma. In this way he is a descendant of Alexander the Great, even though the universe has become considerably older in the meantime and youthful dreams of meteoric conquest had been replaced by ruthless pragmatism. This is the way that the conquered Greek world saw its new Roman masters, and in turn they must have appreciated such flattering images.

The head is said to come from Asia Minor. It must have belonged to a statue like the standing so-called bronze ruler (fig. 1, p. vi) in the Museo Nazionale delle Terme, which in Baroque style and in approach to portraiture is its nearest kin. The character compares well with the literary descriptions and images on coins of L. Cornelius Sulla (138–78 B.C., fig. 11) the great general, who in the early first century B.C. tried to reverse the inevitable change of Roman *civitas*, by casually imposing a military dictatorship in an attempt to save the unsaveable.

2 This head, made for insertion in a statue, presents a good example of the transition in style between late Hellenism proper and its continuation in the Roman world. The style and craftsmanship are comparable to portraits of the first century B.C. carved in Italy. However, there is something in the personality of this young man that is definitely not Roman. The provenance is well established and confirmed by the Asia Minor marble. It is nothing ethnic that dominates the expression, for we have seen portraits of former slaves of Levantine stock who when living in the City did their best to look like Roman senators (see no. 10). Our melancholy young man totally lacks the civism proper to the society in Rome in the first century B.C. His appearance corresponds rather to the last stages of small Hellenistic kingdoms in Asia Minor, so much so that some archaeologists have tried to give him the name of one of these ephemeral rulers.

3. Terracotta head of a girl

The Etruscan tradition continued when Etruria was already ruled by Rome. It is more a character than a real portrait. First half of the first century B.C.

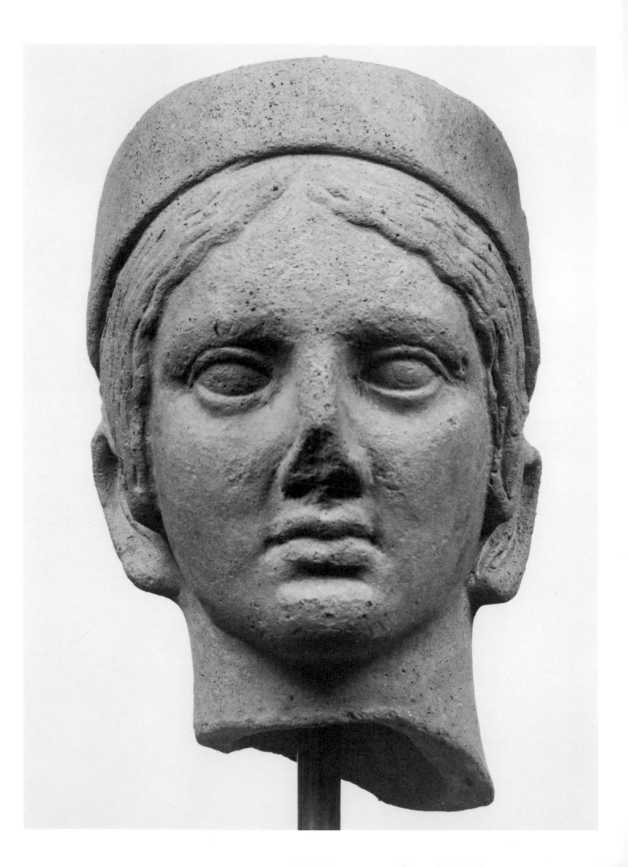

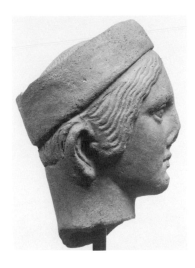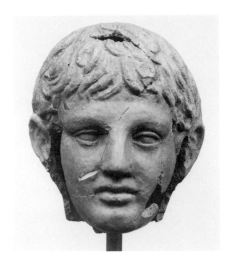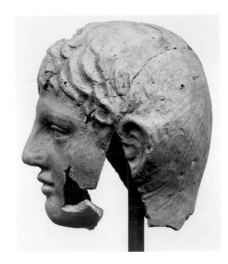

3 Terracotta heads were among the most popular votive offerings of the Etruscans, produced from the fourth century B.C. onward in great quantities. The two heads which are included here stand out from this mass production. The fine head of a young woman does so in three ways: (1) her outstanding artistic quality, (2) the existence of some elements of personalization, and (3) the fact that it was not merely a head but must have belonged to a bust if not to a complete statue. If not a portrait, it was at least clearly intended as an image of an individual. Of course, the primary concern was to show her youth and her beauty. The artist also managed to convey her reserve and her modesty, the most often praised female virtues in antiquity. The variation from standard proportions suggests a possible chronological connection with the great flourishing of portraits in neighboring Rome in the first century B.C. Even though the original polychromy has been lost, the image retains its impact.

4 The well-preserved polychromy is the main attraction of the other terracotta Etruscan head. This was a standard ex-voto head with only the neck now missing. Closer inspection reveals much more cursory work than the first impression makes one believe. The individuality also dissipates in this closer view. The style places it in a neoclassical trend, in preview of Augustan portraiture. This head dates later than that of the girl, perhaps to the third quarter of the first century B.C.

4. Terracotta head of a youth with well-preserved polychromy

This was a standard ex-voto offering with little individual characterization. Third quarter of the first century B.C.

**5. The McLendon Caesar
(102/100–44 B.C.)**

*Late first century B.C. replica of
the only portrait representing
Julius Caesar created in his own
lifetime about 44 B.C.*

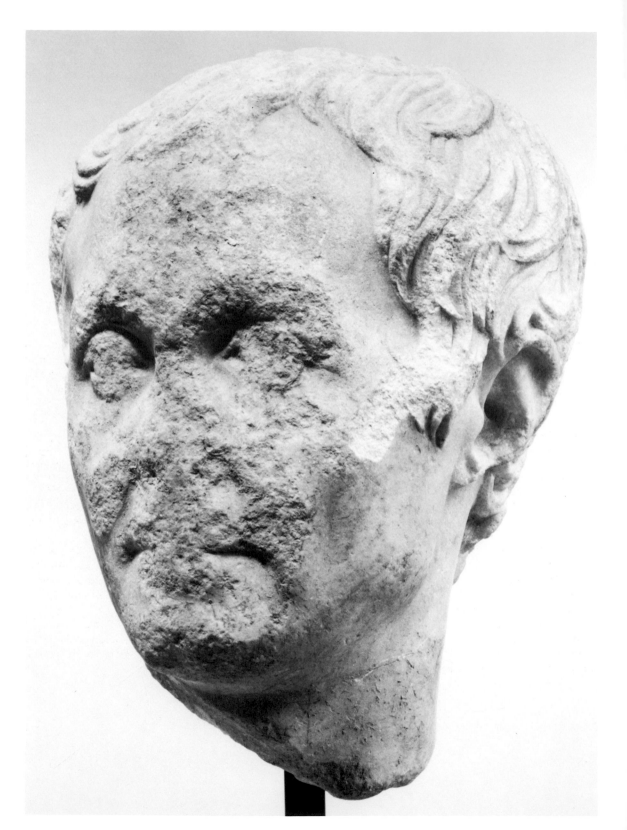

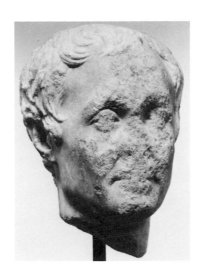

JULIUS CAESAR

At first glance, it is difficult to believe that the three images of Julius Caesar (102–44 B.C.) in the Getty Museum are of the same person. They look like three entirely different people, but a common likeness clearly links them together. But is there any real likeness of this great man? The many different presentations of Caesar's personality surely reflect the varying political and social overtones associated with the founder of the Roman Empire.

5 The condition and artistic quality of all three Getty heads is not outstanding, and the piece which was once the finest (called the McLendon Caesar) has suffered most over the ages. One can guess at its features, but enough remains of the profile to compare it with coins struck just before the violent death of the benevolent dictator in 44 B.C. (fig. 8). This image of Caesar survives in several sculptured variants preserving Caesar's amazingly asymmetrical skull, which must have been an anatomical peculiarity, his receding hairline, and his lean, weathered skin. These features are politely minimized on the coins where Caesar is given abundant hair. On the other hand, the coins also describe unflinchingly the scrawny wrinkled skin of his neck and his prominent Adam's apple.

The other sculptural variants of this portrait are closer to the original image than is our head. The sculptor, working in Asia Minor (as indicated by the marble type) was perhaps influenced by the idealized portraits of early Hellenistic rulers. He ironed out some of the unpleasant features. Our replica may be Augustan, a period which found the memory of Caesar politically very useful to the new regime. There is something very real and appealing in this image. In spite of the unpretentious level of craftsmanship and its ruined state, we can still perceive the image of a man who united a firm hand and a generous mind, a man of Roman *auctoritas* tempered by Greek *paideia*, a man of ambition who wanted to serve, a true Roman devoted equally *urbi et orbi*, to the city and to the world. More than in the two other images, the sculptor seems to have participated in the exaltation which Caesar must have inspired.

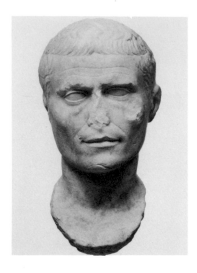
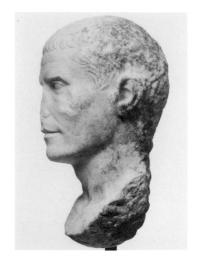

6. The Blücher Caesar

The head belonged to a statue with its head covered by a veil, representing Caesar as the pontifex maximus*, the supreme priest of Rome, and dating from the very end of the first century B.C. The portrait type, on the other hand, belongs to the effigy based on Caesar's death mask of 44 B.C.*

6 The second Caesar belonged to the descendants of General Blücher, the victor of Waterloo. The Blücher head was modified from a prototype intended to be seen from all around, and was prepared to be inserted in a statue with the head covered by the toga. Thus the sitter was represented as a sacrifiant, perhaps recalling the supreme religious office of *Pontifex Maximus* which gave Caesar and all his successors a special status. Consequently, the modeling of the sides, back, and top of the head is sketchy, and the whole orientation of the face is rather grim and set. This modification of the type has prompted some authorities to question the identification as Caesar. A technical detail, however, acts strongly in favor of this head being a portrait of a famous person. Above the forehead on both sides are two small rounded indented protuberances (puntelli) that were not effaced after the process of reproduction. They demonstrate that the Blücher Caesar is a reproduction of a well-known type and thus a celebrity. A careful reading of the features points to the second version of Caesar's iconography, which seems to derive from the death mask that historical sources mention having been displayed before and during his funeral. The lips, which are stiff and slightly sagging at the corners, the protruding cheek bones, and the sunken flesh of the cheeks suggests the *facies hippocratica*, the death mask. The eyes are lifeless, having been made "classical" according to the standard convention of improving images from death masks. The artist attempted to overcome the frozen grimace of death but succeeded only partially. Our replica, carved in Italian marble, is more pedestrian than the best examples of this second type, but it still reveals how Caesar disdained his own end, knowing well that the brave die but once. The dry execution of the Italian craftsman suggests the very end of the first century B.C., when Augustus was well established as Caesar's heir.

7 The third example, the Getty Caesar, is a colossal sculpture with an elongated neck, carved to be dropped into a draped statue body. The representation provides us with a monumental and simplified vision of the man, evoked as the founder of the Empire. The coins of Caesar struck under the emperor Trajan (A.D. 98–117) provide an excellent analogy (fig. 12): the simplified features and the summary modeling were intended for view from afar. One can visualize the statue exhibited as part of a group in a temple of the divinized Trajan such as built at Pergamon. Our colossal Caesar may then have been the first in the series of an imperial portrait gallery demonstrating the uninterrupted sequence of the rulers of Rome. The rounded skull, heavy eyebrows, generally rounded face, and massive structure of the forehead strongly suggest the appearance of Trajan whose likeness may have been projected here onto his famous predecessor. Trajan surely did not order the conflation of his and Caesar's likenesses, and the sculptor may not have been conscious of this assimilation. The idea of the perennial Empire had already been expressed by Tiberius when, tempering the Senate's mourning of Augustus, he declared: *principes mortales res publica aeterna.*

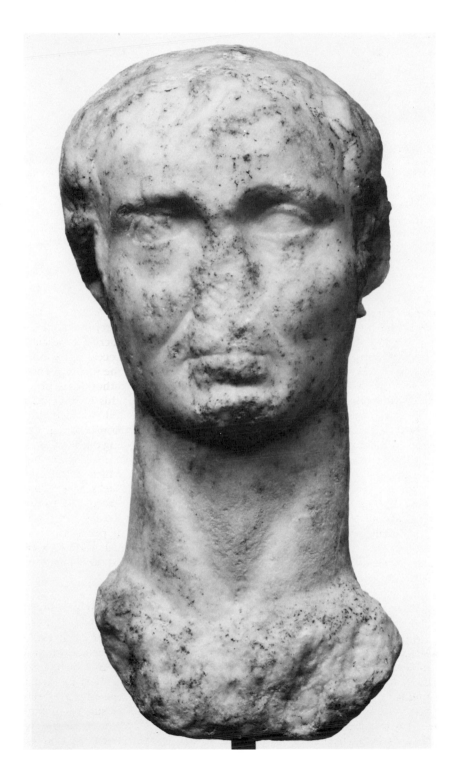

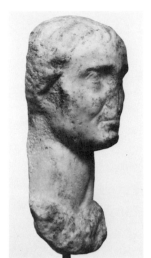

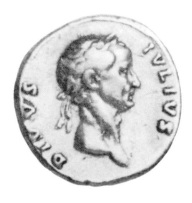

7. The Getty Caesar

This is an image of the father-founder of the Roman Empire, with the addition of some elements from the likeness of the emperor Trajan (98–117) to express the perennity of Rome.

Figure 12. *Gold aureus of Caesar struck by Trajan. Photo: F. S. Johansen,* Analecta Romana, *1–4 (1960–67), p. 14.*

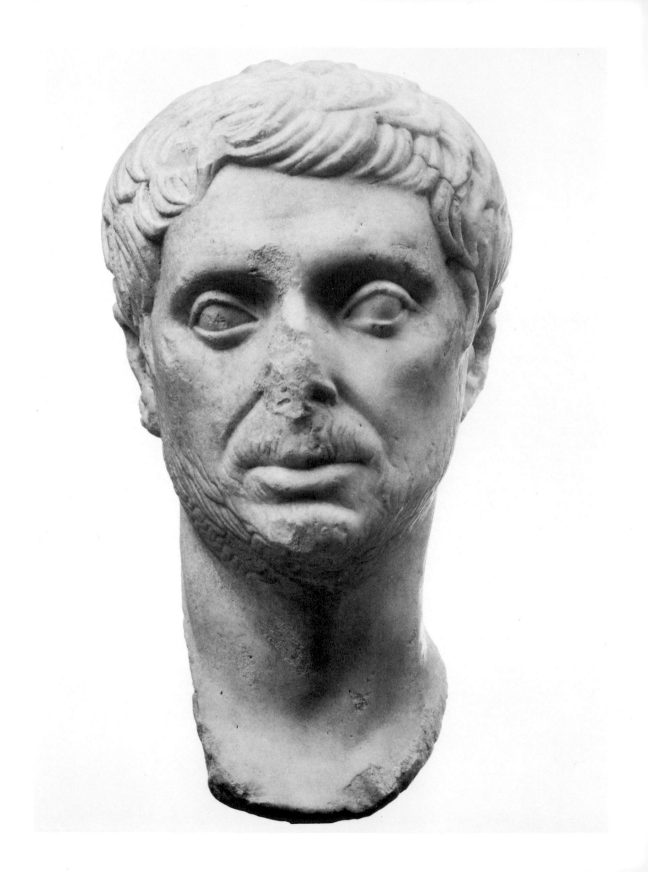

20

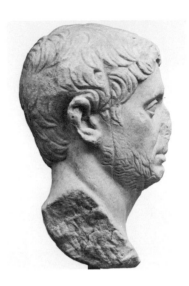

In this masterpiece of Augustan classicism, the private character of the portrait practically eliminates the civic ethos proper to a Roman aristocrat. Late first century B.C.

THE TRADITION OF THE REPUBLIC

8 This marble head of excellent quality, both as a sculpture and as an image, came to the museum under the name of ''Brutus,'' the favorite of Caesar who became his murderer. Unfortunately, the name results from wishful thinking. Coin images of the famous assassin shows him with a short beard and features, but without details precise enough to allow comparisons with the sculptural portrait. However, the false name accurately reflects some association with Caesar's portrait and can provide a starting point from which to understand it. The portrait must date from the Augustan period, still in the first century B.C.

It is superior in carving but drier in style when compared to the McLendon or Blücher Caesars. The subject appears cultivated and generous, but he seems filled with anxiety and is turned inward towards himself. The comparison to Caesar's portraits make clear how the brio of the dictator's representation is not only based on his exterior appearances but on his involvement, his identification with Rome. The focus of our *privatus* is with himself. But what fine modeling and what sublety is communicated here, making this solitary, melancholy face sympathetic. Is this indeed the man as he appeared to himself? We can only imagine. But what we may see is the tired mood of the *pax Augusta* when the civic ethos was replaced by a strictly private orientation: *quotus quisque reliquus qui rem publicam vidisset.*

21

9. Elderly man from southern Italy

The portrait bust inserted in a pyramid-shaped monument shows the continuation of Roman traditions under Augustus. End of the first century B.C.—early first century A.D.

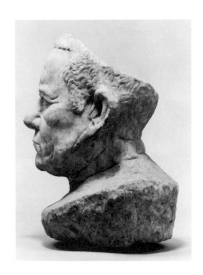

9 This portrait of a man reminds us of a face from the American Midwest; he appears shrewd, well-rooted in his life and in the earth. Like the historical Romans of Republican times, he could have been a senator, perhaps from Nebraska. But he is not from the Republican period, unless one could continue to believe in the old Republican institutions and rituals which Augustus kept alive because it suited him to maintain the illusion of *res publica*. It is fairly possible that he did. He is a provincial and his rustic existence in Southern Italy may not have been much disturbed by the cataclysm of civil wars and the establishment of the Empire. Or perhaps like Augustus, he too may have wanted to proclaim the uninterrupted continuity of social institutions and values. Thus, stubborn and marked with age but full of vitality, he appears to us in the Republican way which his sculptor has rendered with a note of provincialism. The dry, linear treatment of the details verges on the treatment characteristic of woodcutting. The modeling is completely subservient to lines. In contrast to true Republican portraits, the death mask seems to have vanished even if the portrait was intended as a funerary monument. The head does not refer directly to *imagines* housed in the traditional atrium but to another custom of a head as a funerary monument, as it was known in the mixture of Greek and native traditions, for example in Tarentum. Also, the sculpture itself does not belie elements of Augustan style. The veristic, pitiless treatment of the wrinkles, the sagging dewlap, and the pouches under the eyes is tempered by a neoclassic restraint.

10. Funerary relief of Popillius and Calpurnia

A couple of freed slaves from Rome, the man and woman are shown in the veristic tradition of the Roman aristocracy. They date from the Augustan period (31 B.C.–A.D. 14).

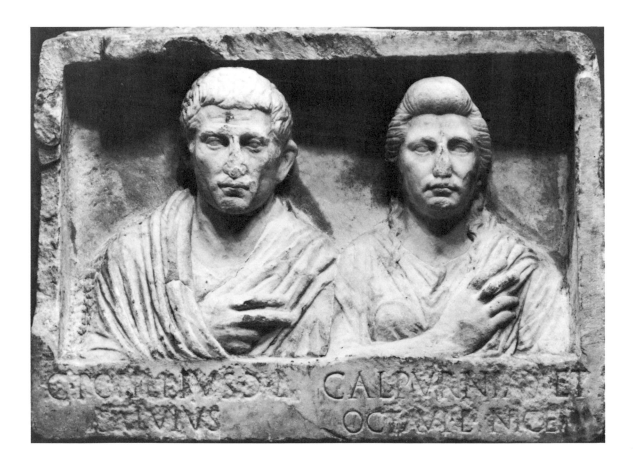

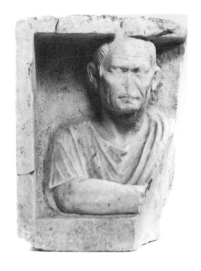

11. Funerary relief of a man (fragment)

The ruthless realism continues the death mask tradition of the Roman Republic. End of the first century B.C.—beginning of the first century A.D.

10 A husband and wife hold hands in death as they were united in life, linked by a gesture but without real communication. They stare forward in hieratic frontality as good ancestors of a good family should. They look very individual and very Roman: the man, serious and clearly careworn in the service of the community; the lady, in a dignified restraint. The carving is unpretentious: the folds of the drapery are repetitive and poorly executed, the modeling of the faces is schematized, and many details like ears and hands are so cursory that they are almost unpleasant. The inscription reveals that this Roman who appears to be so traditional is really a former slave living in a common law marriage with another former slave. Thus, the sculpture is a good example of how the custom of funerary effigies, which commenced as the privilege of the upper caste, became widespread throughout the population, so that even freedmen commissioned images that conformed to the appearance of aristocrats entrusted with the care of the *res publica*. This was well understood by the craftsman, more stonecutter than artist, who looked for inspiration not only in the traditional *imagines* but still more in contemporary official portraits of the imperial house.

A second illusion dissolves on closer examination. No individuality, no actual likeness, is represented. The marble reproduces in an unpolished way the neoclassical appearance of imperial princes (compare for example the following portraits of Tiberius (nos. 21, 22) and Germanicus (no. 23) to which the sculptor has added, perhaps involuntarily, some rustic undertone. The lady corresponds well to the image of Livia (nos. 16, 17) not only in the dignified hairstyle but also in the tightly pursed little mouth and the general proportions of the face. In style the relief is Augustan, while in the images appears a strong link, pointing to the venerable Republic, as in the portrait of the rugged man (no. 9), or the comparable small portrait of a woman (no. 12) and the so-called mother of Augustus (no. 13).

11 A bust of elderly man remains from a double funerary relief. The other half may have represented a brother or a wife. They were most likely turned slightly toward each other, but still maintained the obligatory frontality. The style points to Rome itself, even if only to an artisan's workshop. This sitter also did not belong to the cream of Roman society, but his presentation is well within the framework of Republican *imagines maiorum* even if carved later under Augustus, for traditions were much stronger in Rome than in the provinces. In contrast to the other monuments, the *facies hippocratica* of the funerary mask is here very perceptible, and one can see well how, in spite of all apparently individual features, the face reflects a social stereotype. Despite his social standing and the new regime, he appears to care about the former *res publica* with all the pride of a member of a senatorial *gens*.

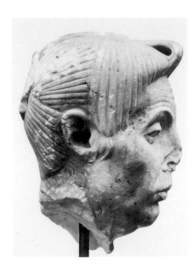

12. Under life-size head of an elderly woman

The sitter is aged and certainly not beautiful; however, the portrait is lively and sympathetic. Late first century B.C.

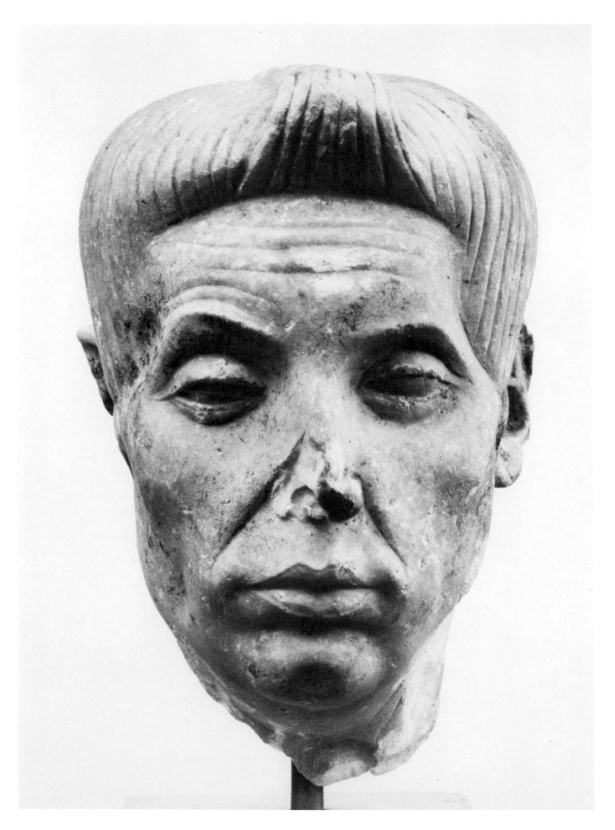

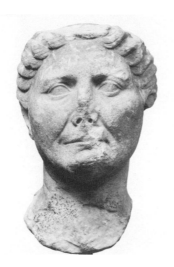 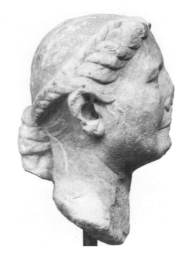 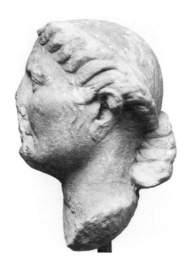

12 For a genuine antiquity everything seems to be against the rules in this small head: technique, carving, modeling, execution of details like eyes and hair, and the slightly nagging appearance. To make it worse, under life-size portraits are more often forgeries than not. But this head is authentic and a masterpiece of its kind. Placing her in the context of comparable portraits, the physiognomy and personality express their uniqueness. This is how Republican ladies and their early imperial daughters most often let sculptors present them: without any self illusions, without pity, and without regrets, but with a great strength. It is this last quality which, without giving Roman women a public voice in the society and its administration, made them its real backbone. Through the relative silence of historical sources, we still perceive the strong personalities of Roman ladies, starting with Sempronia, who shaped both her sons, the Gracchi, to their tragic destinies. Our lady lacks that vigor and that preeminence *nec plus ultra*, but she partakes of the same solid, unsentimental, down-to-earth nature which provided the indomitable, day-to-day existence of Rome. The closest parallels are from the early Augustan period, an epoch perhaps reflected in the visage of our lady who must have known all the hardship of the last great civil war which had made the Romans regret but slightly the demise of the Republic.

13 This portrait head, made for insertion in a statue, is plain both as a sculpture and as an image of an individual, giving a correct, unemphatic view of an old woman. She is conscious of her status; this is the only feature stressed, besides the advanced age, with a restrained modesty which appears absolutely natural. It may not be. It is more probable that it is a reflection of the social behavior which became the normal mien of the Republic Roman matron. There are several heads comparable to this one but none of them is an exact replica. The proposed identification as Atia, Augustus's mother, is supported by the fact that the head was found together with that of a man (slightly larger in proportions) which has been known in two other replicas and tentatively identified as Augustus's father, C. Octavius. There were portrait statues of Atia erected throughout the Roman world. Kenan Erim has kindly informed me about inscribed bases found with her name at Aphrodisias in Asia Minor. The piece dates without any doubt to the Augustan period.

13. Matron, perhaps Atia, the mother of the emperor Augustus

The head was allegedly found with a portrait usually identified as Augustus's father, Gaius Octavius. The unattractive face shows the strong character of a true Republican wife and mother. Later first century B.C.

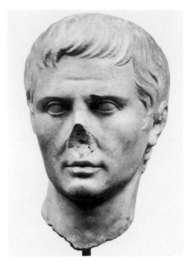

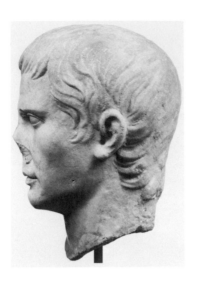

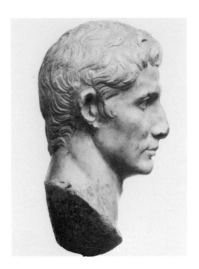

AUGUSTUS AND HIS FAMILY

14. The emperor Augustus (31 B.C.–A.D. 14)

Replica of the standard type of the aging emperor from the early first century A.D. An excellent example of Augustan classicism in which the precise Roman quality of portrait is elevated by the use of Greek classical ideal canons.

15. The Nilsson Augustus

A portrait of Caligula was recarved, after the memory of the young tyrant was condemned, into this standard image of the founder of the Julio-Claudian dynasty. 40s of the first century A.D.

14 The first impressions of this head of Augustus (b. 63 B.C., ruled 31 B.C.–A.D. 14) are lukewarm. Modern treatment with acid gave the surface a certain early nineteenth century air and marred it, reducing the sharp incision of the details, suppressing the modeling, and leaving the stone cold and unresponsive. Slowly one becomes aware that the head was a good reproduction of the standard, so-called Prima Porta type which presented the aging founder of the Empire in the guise of a classical Greek young man—elevated above incidents of mood, age, and even actual likeness. No one would say today that it reproduces an ideal Polykleitan type: however, everybody can see that Polykleitos's *canon* is the basis of the proportions, the art, and the elevation of the individual. At a deeper stage of examination, the head reveals much more about the man we see: will power, intellect, and Roman pragmatism in a Greek mantle. This is the man who could cloak his conquests in constitutionality and lead Rome as *princeps*, the first among equals, to new heights of peace, prosperity, and power. Even a discreet indication of Augustus's age is perceptible, especially in the naso-labial zone. It is respect more than love that we feel for both the sculptor and the man.

15 The other Augustus in the Getty collection appears more romantic with his dreamy eyes, lively movement of the facial muscles, and full lips. Here we can imagine the energy of the eighteen-year-old heir of the murdered Caesar, grasping for power and revenge but also filled with his adopted father's visions for the future of Rome. The hair has the characteristic "fork" over the brow typical of Augustus, but the sculptor has had some difficulties. In general he followed the standard image of the Prima Porta Augustus as in no. 14, but there is some uncertainty buoyed by inflated volumes and the right surface. One explanation of the peculiarities of the head is simple and has been suggested by Paul Zanker. The head was originally a Caligula (compare no. 24). After the violent death of the tyrant and condemnation of his memory, it was reworked into an inspired image of the founder of the Julio-Claudian dynasty. The features, which are untypical of standard heads of Augustus, especially the wide open eyes, the transversal modeling of the forehead, and the deeply sunk temples are characteristics of Caligula's likeness.

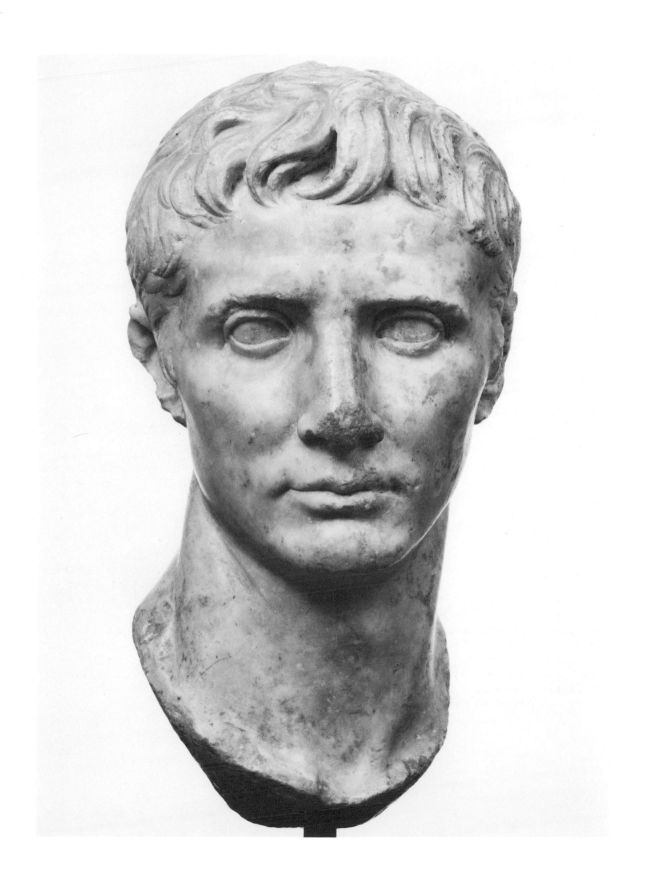

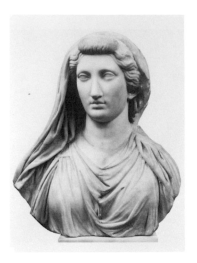 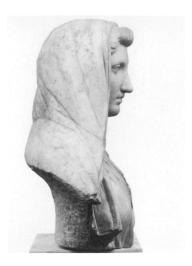 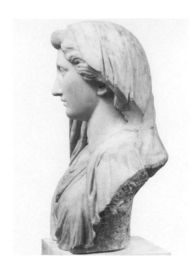

16. Fragment of a statue of Livia, wife of Augustus

Cut down to a bust in the nineteenth century. The portrait dates to the late first century B.C.

16 That this portrait of Livia (58 B.C.–A.D. 29), the wife of Augustus, exists today as a bust is a modern quirk of fate. Originally it was part of a statue. Probably after an accident it was cut down to a bust of an unusual shape with the left shoulder restored, probably in the nineteenth century. Of course, the surface was repolished and the nose made anew. Contrary to the normal restoration procedure, this was not done to enhance the piece as an antiquity but to accommodate it to a new destiny. Our portrait of Livia served in a church south of Naples as the image of the Virgin Mary, and she filled the role rather well! Although the countenance of the first Roman empress is fairly recognizable, her features passed here through a more radical Hellenization than most of the portraits of the early Julio-Claudian period, including those of her husband Augustus. It may possibly be an idealizing posthumous effigy, but even the portraits of Livia's lifetime, like the next example, do not appear too individual. The dominant impression of classical beauty must have been considered adequate as an expression of the dignity of the first lady of the Empire.

17 The other Livia in the collection, made as a bust from the first, shows more of her famous personality. We see her strong will and her taste for command, restrained only by self-imposed good manners. This all appears as a logical continuation of traditional virtues proper to a good Roman lady of Republican times. Livia had no official prerogatives, but her control of the emperor had no limits other than the ones she admitted herself. The remembrance of good, old-fashioned times can also be credited with her simple and rather unpretentious hairstyle. However, the Hellenization of this image is clear. No one could guess that she was over sixty, the age which actually corresponds to this portrait type. Livia's real appearance is still strong enough under the ennoblization to recognize how much Tiberius (nos. 21, 22), blood of her blood, took after her in looks. They shared the same fierce and resolute nature, but Livia was without the underlying melancholy apparent in portraits of her son.

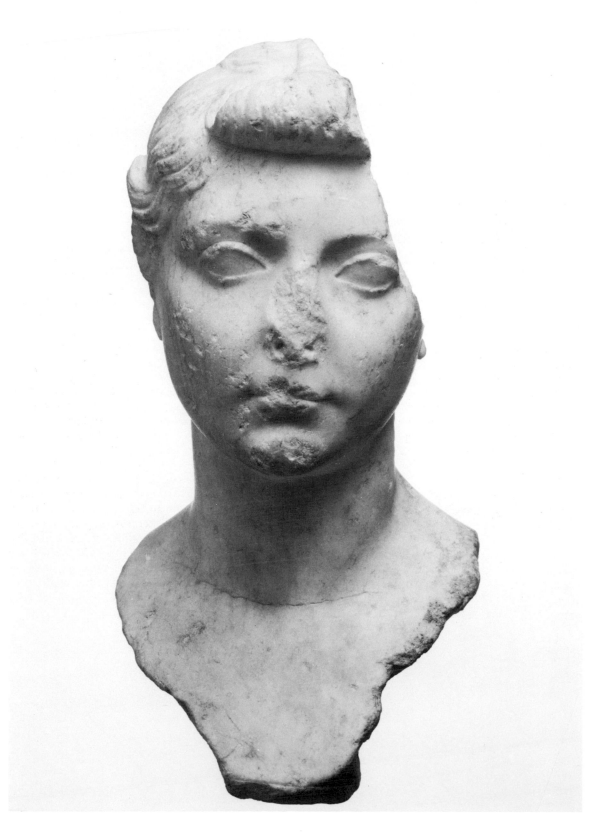

17. Bust of Livia

No one would ever believe that the sitter is over sixty years old. Early first century A.D.

18. Bust, perhaps of Octavia the Younger, sister of Augustus and widow of Mark Antony

A paradigm of the virtues deemed proper to a noble Roman lady: modesty, firmness, restraint. Early first century A.D.

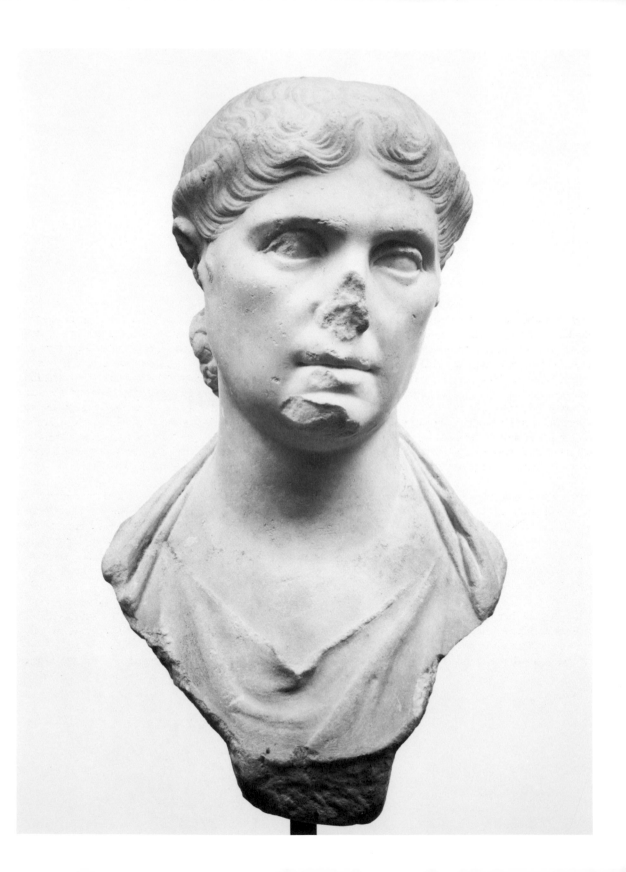

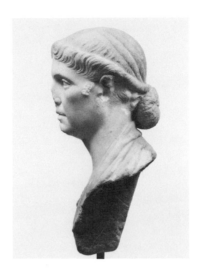

18 Another lady of the imperial house continued the traditions of Republican Rome more than does the calculated elegance of Livia. This sculptor also used Augustan classicism in his portrait as he gently softened the signs of age and provided a general framework for the image. But a very strong personality is evident. In the self-controlled discipline of perfect behavior and exemplary modesty, we still can perceive a lady very aware of the social duties of her rank and her family tradition. She expresses an indomitable will, and the full consciousness of one's duty to be performed well. This is a true descendant of both the mother and the wife of Coriolanus, who prevented him from destroying Rome, knowing that it meant his death, because he had overstepped the bounds of the community. Even the hairstyle is consciously simple, in harmony with the noble self-restraint of the lady. Hers is not an easy face to love, but she may be the best portrait in the entire collection. She was a lady from the Augustan court, perhaps Octavia the Younger, sister of Augustus and widow of Mark Antony, or Antonia, daughter of the triumvir Mark Antony and Octavia.

19 The artistic expression of the portrait of a girl places it in the Julio-Claudian period of the first half of the first century A.D., but the subject manifestly comes from another world than Rome. She must have risen to high society in Rome, for the sculptor who was paid for his work was of the first caliber. But her barbarian origins are clear in both her looks and in her psychology, providing a lively note, different from the usual stereotyped image of the modest Roman lady. Yet the sitter herself may not have enjoyed the uninterrupted world of contradictions she lived in. Perhaps fortuitously, the sculptor has caught some anguish in her large, un-Roman eyes, adding a more touching note to the suggestion of her intriguing character.

20 A small head offers a good contrast to the last. Here the middle of the Julio-Claudian period finds a pleasant and typical representative. Even with well-defined personal features, the sitter appears to be only one woman like another. Her elaborate hair fashion, her gentle smile, and her mild features fit well in the pattern established by the imperial ladies between Livia and Agrippina Minor. The portrait must once have been part of a relief, as indicated by the otherwise inexplicable flattening of the voluminous chignon on the right side.

19. Young woman, probably of oriental origin

A good example of how Roman portraiture could accommodate itself to a discreet ethnic charm. Early first century A.D.

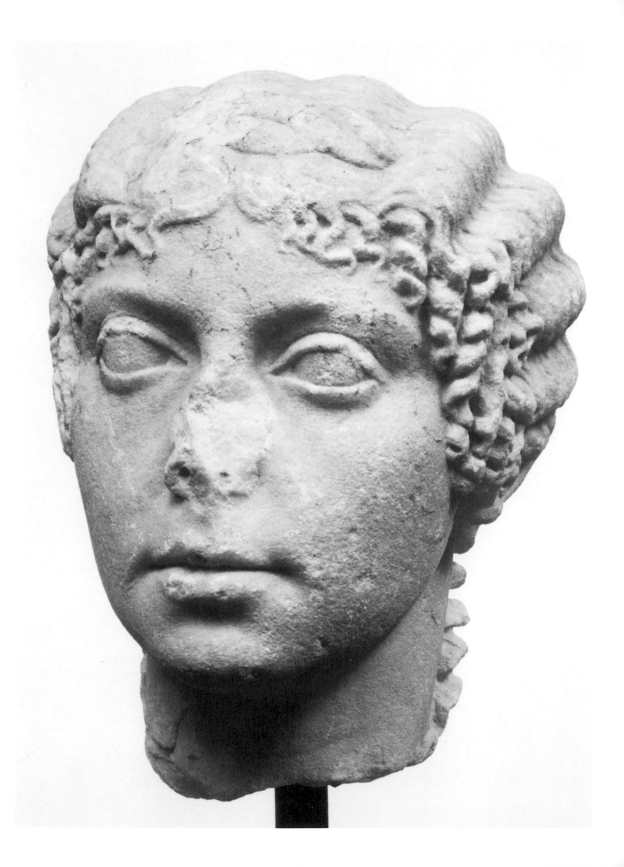

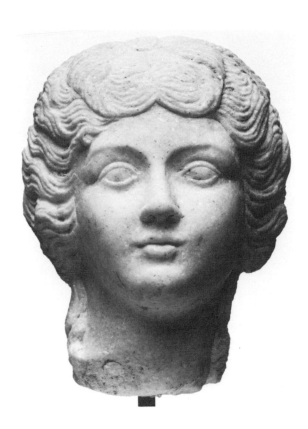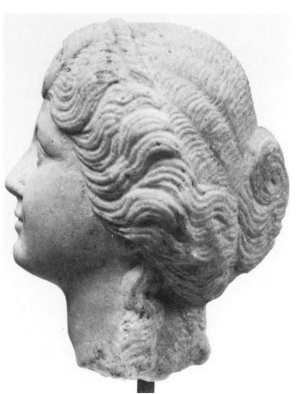

20. Small head of a woman, probably from a relief

The artist enjoyed depicting the fresh, youthful characteristics of the sitter. From the 30s of the first century A.D.

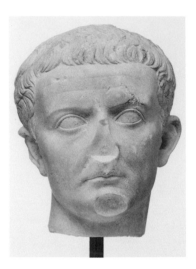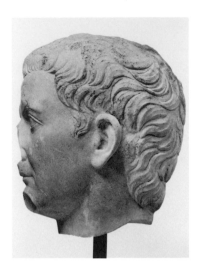

21. Fragmentary head of the emperor Tiberius (14–37)

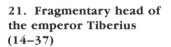

The portrait shows the strong family likeness between Tiberius and his mother Livia. End of the first century B.C.

22. The Lansdowne Tiberius

The standard image of the second emperor from the 20s of the first century A.D.

21 The two portraits of Tiberius (born 42 B.C., ruled A.D. 14–37) confirm at first glance his family ties with his mother Livia. It is not just the general structure and proportions of his face, but it is also the way his narrow lips part in a forced little smile, as if trying to overcome, at least in the case of the son, a deeply morose nature. The head represents the emperor at well over fifty years old, about the time (A.D. 4) that Augustus adopted him, confirming his rank as heir apparent. It is a rather standard replica without too much artistic pretension, but it still allows some observations. As the court art of the Empire continued, its neo-classicism became more distant and cold. The proportions and shape of this head mark a step away from the Polykleitan *canon* whose schema had determined the appearance of Augusts's portrait types towards Lysippos whose *symmetria* provided the scaffold for Tiberius's images. The historian Suetonius reports that Tiberius had such a passion for Lysippos's famous statue, the *Apoxyomenos*, that he removed it from public view with the intention of keeping it in his own bedroom. Only after Rome rioted in protest did he return it to public display. One is tempted to make a connection between Tiberius's personal taste for Lysippos and this change in proportions for imperial portraits.

22 The other portrait of Tiberius was originally of superior quality. Modern cleaning and, alas, recutting have reduced its appeal considerably (fig. 13), but it is still evident that its sculptor was more competent than the craftsman of the first image. Also, the quality of the marble is better. Despite its deteriorated state today, the modeling of the facial volumes and the sensitive carving of the locks of hair show a sure grasp of the chisel. The artist delicately reveals the age of the emperor; he is here manifestly older than in the first example. Tiberius carries his dignity with much less ease than Augustus, and not without some pessimistic ambivalence. He is the *princeps*. He accepts the *paideia* of the rejuvenated Greek ideal, but without any elevation of his personal feelings, he appears only more of a loner.

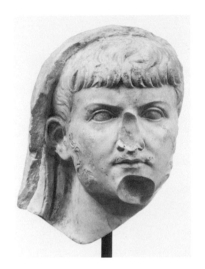

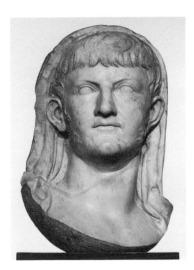

23 The identification of this badly mutilated but originally excellent portrait is discussed among archaeologists. Whether Germanicus (15 B.C.–A.D. 19) (as proposed by Patricia Erhart) or one of his sons (as suggested by others), we remain in the same time, the same family, and the same trend. The portrait is a good illustration of the second stage of early imperial classicism: the surface seems to be frozen, the modeling simplified, and the distance from the viewer increased. The first proposal seems to be probable. The close similarity with Tiberius surely has some basis in family ties, but there is more to be said. The historical sources emphasize that the characters of uncle (Tiberius) and nephew (Germanicus) were clearly opposite.

While the actual likeness of our Germanicus is reduced to the level necessary only to recognize the subject, the emphasized similarity with Tiberius assumes a political function. The heir apparent of Tiberius, Germanicus is presented as he performs a religious sacrifice, his head covered with a fold of the toga. He concentrates totally on this act of *pietas*, an old Roman virtue. His *pietas* is, however, turned not only towards the gods and Rome but also, with some subtlety, towards Tiberius, his father by adoption, his uncle, and his emperor. The same quality seems to mark other types of Germanicus's portraits, making clear that this interpretation emanated not from Germanicus himself but was inherent to the imperial propaganda.

It is interesting to compare the photographs of this head today without modern restorations with those of the object before they were removed (fig. 14). The mutilated appearance of the face may be distracting at first glance, but the loss of the disfiguring restorations makes it easier to appreciate the competent craftsmanship of the sculptor.

Figure 13. *Head of Lansdowne Tiberius as restored in the eighteenth century and attached to an alien statue body for display in Lansdowne House, London. Photo: EA 3054.*

23. Germanicus (15 B.C.–A.D. 19)

The portrait of the adopted son of Tiberius emphasizes the family likeness between them to underline the pietas *of Germanicus.*

Figure 14. *Head of Germanicus with its nineteenth century restorations. Comparison with its current state reveals how disfiguring the added nose and bust really are.*

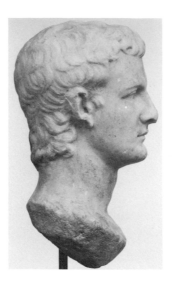

24 This excellent head of the emperor Caligula (37–41) has several peculiarities. The major one is the style. The workmanship is outstanding, but one perceives some insecurity in it, as if the artist tried to move the rather cold, late Julio-Claudian version of classicism towards a more animated image and then stopped halfway. And this may be the explanation: an Asia Minor sculptor abandoned the standard practices of his school (like the supporting pillar of stone at the nape) and reproduced a prototype by a court sculptor, but the baroque, hellenistic local traditions colored the result.

Not many portraits of Caligula survive. This emperor's initial popularity as the son of Germanicus and succesor of the dour Tiberius was short lived. Afterwards, it did not survive the well-deserved damnation of his memory which was accompanied by the destruction of his monuments. While a comparison with the portrait of Germanicus (no. 23) shows no particular family likeness, it illustrates well the last stage of Julio-Claudian neoclassicism, becoming rigid and even sterile, to be changed under Claudius and still more under Nero (no. 30) when clearly anticlassical elements made the portraits more lively.

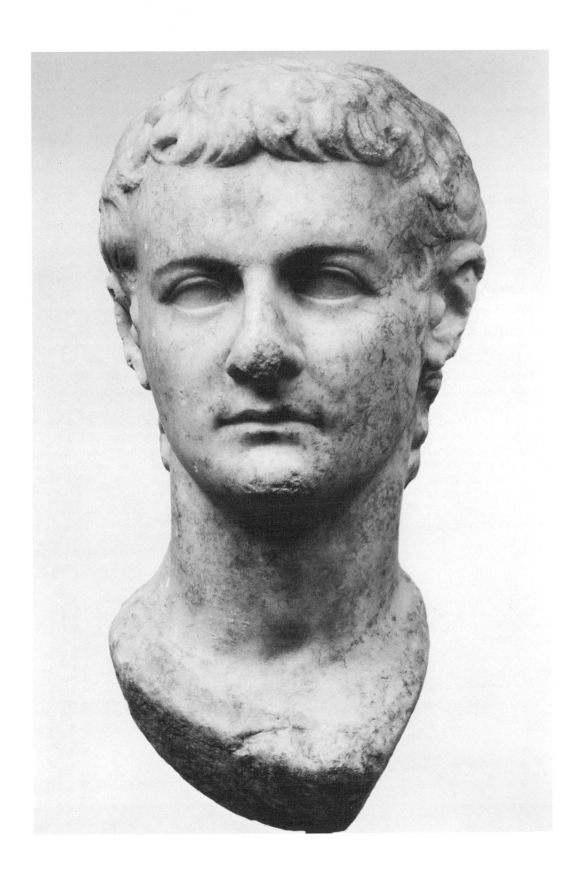

24. Gaius Caesar, called Caligula (37–41)

From Asia Minor. This is a mature portrait of the emperor, reflecting the last stages of Julio-Claudian classicism.

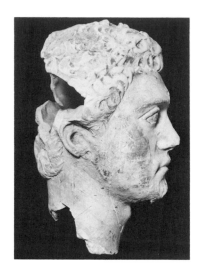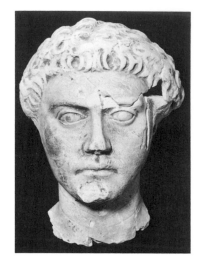

25. Plaster head of a man

The head must have been a sculptor's model and may be a modified life mask. Early first century A.D.

LATER JULIO-CLAUDIANS

25 The plaster head, said to be from Southern Italy, must have been a sculptor's model. Given the sketchy character of the hair, one might even be tempted to identify it as a life cast, with some later modifications. The model may even have opened his eyelids during the process, as is technically possible, which may explain the somewhat cramped appearance of the bulging eyes. On the other hand, the modeling is flabby. The physiognomy and expression, for once reflecting actual likeness, correspond well to advanced Julio-Claudian portraiture, inevitably following the trend of the period. The closest parallel to our head is a marble portrait of the Claudian period in the Ny Carlsberg Glyptotek said to be Licinius Frugi. Few other plaster models for portraits are known, but a complete nest of non-portrait plaster models was found in a sculptor's workshop in Baiae, dating from approximately this same period.

26/27 Two statues of Romans in their formal garb, elaborately wrapped woolen togas falling in a multiplicity of complex folds, have unfortunately lost their heads. For the better of the two statues, this is truly a pity. The earlier draped body is of very fine quality, and it was originally carved from one block of marble including the head. It dates from the first century A.D. The head was inserted separately in the later and poorer example, which was produced in the second century A.D. This body served primarily as a support for the portrait head. The drapery folds of the earlier statue are done with care and are full of movement; on the later, they follow a lifeless schema.

We should not be misled by the naturalism of the toga statues; even in the best examples, they do not reproduce the actual appearance of the toga. How would it have been possible to maintain those beautifully arranged patterns of intricate folds? The sculptor has followed tradition established by Greek sculptors for the rendering of drapery. Excellent and faithful examples of the artistry of drapery carving, going directly back to Greek prototypes, is represented by the so-called Large and Small Herculanean Women and by a female statue from the early third century (nos. 51, 52, 81).

26. Roman in a toga

First half of the first century A.D.

27. Roman in a toga

Second half of the second century A.D.

41

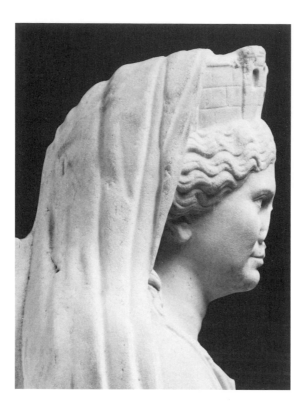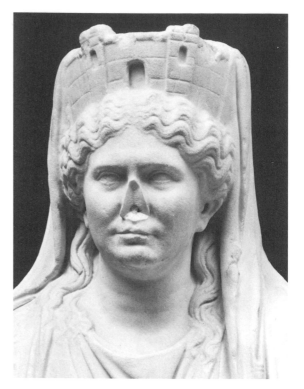

28 The Getty Museum's statue of Cybele was a source of great pride to Mr. Getty because of its modern history. It was famous already in the sixteenth century when it belonged to the Mattei collection in Rome; later it was part of two great English country house collections. The original placement of the statue in ancient Rome must also have been venerable: probably the sanctuary of Cybele.

The preservation is astonishing. The statue has lost little except in details: the restorations (nose, fingers, cornucopia) both of the sixteenth and nineteenth centuries, have been recently removed. The statue combines two juxtaposed elements. The body is a stereotyped image of the goddess Cybele wearing a chiton with high girdle. The body, perceptible under the drapery, is as schematic and impersonal as the correct but unimaginative folds of the mantle. In her left hand, supported by a cornucopia, the goddess held a libation bowl; on the right knee she held a bouquet of poppy bulbs and some other unidentified fruits and flowers. A diminutive lion sits by the right foot of Cybele and looks up respectfully towards her face. He must be surprised at what he sees: the head has nothing to do with the body. While the mural crown corresponds to the function of the goddess as protectress of cities, the large face, with its serious expression, is of a middle-aged, middle class Roman lady: solid, quiet, without imagination, and surely with no pretensions other than the respect due to her office. She is a priestess of the goddess whose appearance and throne she occupies.

The waved hairstyle follows the late Julio-Claudian pattern and, together with the frank realism of the face, which is balanced by the neoclassical restraint of the Augustan era, is comparable to the following portrait head of Agrippina the Younger (no. 29), mother of Nero.

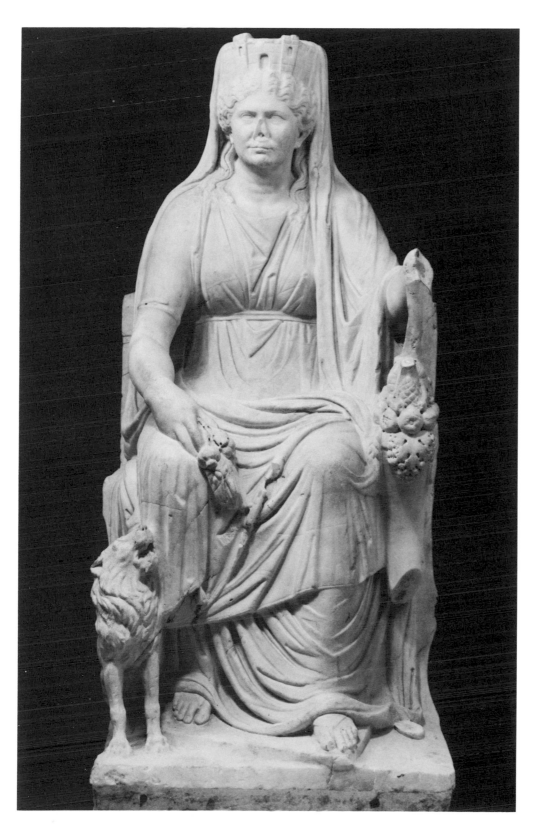

28. Seated statue

with the attributes of the goddess Cybele and the portrait head of her priestess, a Roman matron of the middle of the first century A.D.

43

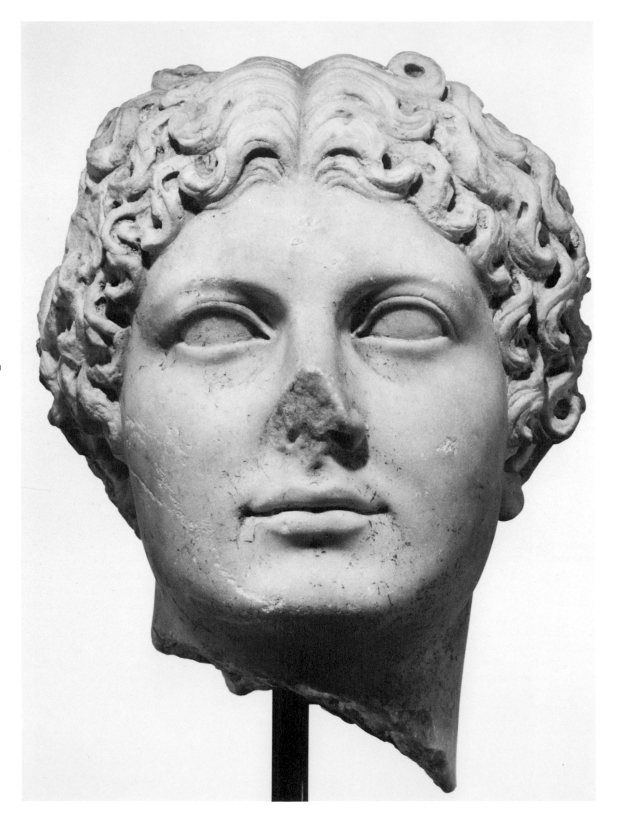

29. Agrippina the Younger, second wife of the emperor Claudius (41–54) and the mother of the emperor Nero (54–68)

The portrait shows the gradual supplanting of Julio-Claudian classicism with a more vigorous form of representation. About 60.

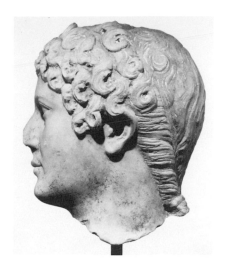

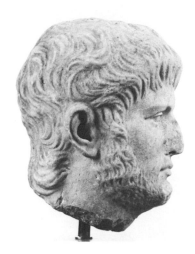

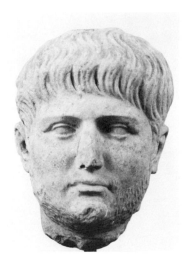

29 The head of Agrippina the Younger (15–59), daughter of Germanicus (no. 23), sister of Caligula (no. 24), reproduces a type representing her when she had just succeeded in A.D. 49 in marrying her uncle, the emperor Claudius and preparing the way for the succession of her son Nero (no. 30) to the throne. She appears young and idealized, as was deemed suitable for the likeness of imperial ladies since the time of Livia, but the sculptor has rendered her strictly individual features, starting with the large cheekbones and oval lower jaw, the peculiar set of the orbits and the large sensuous mouth. Her mien dissimulates the will for power that drove Agrippina's life, giving instead a well-trained appearance of kindness. Intellect seems to govern her emotions, but this may just be the surface of a well-established social pattern. The later stages of Julio-Claudian art or, if one wishes to see it so, its return to the realistic tradition of good old Republican times, is clearly marked. The neoclassical trend favored by Augustus must have been felt as tedious and increasingly sterile. Some Flavian ladies (nos. 36–39) continue and develop further this new style, their image torn away from the pathos of imperial dignity which had become as prominent in the disseminated images of Nero's mother as it was really in her personality.

30 The overlife-size head of Nero (54–68) appears as an amorphous, if not repulsive, caricature. One would like to imagine the sculptor sharing the feelings of hatred and despite for the incompetent tyrant which animated the Roman historians. But these aristocratic literati, like Tacitus, were expressing the judgment of the senatorial opposition, while the masses of people, especially in the Greek-speaking half of the Roman world loved the dilettante emperor dearly and mourned him after his suppression. Our head, from Asia Minor, reveals simply the lack of competence of a provincial craftsman who unintentionally travestied the latest portrait type of Nero into a blasphemy of his divine majesty. Some features of the original, and of the sitter, made this change easy. While on Nero's latest coins the hair is raised and magnified in a fashion inspired by Alexander the Great and by effigies of gods, his face lacks utterly any divine serenity. The trend of portraiture was turning away from the ennobling classicism and Nero in his later years was becoming unpleasantly fat. However, contrary to us, the people of the Roman province Asia did not here perceive the ugly swollen figure of a tyrant, but a radiant likeness of the last direct descendant of Augustus who, in Rome, lent his features to the colossal gilded statue of Helios.

30. The emperor Nero (54–68)

From Asia Minor. The later type of the young emperor's iconography, representing him as semidivine, is reduced to caricature by the provincial replica. Late 60s of the first century A.D.

45

31. The portrait of a man from Alexandria

The conception of the portrait is Roman; the craftsmanship continues the long Egyptian tradition of carving hard stone. About A.D. 70.

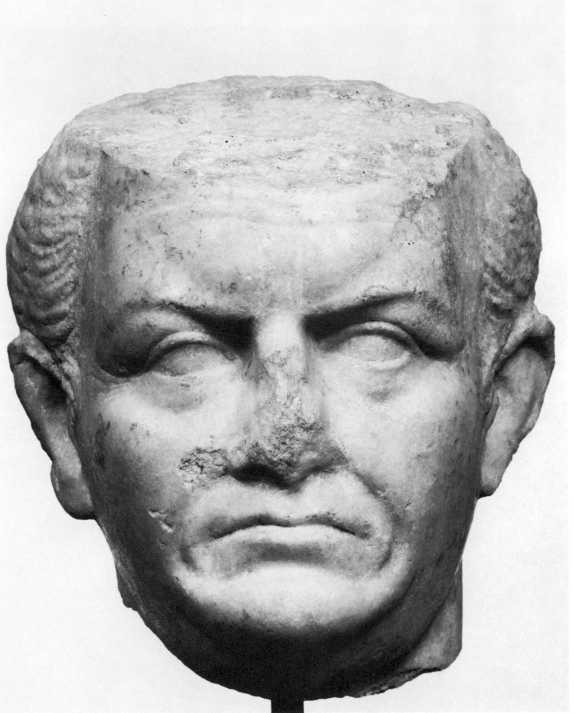

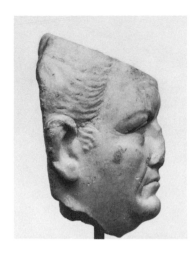
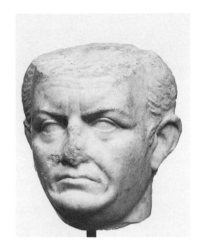

FLAVIAN REALISM

31 This man looks so serious that one could be tempted to classify him among Republicans or at the most as a distant relation of the emperor Claudius (41–54). He is too relaxed for either, however, lacking the civic ethos of a Republican or the anxious self-caution of a contemporary of Claudius. Also, there is an unusual note in the work. The sculptor is manifestly trained in the craft of cutting hard stone rather than the art of modeling marble. This is the Egyptian tradition, and it corresponds partly to the Alexandrian habit of completing missing parts of an expensive marble creation in cheaper material, usually stucco. This is the explanation for the missing crown of the head. Marble is not found in Egypt, and the scarce stone was imported. One bonus of this is that of all our pieces, this one is the only one carved in the highest quality cream of all ancient marbles—*Parian lychnites*. The closest iconographic parallel would be Vespasian or, in this collection, rather the so-called Galba (no. 32) of eastern workmanship than the completely Italian Vitellius (no. 33), but not only the provenance but even the personality must be Alexandrian.

32. The emperor Galba?

The head has been torn off an over life-size relief carved in A.D. 69. The aging general, briefly raised to the purple, is depicted with all the signs of his years.

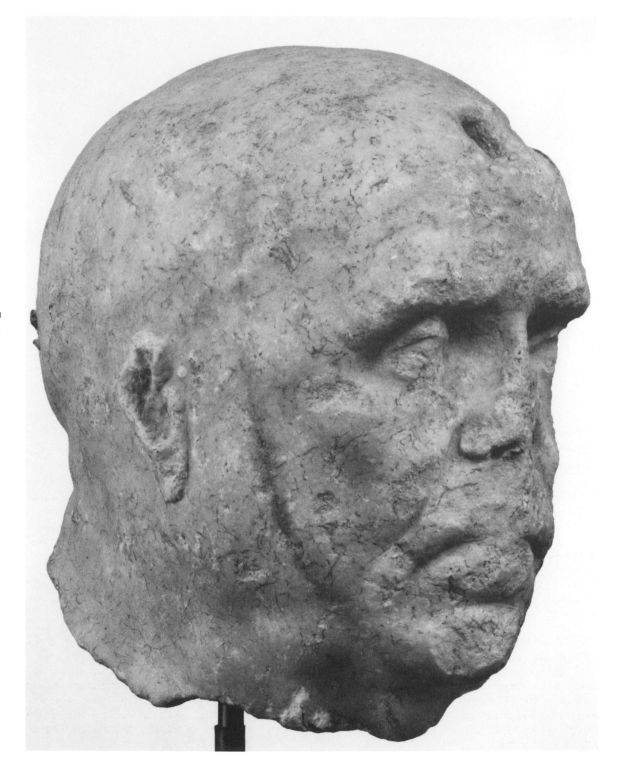

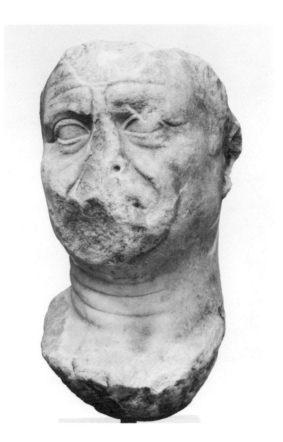

33. The emperor Vitellius

The realistically depicted face of the overweight pretender was intentionally mutilated after his assassination in 69.

32 This over life-size profile has been violently removed from a relief. The fact that there was originally a bronze crown fixed at the nape and over the forehead indicates an emperor, and the fact that it was detached from a major offical relief in haste points to an abrupt change on the throne of Rome. The style points to a date early in the second half of the first century A.D. The features are too old for Nero and entirely different from those of Vespasian. We must be then in the year 69, the year of three emperors, whose iconography is still difficult to unravel. This man must be over sixty years old; and of the three possibilities, only Galba (c. 3 B.C.–A.D. 69) was this age when proclaimed emperor by his troops in Spain. If the identification is accepted (and there is some correspondence with the iconography on coins of this short-ruled emperor), then the image must have been carved by a major sculptor, but in a hurry, in Asia Minor where Galba was at first accepted and then later rejected in favor of other pretenders. It is force, not venerability, that marks the features of this bold, old man. The appearance he issues is that of a backward-looking Republican with the old virtues, an image continued still more powerfully in the portraits of Vespasian.

33 The last emperor from the trio of 69, Vitellius (15–69) is as difficult to identify as the others, and this sculpture presents the additional obstacle that it was intentionally mutilated, perhaps because of the official condemnation of Vitellius's short reign. The carving is superb, however, and what remains stands close comparison to the gargantuan head of Vitellius in Copenhagen. Our sculptor muted his depiction, but the realism remains pitiless. There is nothing imperial in the man, nor is there any of the rude but tough earthiness which would later enhance the ugly face of Vespasian. Even the sympathy we could feel for our uncouth provincial (no. 9) is not here. All the sculptor clearly states is the timeless revelation that Vitellius overindulged in food and drink.

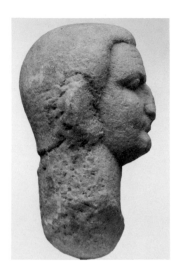

34. Unfinished head of the emperor Domitian (81–96)

From Asia Minor, the portrait represents the cruel emperor as dominus et deus. *It was left incomplete when the final conspiracy against him succeeded in 96. It illustrates the work procedure of first century A.D. Roman sculptors.*

34 The last emperor of the Flavian dynasty, Domitian (81–96) appears in the last version of his imperial iconography: *dominus et deus*. The surprising fact is that both the individual likeness and the self-divinization are clear even in the roughed-out initial carving of this unfinished head. The sculptor must have been competent, and he worked in the same province—Asia Minor—as the hack responsible for the amorphous dropsical Nero (no. 30). The efficient impeachment of Domitian (he was assassinated in A.D. 96) probably halted the chisel, providing the opportunity for us today to catch the sculptor at work.

There are basically two approaches to a marble block. Michelangelo's method, following a tradition inaugurated already in Hellenistic times (although Michelangelo didn't know this), characterizes well the more recent one: the sculpture is perceived already in the block and the sculptor labors to bring it to light. The older, Greek approach maintained by this portrait is much less subtle and more direct: the stone is cut away from the four sides to shape the desired volumes. Of course, for an imperial portrait like Domitian's there was a model, and the three-point transposition technique (see also p. 00) is the very first means mastered by any stonecutter. The first tool used for the rough cutting of this head was the simple point or pick, of which traces can be seen especially on the back of the head. Next used was the claw chisel that left abundant traces all over the face. The sculptor proceeded cautiously: details, like ears, which could easily be broken were carefully protected, half submerged in the stone. It is clear that the head was intended for insertion into a standard body used for imperial effigies like the following headless cuirassed torso (no. 35).

35 This cuirass statue is a good representative of a standard imperial iconographic type, representing the emperor as *imperator*, victorious commander of the Roman army. As was frequently the case, our example was made to have a portrait head inserted. The whole statue stood with the weight on its left leg, the right foot a little to the side and the right arm raised in a gesture of *adlocutio* (addressing the troops). The emperor is in cuirass with the *paludamentum*, purple general's cloak, over the left shoulder and forearm, the sword worn on a baldric. The cuirass is without relief, although roughly polished for painting, and on the preserved and visible left shoulder flap is the lower half of Jupiter Fulmen's thunderbolt. The three metal side hinges of the cuirass are precisely indicated where they could be seen on the right side but hidden and neglected on the left. The windswept appearance of the leather straps protecting the hips and abdomen below the cuirass is typical of Flavian impressionism.

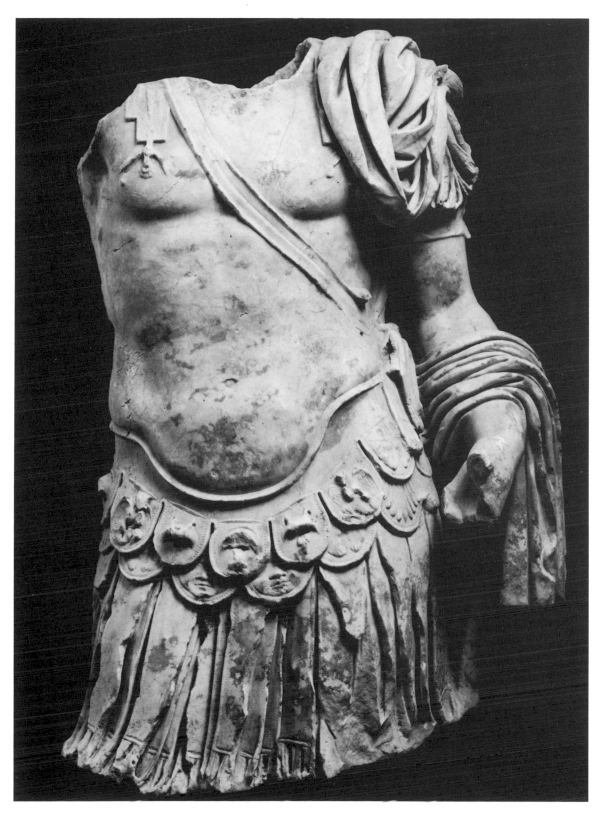

35. Torso of a cuirass statue of an emperor

The originally inserted head probably represented Domitian. Late first century A.D.

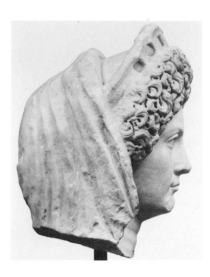

SEVEN FEMALE HEADS (FLAVIAN-PLOTINA)

The seven female effigies form a group, illustrating the evolution both of style and fashion of hair in the late first or early second centuries. The two imperial ladies provide the chronological frame for the whole group: Julia, daughter of the emperor Titus, and Plotina, wife of the emperor Trajan. All seven ladies reveal strong, even domineering personalities—reflections of their time as well as of themselves.

36 Julia Titi (d. ca. 92) is reflected in the historical sources as an outspoken and rather libertine personality. Daughter of Titus and mistress of her uncle Domitian, she received the honor of having her official image struck on coins, which are the starting point for the identification of her sculptural portraits. With all due reservations concerning the "reality" of imperial portrait types as created by official court sculptors, Julia appears to be an independent character. Little remains of the matronal virtues which marked even younger women from the late Republic through the early Empire. There may be some slight doubt about the identification of our head, as it does not fit perfectly in the established group of Julia's portraits; and the quality is considerably superior to the numbed artisanal repetitions frequent in the standard copies of imperial images. Both questions may be answered by supposing that this sculpture is a posthumous image in which the souvenir of Julia's lively nature elevated the artistic imspiration in even an official image. We see her just as herself: free from any bonds, her appearance reflecting her joy in life with a candid insolence. Imperial status is alluded to by the heavy diadem which was inserted with colored stones and glass imitating jewels. The plump cheeks cover the bone structure well, and the full lips are pursed, revealing a sensuality dominated by a rather capricious intellect. However independent of mind, she pays full tribute to the fashions of the day. Hours must have been spent with the hairdresser in order to erect the elaborate curly pyramid of coiffure, even though it includes a clearly evident artificial hairpiece. The whole must have been the sculptor's joy. He used the running drill abundantly to render the deeply cut locks which contrast with the subtly modeled forehead and cheeks. The traditional polychromy, now practically vanished, must have enhanced the general pictorial approach. On closer inspection we can still trace the incisions for painted irises and pupils, which must have given a rather penetrating look. The lips must have reflected the copious use of cosmetics and the reddish hair, the use of henna or other dyes.

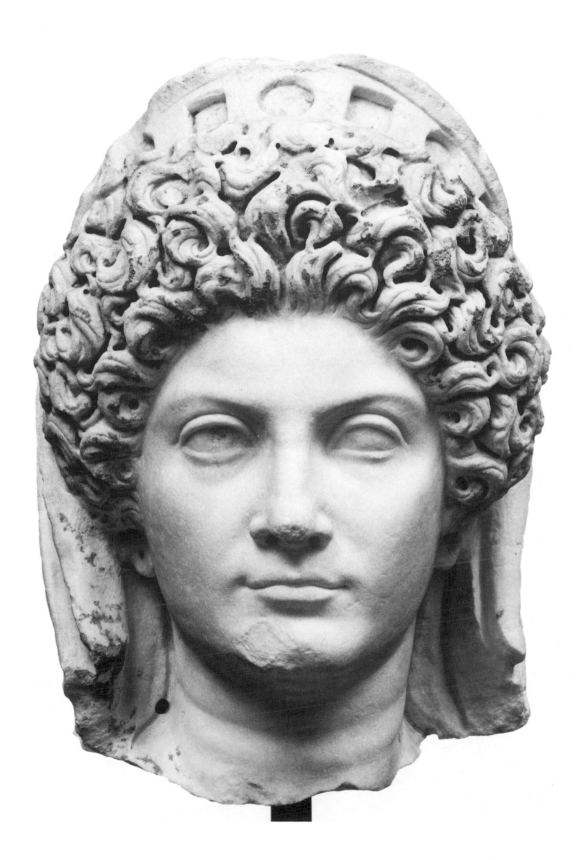

36. Julia, daughter of the emperor Titus

The perfectly preserved head is perhaps the most charming female portrait in the collection. About 90.

37/38 These two ladies are outsiders, not in fashion or in birth but in their geographical origin. While Julia and the other ladies' portraits were clearly carved in Italy, the bluish grained marble in these examples points to Asia Minor. The most striking local feature is the block of raw marble supporting the nape to prevent easy breakage. Both statues were likely carved in the same workshop, if not by the same hand, possibly as pendants or as parts of a larger group. The sculptor dutifully followed the fashions of the time, as he used the drill to make circular cuts in the mass of hair over the conical forehead, but there is little if anything pictorial in the overall approach. The result gives rather the impression of cutting the stone to shape rather than discreetly carving it to emphasize subtleties of modeling. He was a competent craftsman at work, typical of the artisans who perpetuated Greek traditions all over the eastern areas of the Roman Empire. The portraiture is stereotyped too. The sharp features of the old lady appear at first very personal, but on closer inspection, although a well-defined individuality seems to emerge, the sagging cheeks and deep wrinkles are just conventional indications of her advanced age. The young woman conforms to similar conventions like a doll, without any personality to animate her features. Both statues are preserved approximately from the waist up. Because so few statue bodies are included in the Getty collection, they stand out as special. In reality they show the usual procedure for Roman portrait statuary: even more than the heads, the bodies repeat standard Greek types. The matron uses the type called the Large Herculaneum Woman; the type of the young woman is yet to be identified. One could imagine that the statues were done to glorify two woman of a rich local family that spent money on an official monument or public charity. Perhaps the family even paid for their own statues. All things considered, both statues are rather well preserved and not badly carved, but they leave the viewer unmoved.

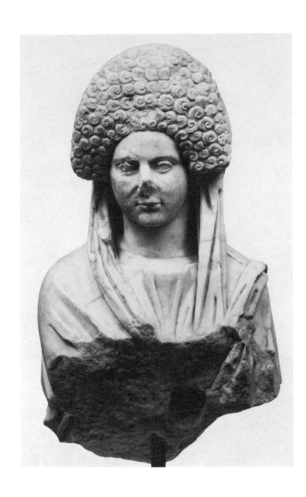

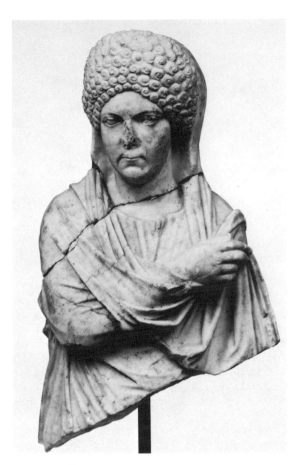

37. Fragmentary statue of a Flavian matron

From Asia Minor. Later first century A.D.

38. Fragmentary statue of a Flavian girl

Pair to no. 37. From Asia Minor. Later first century A.D.

39. Bust of a Flavian woman

The sitter is homely, the portrait is excellent. Early 90s.

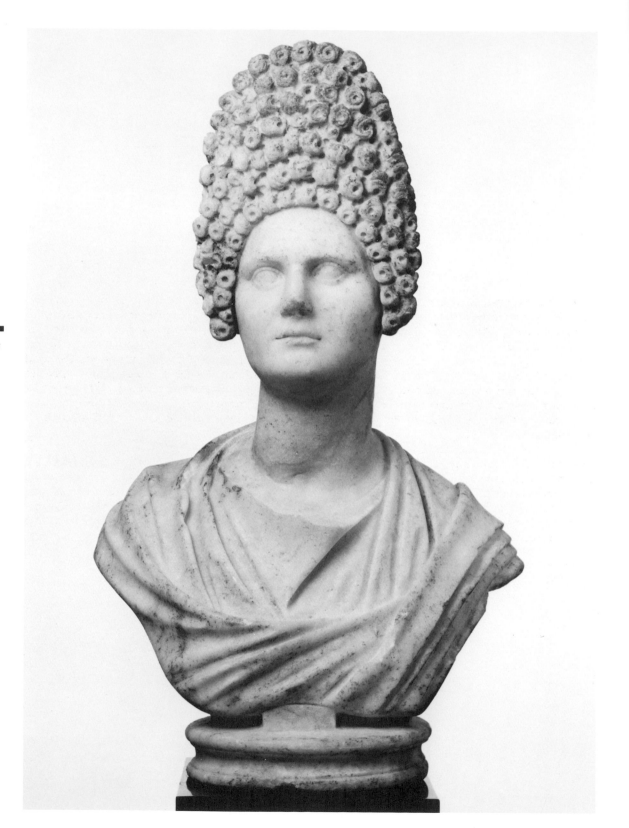

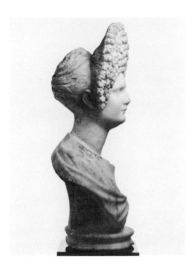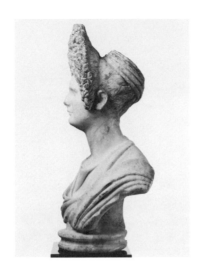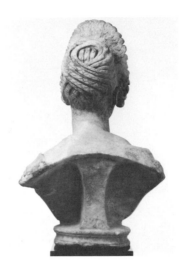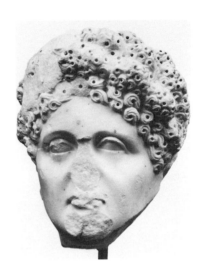

39 The next bust, miraculously preserved including the nose, is closer to Julia in quality both of carving and in portraiture, even though it is slightly later, belonging to the last decade of the first century A.D. The sitter must have had little personal attraction, for she appears homely and dull. The sculptor enveloped her bust in a fashionably arranged drapery, and he apparently enjoyed carving her very elaborate hair style, ostentatious in a *nouveau riche* way. While Julia carries her pyramid of curls with an inborn elegance, this good lady shows only that she can afford an expensive hairdresser. Little else distinguishes her rabbity looks, but closer inspection shows a competent sculptor at work delivering conscientious work for his fee. The pictorial approach is even stronger here than with Julia, as the very soft modeling is palpable only in a raking light. One can more easily forget the undistuished sitter of this portrait than the sensitive craftsmanship of the sculptor.

40 Time was not merciful to the next lady. The portrait was once very powerful, but today her face is a ruin. The sharply cut features reveal her at the end of her forties, but she has not aged too well. Her strong will dominates as the best aspect of a vulgar face. The sculptor enjoyed depicting the hair and contrasted her angular face with the soft mound of curls. An artificial insert holds up hair which is crowned with flowers and leaves. The marble and technique are Italian, and the portrait must date from the first ten years of the second century A.D.

40. Head of a woman

The piece is a ruin; the workmanship was originally as elegant as the sitter was plain. From the very end of the first century A.D.

41. Head of a woman

Under the apparent insignificance, the sitter and the carving are outstanding. From the very early second century A.D.

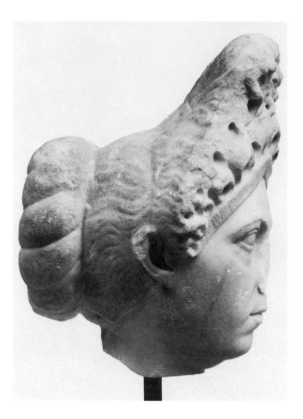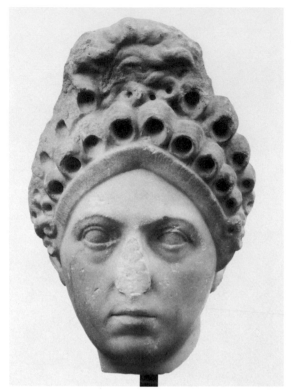

41 Another Italian sculptor carved this portrait head in the first decade of the second century. If we do not give her a second look, there is nothing special to attract our appreciation. But the asymmetrical position of the knot of hair provides the correct view of the face (from two-thirds right), and then the quality of the portrait slowly becomes tangible. She appears years younger than her real age, for the sculptor adroitly understated the heavy pouches under her eyes and the double chin. He even provided her with more intellectual expression than her personality probably boasted. The elaborate crown of hair is based on Flavian fashions but points toward the simpler, more geometric hair styles of Plotina (no. 42). The rendering of the arabesque-like strands of the hair turns the design into a drawn ornament corresponding to the empress's. Our conception of this portrait may also be marked by the empress's official personality: there is a clear revival of traditional matronal virtues, combining strong character and restraint. Looking just at this isolated head, one would like to imagine that this was the real nature of the sitter, but the portrait fits a contemporary vogue exemplified by Plotina herself. Here is one more warning against an anachronistic interpretation of Roman portraits.

 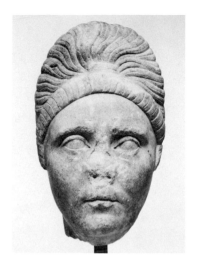 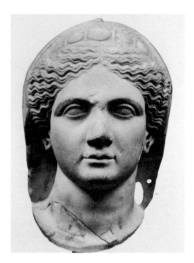 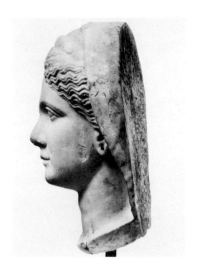

42 The head of the empress Plotina (d. 121/ 2) suffered some modern retouching which has reduced its artistic merit. Originally it was a standard representation of a current portrait type. Today its interest is increased, however, since there is no other exact replica. Sheldon Nodelman has argued convincingly that the rejuvenated face must be a posthumous creation, intentionally recalling Plotina's early portrait type. After her death, the divinized empress continued to enjoy veneration by the thankful emperor Hadrian whose adoption and succession she had promoted.

These seven portraits (nos. 36–42) provide an excellent illustration of how images of women from the late first and early second centuries A.D. tend toward a strictly private appearance, a tendency observed in men's portraits as well. At the same time, there is the paradox that the flamboyant sculptural fashions and flux of social values at this time were an obstacle that lessened strong individual portrait characteristics. The first decades of the second century brought not only the greatest expansion of the Empire but also a revival of venerable pre-imperial traditions. Although the old values did not fit well in the new scheme of Empire, portraiture profited. Neither Plotina nor the other ladies appear as real *mater familiae*, but the new conscious responsibility towards the community ennobles their portraits.

HADRIANIC CLASSICISM

43 There are two portraits of the empress Sabina (d. 136/ 7) in the Getty collection. The identification of one of them is open to discussion. Originally marred by several modern restorations, this head was not considered a portrait of a mortal at all but an image of a goddess, Juno. It is now generally agreed to be a portrait and an imperial lady, but the possibility of an earlier date is maintained by some archaeologists. The empress, represented with covered head, shows very little personality. The features are diluted by an academic elegance, tempered with a little melancholy. The fact that the anatomical structure is lessened emphasizes that a general mood was intended, playing in favor of the later date. Sabina is thus the only serious candidate.

42. Plotina (d. 121/2), wife of the emperor Trajan (98–117)

Common workmanship reproducing a possibly posthumous image of Trajan's wife from the early 20s of the second century A.D.

43. Veiled head of an empress

Possibly a posthumous, idealized image of Hadrian's (117–138) wife Sabina (d. 136/7). From the late 30s of the second century A.D.

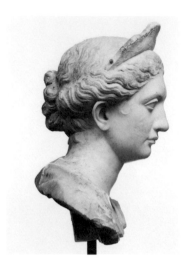

44. Posthumous bust of the empress Sabina

An exquisite image of deep melancholy. From the late 30s of the second century A.D.

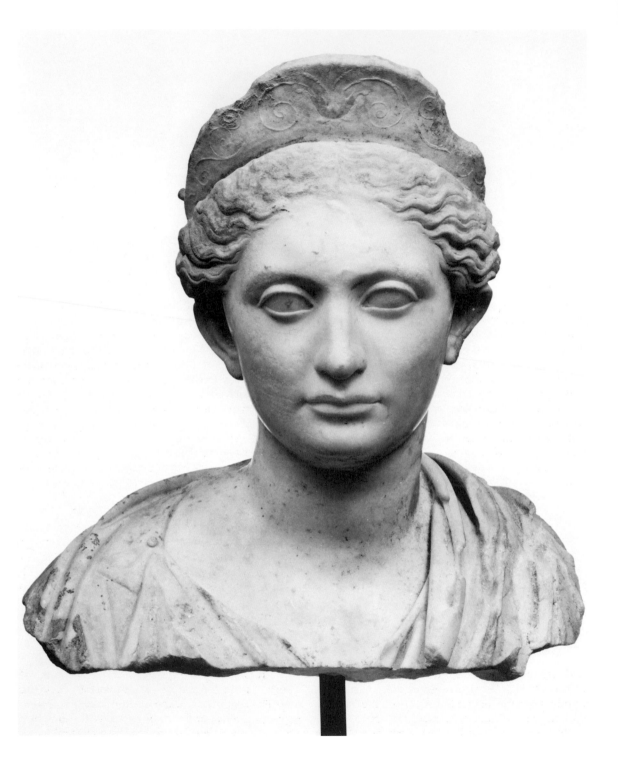

44 While the author of the first head of Sabina was an unpretentious craftsman, the other bust of the empress is an unquestioned masterpiece. The quality and effect induced even an archaeologist (who probably never saw the piece itself) to doubt its authenticity, but nothing can be more wrong. Abundant traces of concretions provide physical proof of the authenticity, and the style and the carving could not be the work of any other time than slightly before the death of Sabina's husband in 138. The bust must be a posthumous portrait, but no exact replicas are known. The delicate mixture of traces of old age with an evocation of a fragile, perishable young beauty say much about what we know of Sabina. Trajan's niece was married in 100 to Hadrian as an early step toward her husband's succession. Their marriage cannot have been happy, and the sculptor quietly evokes the memory of a wounded rose. Sabina, created Augusta and granted the honor of coinage in 128, wears a diadem here with delicate tendril ornamentation, which elevates her to a posthumous apotheosis among the goddesses. Juno comes to mind, but Sabina lacks the goddess's aspiration for command. The sculptor expressed much less the shy and retiring empress's personality than he was inspired by the general mood of the times, also evoked at its best (what irony!) in the sentimentalized image of Antinous, the young favorite of her husband.

45 The portrait of Antinous (110/12–130) falls outside the well-established iconographic series. This is not because of the over life-size scale, but because our head is clearly very provincial, coming from Asia Minor, though not from Antinous's native Bithynia in the northwest but rather from the southwest. The portrait is clearly posthumous, the result of Hadrian's extravagant mourning for his lost favorite. Some loyal subjects must have exercized their zeal with a delay suitable for their provincialism. The fleshy, dreamlike beauty of this utterly unathletic youth is the hallmark of Hadrian's philhellenism, but here it falls into uninspired banality. The eyes are plastically indicated, as is common for the portraits done from the beginning of the 140's under the reign of Antoninus Pius. The provincial craftsman is ahead of his time in his neglect of the anatomical structure of his subject, allowing the cold nature of the marble to prevail.

46 The poor preservation of this head of a young boy makes it difficult to appreciate fully. Even originally the quality of the work was less than outstanding. An artisan from Asia Minor was responsible, as is clear not only from the marble but also from the traditional pillar-like block left uncarved at the nape. He produced a youthful, unpretentious face, perhaps reflecting the sophisticated appearance of Antinous. It shows how the "divine" beauty of this boy from Asia Minor marked not only an attempt to return to classical Greek values but also became in its turn a social stereotype, an example for everyone to follow. Many upper- and middle-class men all over the Empire, from the great Athenian *hommes de lettres* Herodes Atticus to this unknown patron in Asia Minor, called on sculptors to perpetuate the youthful charm of their favorites.

45. Antinous (d. 130)

This may be a posthumous, provincial sculpture. It is hardly recognizable as the favorite of the emperor Hadrian. About 140.

46. Head of a youth

From Asia Minor, an unpretentious image of a youngster in the tradition of Antinous. From the 30s of the second century A.D.

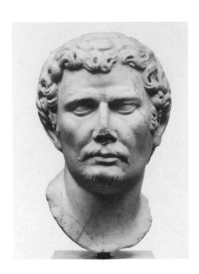

47. Bearded man

An attempt to present a Hadrianic intellectual with the beard and idealized appearance of a classical Greek. From the 20s or 30s of the second century A.D.

48. Head of a barbarian

Rather than a portrait, this is a genre impression produced to illustrate Trajan's conquests along the frontiers of the Empire. From the 20s of the second century A.D.

47 The head of a bearded man may once have been of good quality, but time has been hard on it. Still, in spite of the damage, it is a good representative of Hadrianic portraiture. The art of the period clearly tried to return to Greek traditions for inspiration, and so does the portrait. The sculptor attempted to make the man look like a philosopher. He turns away from the outside world as if he were erecting a fence around his own private universe. The meditative mood is enhanced by the beard, a hair fashion reintroduced to Rome by the philhellenic emperor Hadrian himself.

48 The Roman sculptor who carved this image of a subdued captive did not have any concrete personality in mind, even though it may appear individualistic to our eyes. Instead he combined some of the ethnic characteristics of northern tribes—beard, unruly hair, slightly truculent gaze—and imbued them with the nobility of the famous hellenistic statues of the vanquished Gauls from the Attalid monument of ca. 230 B.C. The modern appearance of the head is marred by insensitive retouching, but much remains from the original appearance. The purpose of such a generalized image was as part of a monument commemorating the last big expansion of the Empire undertaken by Trajan over the barbarian Dacian tribes along the lower Danube, as recorded by similar symbolic statues in his Forum at Rome.

SARCOPHAGI

Portraits were placed on Roman funerary monuments for identification, at least one might think so. Two sarcophagi in the Getty collection are dated close together. Both come from early in the new Roman fashion for inhumation of the dead instead of the centuries-old tradition of cremation and burial in urns. The change created a whole new industry for marble-carvers, combining images of the deceased first with elaborate ornaments and soon with complex mythological or even biographical themes.

49 The earliest sarcophagus in the collection belongs to the Trajanic period of the very early second century A.D. and shows a bust of a boy held by two Erotes. The association is suitable, given the age of the deceased and the natural and sentimental taste for representing Erotes involved in children's activities. The bust extends rather low down the chest, and the short hair and rounded features may suggest a later imperial date, but a look at the rest of the decoration of the sarcophagus changes this appraisal totally. On the front and sides of the sarcophagus, Erotes are feeding griffins. Griffins reappear on the front of the lid as purely ornamental creatures. The motif itself is known from a series of terracotta architectural reliefs from the end of the first century B.C. and then later, colder and more elegantly classicizing, on the marble architectonic decoration of Trajan's Forum. This last indicates the date. Even if the sarcophagus is less pretentious and the artisanal cutting more stonelike, the boy's image does not lack some of the Trajanic virtue that imbues imperial portraits like Plotina's (no. 42). A touching detail of the sarcophagus may be mentioned: inside, a stone cushion with a rounded depression for the head was carefully rendered, ready for the quiet rest of the deceased child.

49. Sarcophagus of a boy, with his bust supported by Erotes and griffins

From beginning of the second century A.D.

50 In the same spirit, a girl is represented reclining on the lid of her sarcophagus. A technical detail shows the continuing attention lavished on her after death: in the right side of the lid, a circular opening was carved to allow food or drink to be poured inside the coffin. The things surrounding her confirm this tender preoccupation. She softly caresses her little pet dog while two dolls rest at her feet. A sleeping Eros, symbol of a premature death, is placed on the back edge of the couch. The limp, immaterial body is just a conventional symbol, but the face with its precocious melancholy attempts to be a real portrait. A gold earring originally hung from her left ear. (Her right ear, turned away from the viewer, is not pierced.) The funerary epigram, unfortunately fragmentary, points in the same wistful direction:

HIC SPECIES ET FORMA IACET MISERAB[ILIS] AETAS EEF [IGIESQUE ---]IS
Or, as one could briefly say, *"So young!"*

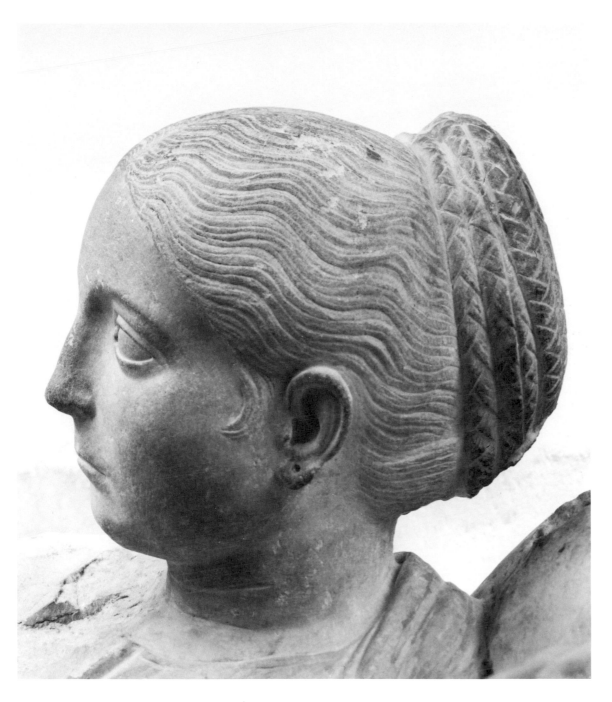

50. Lid of a sarcophagus with a reclining girl

The asymmetric face gives a moving statement on the premature death of a beloved daughter, corroborated in the Latin epigram. From the 20s or 30s of the second century A.D.

65

51. Statue of a woman

Said to be from Asia Minor. The inserted head is a good portrait; the body is a conventional support reproducing a fourth century Greek type called the Small Herculaneum Woman. From the 20s or 30s of the second century A.D.

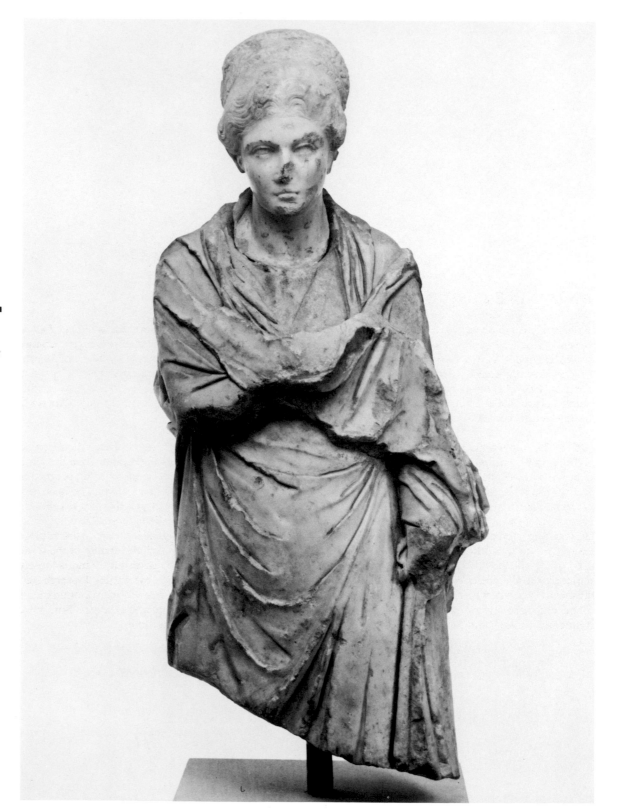

ANTONINE PORTRAITS

Several groups of men's and women's portraits form a chronological series both for style and for the development of Roman portraiture. They include images of several emperors and their wives, providing a solid framework for those of private citizens. Starting with a head of Antoninus Pius (138–161, no. 58), the successor of Hadrian, the series terminates with a portrait of the founder of the new dynasty, Septimius Severus (193–211, no. 63). The group is presented in two halves, ladies first. This is justifiable because their hairstyles provide a separate, parallel chronological check, but comparable pieces from the group of men will be referred to constantly.

51 The first woman in this group actually dates from the previous reign. Her head is clearly Hadrianic in coiffure, style, and portrait type. The spirit of Sabina (nos. 43, 44) is diluted, however, and while the piece comes from Asia Minor it seems to emphasize traditional Roman virtues. The lady appears solid, pragmatic, and respectable. There is no nonsense about her. If she has feelings, they are not shown. The head was worked separately as a good portrait to attach to a standard body. It is the body type that determined the placement of the portrait here amid the Antonine ladies. It reproduces the type called the Small Herculaneum Woman, repeated countless times as the body support for heads of both Roman girls and matrons. Our piece is of rather good workmanship, even if the marble is of a slightly inferior grade than the quality of the stone used for the head. The Greek prototype for the statue originated in the fourth century B.C. and is loosely connected to the creations of the school of Praxiteles. So is the prototype of the next statue, the Large Herculaneum Woman, which, as its name implies, was carved as a pendant to the other. Both are embodiments of graceful modesty and perhaps originally represented the goddesses Persephone and Demeter. Both were frequently copies, both with ideal heads and as supports for portraits, in Roman times.

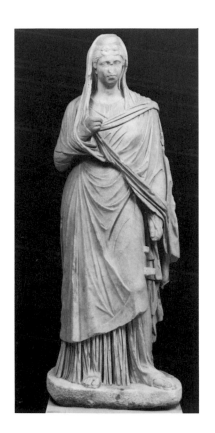

52 The portrait head of the intact statue of the Large Herculaneum Woman is of Faustina the Elder (d. 140/ 1), wife of the emperor Antoninus Pius (no. 58). Here the statue and the head were carved from the same block of marble, and the sculptor left a big lump of uncut marble at the nape to protect against easy breakage, a technical detail previously noted as peculiar to Asia Minor workshops. The craftsmanship is very correct, even if the treatment of the elaborate drapery folds gives the impression of academic coldness. The head itself is a rather mechanical repetition of the standard type used for the empress. The statue, slightly over life-size, must have originally been part of a large group including other members of the imperial house. We can visualize this Faustina with our Antoninus Pius (no. 58) alongside her. Even in the weathered condition of the emperor's head, however, the workmanship is clearly different, at the same time more rustic and more free. Another interesting detail about our Faustina is her modern state of preservation. The small restorations of the face and hands were recently removed, but the carving of the front of the base and the inscription giving the empress's name remain and may date back to the seventeenth century. The general aspect of these modern interpolations is reminiscent of the marbles collected by the earl of Arundel (c. 1585–1646) that mark the beginning of collecting in England. The origin in Asia Minor agrees with this speculation.

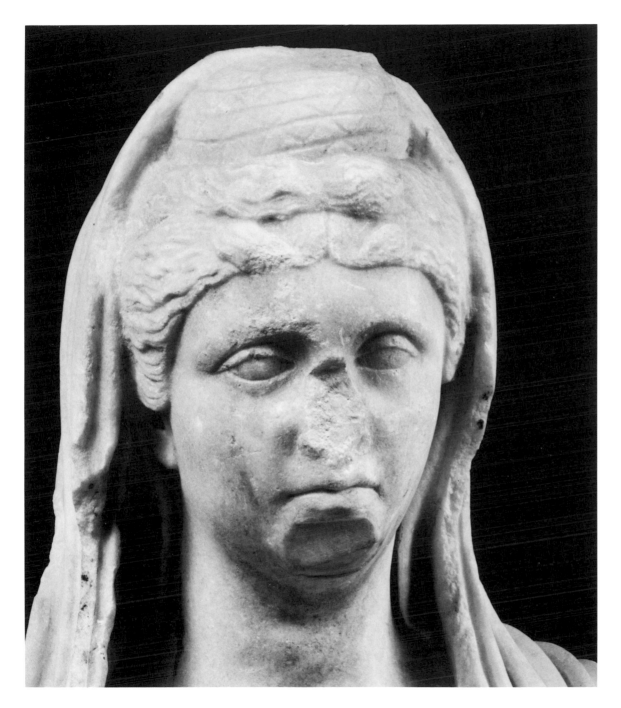

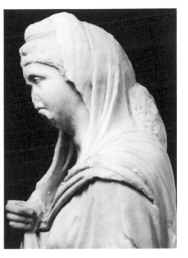

52. Over life-size statue of Faustina the Elder (d. 140/1)

Wife of the emperor Antoninus Pius (138–161). The head is a conventional portrait; the body reproduces the classical fourth century B.C. type called the Large Herculaneum Woman.

69

53. Bust of a matron

From Alexandria. The sitter is colorless; the modeling is excellent. From the end of the first half of the second century A.D.

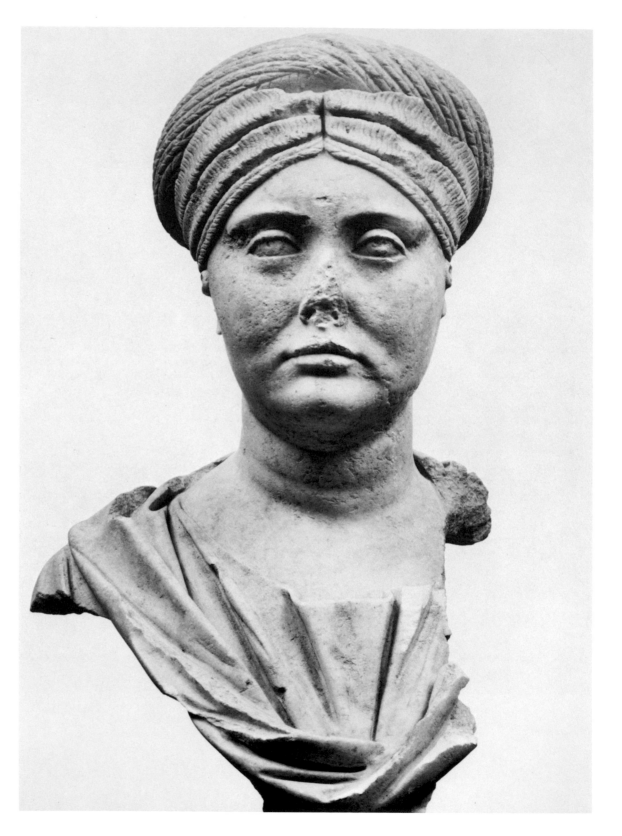

53 Contrary to most Alexandrian sculpture, the bust of a woman has little of the native Egyptian in her style or appearance. She demonstrates how the overwhelming Roman ideal shaped both art and "likeness" in Roman Egypt. It is in the matronal style, going back to prototypes in late Republican times and revived under the Flavians. Without any embarrassment, the artist reproduced the sagging flesh of her cheeks and dewlap, the unappealing but still interesting personality, the shrewdness masked by a cowlike passivity. There are more details that were possible only in Alexandria: the care given the sophisticated hairstyle, for instance, shows not only the elaborate pattern but also the relaxed verism of Italian modeling. The strands of hair are not just incised but also carved in relief. The whole spirit of the piece shows the confident atmosphere of the early second century when the *pax romana* made most people's lives and looks happy.

54 Another example from an old English collection is the female bust formerly in the Lonsdale collection, Lowther Castle. Its interest as an ancient sculpture is reduced almost to nothing, for not only the basic support but the whole bust is modern, together with the top of the head, nose, and both ears. The surface of the ancient part has been completely repolished, drastically affecting the ancient modeling, and even the details of the crown-shaped coiffure which corresponds to fashions from the reign of Commodus (180–192) have been redrawn. What remains of the portrait is enough to confirm its date in the well-advanced Antonine period. Its importance today rests much more on its role as a document from an eighteenth century Grand Tour than as an example of Roman portraiture.

54. Restored head of an Antonine woman

On an eighteenth century bust. From the 80s of the second century A.D.

71

55. Head of a woman

Comparable to Faustina the Younger, wife of Marcus Aurelius (see no. 57). From the 60s to 70s of the second century A.D.

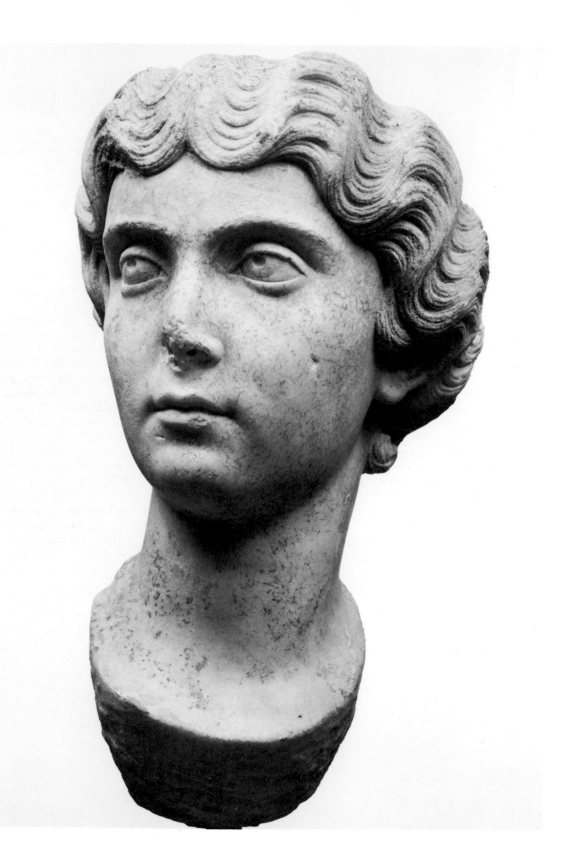

55 Another lady, carved in Italian marble, has been called Faustina the Younger, the daughter of our Large Herculaneum Woman, Faustina the Elder, and the wife of the emperor Marcus Aurelius (no. 81). She does resemble the empress somewhat. The hairstyle is similar, as are the general features, such as the very sensual mouth and the intellectual if not quizzical eyes. The artist was so interested in pictorial effects that the cheeks are soft to the point of having their bony structure melt away into the flesh. But this lady is not Faustina. The workmanship is clearly original, too good for the mechanical repetition of an imperial copy. And, however much the lady or the sculptor try, the result lacks true imperial distinction. The head, made for insertion in a statue, is perhaps the most attractive female portrait in the collection.

56 Even in the completely reworked state (all over the hair there are traces of modern claw chisel work, and the face, including the original nose, has been recut), the next head shows a rather powerful image of a woman of strong character. She is truly Roman. Only the incised pupils, coiffure with heavy knot of hair, and crimped waves correspond to her own time. The lady has nothing to do with the *niaiserie* of her unemancipated contemporaries. The style and the personality recall the strong personalities of ladies of the Flavian period (nos. 36–39), and one can only deeply regret that the intentionally ruined surface deprives us of the full joy of a nonconformist sculpture and personality.

56. Head of a woman

Originally an excellent portrait, it has been irretrievably recut in modern times. From the 70s to 80s of the second century A.D.

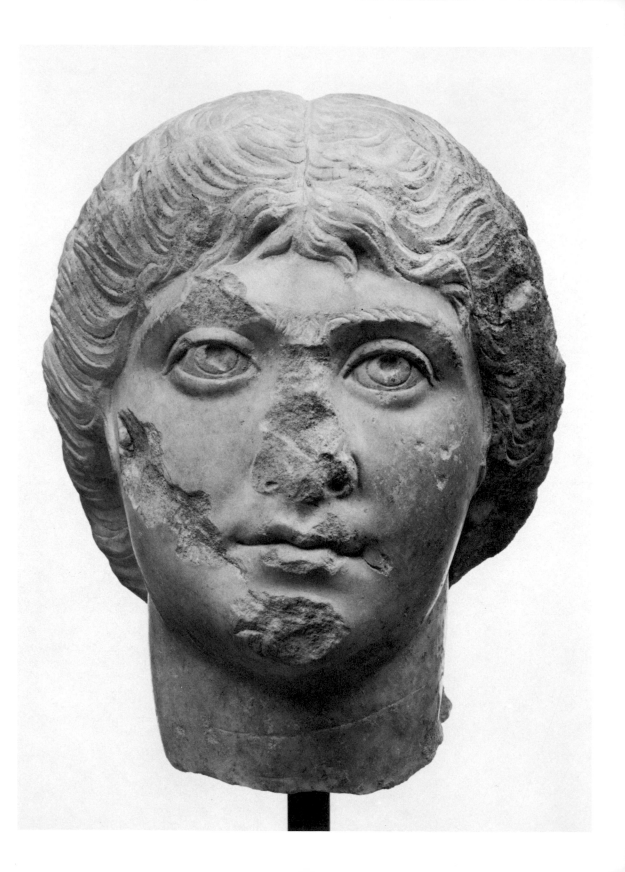

57. Slightly over life-size head of Diva Faustina, that is Faustina the Younger (d. 175) as deified after death

The wife of Marcus Aurelius is rejuvenated and provided with the rigid appearance of an oriental goddess. From the 80s of the second century A.D.

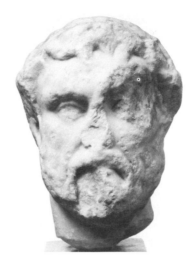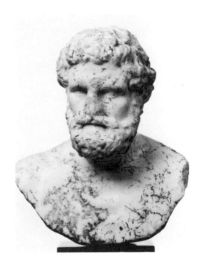

57 None of this can be said about the real Faustina the Younger (d. 175), wife of Marcus Aurelius (no. 61) and mother of Commodus (no. 63). Our over life-size portrait of her is marked by official dignity. The replica—and it must be one as there is a puntello clearly indicating reproduction on the back of the head—is of good artisanal execution from an official prototype. Still, the image does not correspond to any known contemporary portraits of Faustina. Thus the head must be posthumous, a rejuvenated image enhanced by her apotheosis to a divine appearance. The craftsman was close enough to local traditions to make the empress as oriental as possible. The unItalian contrast of polished face and rough hair is handled in an utterly different manner than the same phenomenon was in Rome (for example, in the Sabina no. 43). The enormous eyes, emphasized by bushy, overlapping eyebrows, float in a face swollen almost out of shape. Nevertheless, the image is imposing. She appears as a divinized empress for faithful subjects in Asia Minor.

58 As a whole, the portraits of women from the Antonine period, especially these last two examples, emphasized womanhood and an aura of diffuse, dreamy sensuality that became more and more detached from reality. Comparable features appear in the contemporary male images. The over life-size head of Antoninus Pius (138–161) is a ruin in its present state, which perhaps accentuates how the modeling of both cheeks and hair has become fluid instead of firmly delineated in volume. The head is a mechanical copy, but the craftsmanship is not without some rustic charm. Antoninus was adopted by the emperor Hadrian as his successor on condition that he himself adopt the teenaged Marcus Aurelius as heir. Solid and dependable, Antoninus adopted the surname *Pius* to emphasize his filial affection for Hadrian, modeled his state policies on his predecessor's, and even stressed a certain physical resemblance between them in his portraits.

59 A small bust of a bearded man, though not imperial, may be looked at here. At first glance, it could be taken for Antoninus Pius himself, and this was the identification originally proposed for the portrait. Closer inspection reveals differences: most particularly, the face lacks even the modest charisma which Antoninus Pius's countenance showed both in reality and in his official portraits. The bust produces a convincing illustration of how faithful subjects tried hard to resemble their emperor, or at least how the sculptors of the day were able to make them look this way. Another case of this is represented by the head of a woman once identified as Faustina the Younger (no. 55). The bust of a man is distinguished by its perfect preservation and good craftsmanship, although the character of the sitter is but a pale reflection of its imperial model.

58. The emperor Antoninus Pius (138–161)

The ruined head from Asia Minor reproduces the first official type of the emperor. From the 40s of the second century A.D.

59. Small bust of a bearded man

The sitter is stylized in the appearance of the emperor Antoninus Pius. From the 40s of the second century A.D.

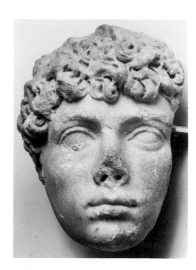

60. Head of a youth from a relief

From Asia Minor. Outstanding portrait from an official relief. One would like to recognize the features of an imperial prince. From the 40s of the second century A.D.

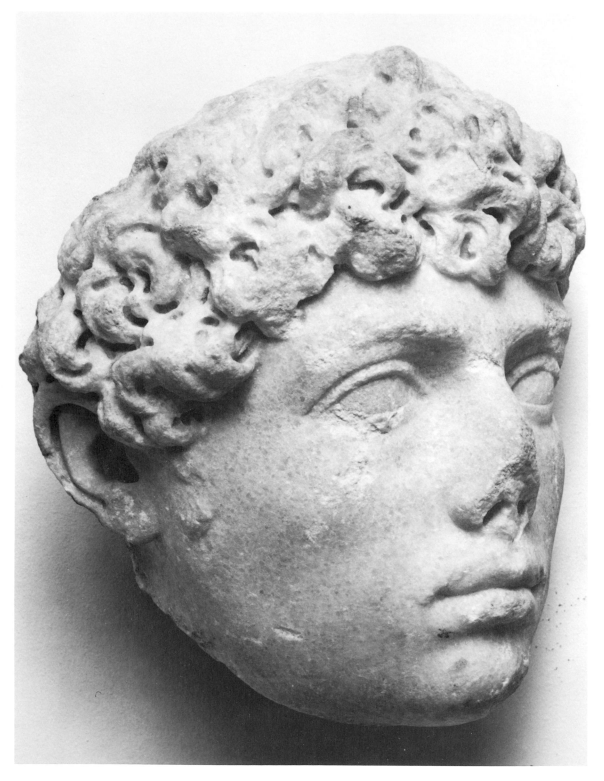

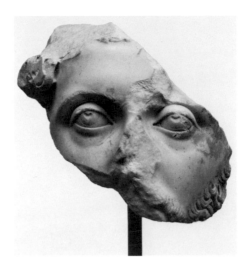

60 The irregularly broken head of a youth suggests at first that it was from a complete sculpture. Only further investigation of the edges at the back indicates that it was broken off a life-size relief. It must have come from Asia Minor and must have been from an official monument. The quality is superior to the well-known set of Antonine panels from Ephesos now in the Kunsthistorisches Museum, Vienna. Chronology does not present any difficulties, and the piece corresponds in every respect to the early Antonine period. The youthful face, calm and friendly, is difficult to identify. If it is an imperial portrait, one hesitates between the young Marcus Aurelius (no. 61) and his later co-regent Lucius Verus (no. 62). Besides the quiet dignity, there is little to suggest the status of the sitter, but like the Ephesos reliefs, the fragment witnesses a revival of Hellenistic traditions in Asia Minor at this period.

61 The portraits of Antoninus Pius's three successors may be looked at together, as they illustrate the next state in portrait development. It is hard to admit it, but it may have been a fortunate accident that turned the head of the emperor Marcus Aurelius (161–180) into such a minimal fragment; it leaves so much room for the imagination to build around it an image of a gentle and wise philosopher-king. The marble has been polished to the point where it ceases to be marble and resembles porcelain. The surface was originally painted, although the incised eye details, the invariable custom in this period, now seem to provide quite sufficient detail. The contrast between turbulent curls of hair and smoothly polished marble must have been extraordinary, creating a shifting pattern of light and dark. While the sculpture denies its volume in the face of thse pictorial accents, the portrait becomes the image of Marcus's soul, profound and philosophical, and the eyes reflect an otherworldly spirituality.

61. Fragmentary head of the emperor Marcus Aurelius (161–180)

The incomplete presentation suggests that the head was still better originally than the already excellent workmanship allows. From the 60s or 70s of the second century A.D.

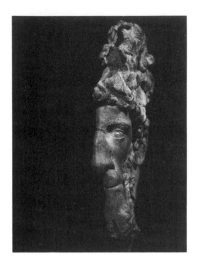

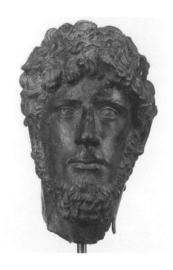

62. Bronze head of the emperor Lucius Verus (161–169)

From Asia Minor. A rather common cast belonging to a group of imperial statues exhibited in a public building in the western part of southern Asia Minor. From the 60s of the second century A.D.

Figure 15. *Bronze head of Lucius Verus in the flattened condition it was found in. Conservation has returned volume and vitality to the piece, but undoubtedly destroyed many nuances.*

62 The bronze head of Lucius Verus (161–169) was found completely flattened (fig. 15). This rather discouraging preservation was successfully overcome by skilled conservation, but surely many nuances of the modeling and characterization were sacrificed in the process. Though no parts are new, the sculpture cannot be the same. Nevertheless, it is rare as a bronze specimen of imperial portraiture, and one must welcome a comparison between the subtlety of the Italian-made Marcus Aurelius which must originally have looked like an embroidery in marble and the simplicity of the Asia Minor sand-cast of Lucius Verus, his co-emperor. One would like to discover a hellenic trend in the bronze, but there is little evidence for it. However, the technical aspects of the casting are considerably better than the two bronzes from the third century (nos. 85 and 86). Marcus Aurelius's nephew, idle and pleasure-loving, lacked both the intellect and the dedication to duty of his co-ruler. Some of this vacuity may surface in our head—or it may be a result of the restoration or of a too-great willingness to read judgments into the features of the time.

63 The emperor Commodus's (180–193) brutal side does not appear in our portrait. In spite of the virtuosity of the treatment and the closeness to his likeness on his coins, the individual eludes us. A very interesting detail is the mounting arrangement of the head: the inside from the neck up has been cut out, which means that the head was placed on a cone-shaped protuberance on a bust or statue. The languid expression defies deeper penetration, but it is clear that this image is not the megalomanic young man who fought in the arena as a gladiator and renamed Rome *Colonia Commodiana*.

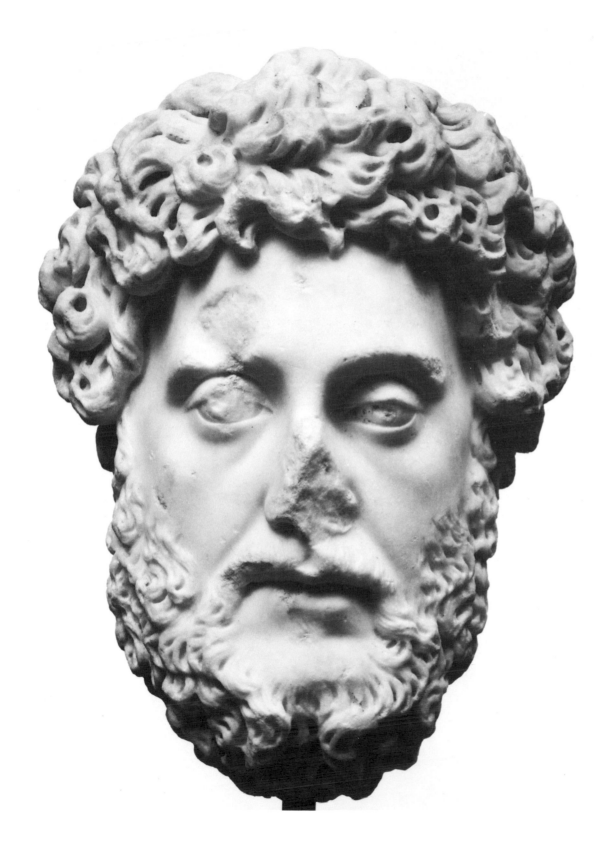

63. The emperor Commodus (181–192)

The head betrays nothing of the cruel nature of this wastrel son of Marcus Aurelius. From the 80s of the second century A.D.

64 Septimius Severus (193–211) belongs here, too, despite the change of dynasty. The art of his portrait type goes back to the style of the early Antonine period. It is probably associated in some way with Severus's dynastic propaganda claiming to be a grandson of Antoninus Pius and son of Marcus Aurelius—and hence a brother of the dead Commodus. At the same time, the portrait belongs to the most frequently preserved iconographic type of this emperor, where corkscrew-shaped locks hang over his forehead. This feature had the effect of incorporating his imagery with that of Serapis, god of his native Africa, who was frequently promoted as the new head of the decaying pagan pantheon at this date. The head is from Asia Minor, as the marble and workmanship reveal. There are no artistic pretensions. The crude carving illustrated involuntarily the beginning of the end in both classical sculpture and in portraiture, whatever single masterpieces would still be produced until the end of antiquity.

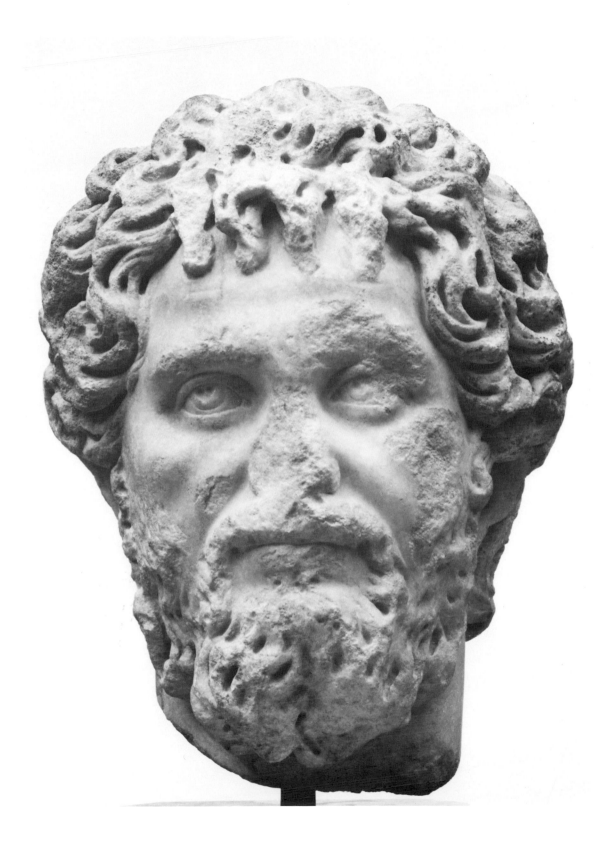

64. The emperor Septimius Severus (193–211)

From Asia Minor. A replica of the common portrait type, representing the emperor with his hair arranged over his forehead in the same style as the god Serapis. From the first decade of the third century A.D.

81

65. Bust of a priest of Serapis

From Egypt. The function of the sitter is indicated by the rosette-star in the diadem. The flat folds of the drapery recall Egyptian carving techniques. From the 70s or 80s of the second century A.D.

PROVINCIALS

65 The private male portraits of the Antonine period offer us not only a variety of interesting faces but also products from different centers. The marvelously preserved bust of a priest of Serapis includes the support, intact nose, and even traces of colors and gilding. It comes from Egypt. The origin is confirmed by the treatment of the drapery. The schematic folds, added cumulatively one over the other, are contrary to Graeco-Roman canons, and there is also no attempt to reproduce the material appearance of the fabric: it looks like stone. One could even say the drapery looks like *hard* stone, which the sculptor has been trained to carve in the best Egyptian tradition. The face, however, is an excellent portrait, in the best Roman imperial style. Perhaps the only provincial element is the emphasis on frontality. The aura of spirituality corresponds well to that of the fragmentary head of Marcus Aurelius (no. 61). The priestly rank is indicated by a gilded fillet around the forehead, whose central medallion bears the seven-pointed star of the god Serapis.

66 Two Syrian sculptures can be considered together. The first is disappointing at first glance. The common local limestone is soft, allowing it to be cut more like wood than harder stone, and the representation is rather poor. But the mediocre appearance does not lack depth of feeling. The inscription makes clear that Xanthion, the son, is the younger, bearded man on the left. The artist has generally attempted to reproduce personal characteristics of both sitters. Not only does the beardless Xanthos wear the Trajanic fashion of curly hair but also the son, with a short early Antonine beard, exhibits a much more softly modeled face. There is even an attempt to suggest something of their personalities. As is the case with the next masterpiece, the provincial artist foreshadows the developments which the official art of Rome would realize only a century later.

67 The other portrait of a man from Syria is a masterpiece in every respect. The carving is rather simple, which reduces the anatomy to a schema and flattens the modeling, but the craftsman knew how to given the head movement and to capture an expression enhanced by enlarged eyes. What a tormented soul appears before us; truly the image of a man from the end of the world. This provincial, without a name and without a history, fits the personality behind the *Meditations* of Marcus Aurelius, written in Greek for himself, better than the official images of the emperor. The head once belonged to a complete statue, but it was destined to be viewed exclusively from the front, as indicated by the block of raw stone left at the nape. There are important aspects of this provincial head's treatment of the portrait, particularly the simplification of forms and the spiritualization, which can be compared to mainstream Italian portraits of some one hundred years later. This should warn us against considering provincial art as incompetent or barbaric or seeing Roman portraits from the later third century on as products of decline and decadence. Indeed, it was on the periphery of the Empire that the evolution of art reflecting deep societal changes took a faster pace, while the center remained more conservative, disguising change behind a façade of traditionalism.

66. Funerary relief of a young Syrian

Dedicated by his father. From Syria. Both men are represented in the fashion of their youths—the bust of the beardless father reveals the Trajanic style while the bearded son is early Antonine. The local sculptor was simple but efficient. From the middle of the second century A.D.

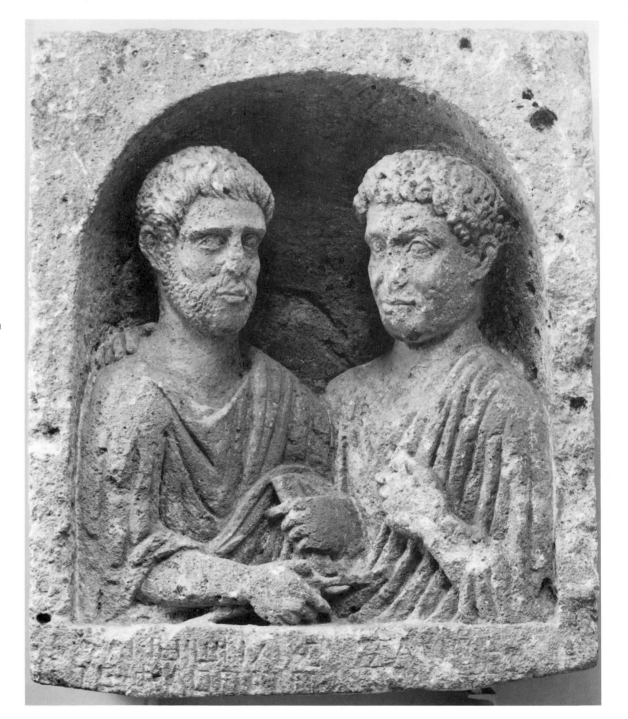

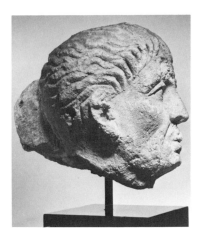

67. Head of a Syrian

The provincial sculptor reduces the modeling of the face but gives the sitter an intensity of expression achieved in sculpture in Rome only in the next century A.D.

68. Bust of a North African

The Italian sculptor succeeded not only in reproducing the ethnic characteristics of the sitter but also in creating an excellent portrait with a very individual face. Late second century A.D.

 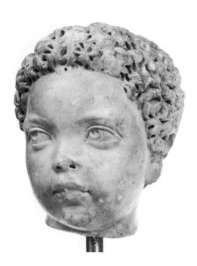

68 The following two portraits both show carefully depicted ethnic characteristics of their African sitters, although perhaps only one is a true portrait. The African man's curly hair, sparse and short beard, raised cheekbones,and peculiarly shaped nose clearly point to a North African origin. These features do not, however, suggest the true character of the man. The success of this portrait is based upon the artist's ability to catch the eloquent expression of his slightly scornful lips, the natural curiosity in his eyes, the slightly mannered self-defensiveness, and the perhaps somewhat histrionic presentation. Was the man a successful actor? He uses his face to project not only his personality but also his reaction to the environment in a way that brings to mind the accomplished art which Redd Fox brings to the modern public.

69 The other African is a Negro boy, one of the most attractive heads in the Getty Museum. It is of excellent artistic quality, and we must ask how much it is truly a portrait. One is tempted to say that it is much more the image of a young, lively boy without a definite personality, a genre piece, than of a specific individual. The sitter, if there really was one, is very little engaged. A parallel from later times are the fresh, smart boys from the streets of Seville as painted by Murillo, very moving but surely not portraits. The technique, especially the rendering of the hair, corresponds to the mid-Antonine period.

69. Head of a Negro boy

The very fresh and attractive image is more a genre than really individual portrait image. Late second century A.D.

70. Bust of a youth

The delicate teenager is marked by a deep melancholy, revealing a total lack of interest in existence. This is perhaps the most psychologically penetrating portrait in the collection. Later second century A.D.

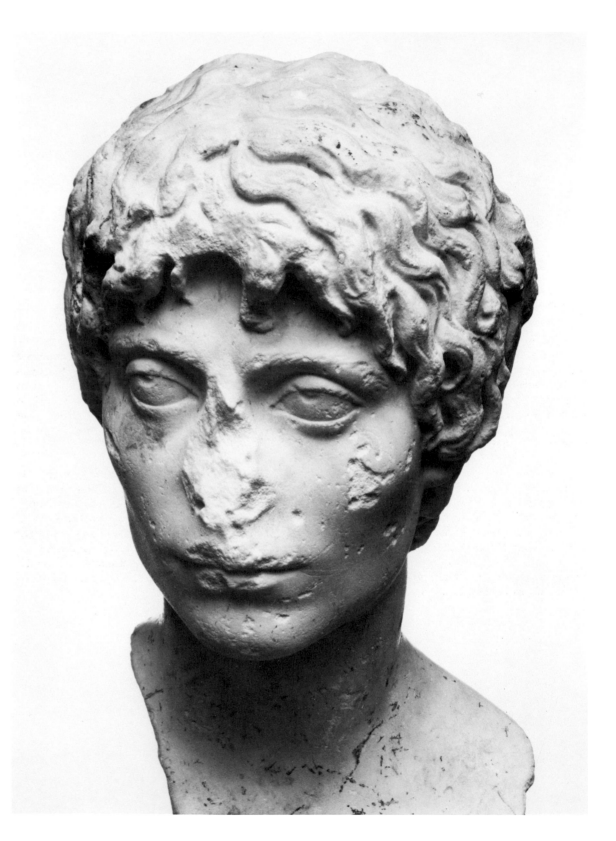

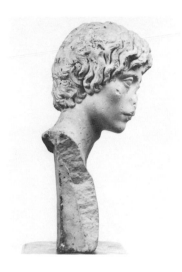
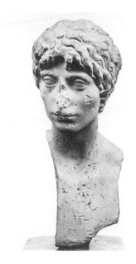
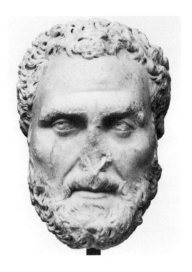

LATE ANTONINE PORTRAITS

71. Head of a bearded man

70 From approximately the same time is the bust of an adolescent which, in spite of some damage to the face, may be the most moving portrait in the whole collection. The sculptor almost neglects the precise modeling of the anatomy. He suggests rather than carves the taut play of muscles over the bones. His attention is concentrated on capturing the psychology of the world weary young man. Perhaps sickly, perhaps dissipated, there is no anxiety in the enlarged eyes, only bored resignation. He is so young, and life seems to be a perpetual frustration. He is well born, but spoiled already: *taedium vitae*, not only of the individual but also of a society. He may have read in the *Meditations* of Marcus Aurelius; but, rejecting the concepts of duty, he appropriated only the deep feeling of the vanity of the world.

71 The next head is characterized as a man of action, the complete opposite of the young aristocrat. He too has enlarged eyes and a philosophical look about him, but his sharp facial features, covered by the short beard, speak not of resignation but rather of a hardened individual ready to fight. He may have been somebody important in Marcus Aurelius's circle, perhaps from his general staff, as the same personality seems to be portrayed in two other heads, one also of Italian workmanship, the other found on the Western shores of the Black Sea in Messambria Pontica (modern Bulgaria). There is some little doubt, however, concerning the date. The sobriety and strong character are stylistic elements common to the time of Antoninus Pius; on the other hand, a later date contemporary with the first portrait types of Septimius Severus when a revival of early Antonine art occurred may be more fitting.

71. Head of a bearded man

While the portrait clearly belongs to the early Severan period, the presentation reveals parallels with both the rough appearance of Septimius Severus and the bluff honesty of Antoninus Pius. End of the second century A.D.

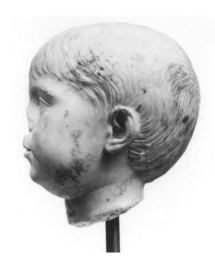

72. Grave relief of Agrippina

Everything suggests that the bust is that of a twelve-year-old boy, but the inscription says that the portrait is of a girl who lived only three years. The actual likeness was not the preoccupation of the artist or of the parents who dedicated the monument. Late second century A.D.

73. Head of a little boy

The sculptor created an individual image of a baby. Late second century A.D.

72 A relief in the shape of a little funerary shrine protects a youthful bust. The portrait seems to represent a boy with short hair of about twelve years. The first impression is that it is a rather good portrait. The inscription comes as a surprise: "RIP. Agrippina our daughter who lived three years, one month, and twenty-seven days. Her parents made this to her good memory." What could be the explanation? Perhaps the loving parents had the inscription engraved on a monument they bought readymade from a stonecutter's shop. Maybe they wanted a boy, or Agrippina was a boyish little girl. However, at three years she could not possibly have looked this old. Whatever the explanation, for the parents or for other people of this time, this was a valid image of the little girl, and our modern conception of the portrait as actual likeness is once more revealed to be completely anachronistic.

73 Through all Roman history, portraits of children betray a problem for the artists and for the parents who usually commission them. The easiest solution for the artist is genre in the pattern of a pleasant putto, called in antiquity an Eros. The peculiarities of personality are rarely indicated, except occasionally when an unpleasant personality is precociously revealed as in the boy Caracalla (no. 77). Our sculptor, though with little artistic pretension, escaped both trends. In a period when portraits of adolescents express the general *taedium vitae* like our excellent bust (no. 70), this artist still succeeded in emphasizing the natural vitality of a human cub. One could be tempted to associate the little boy with a good, rising middle class family while thinking the Antonine teenager must belong to a decadent aristocracy. This may be true in the most general sense of Roman history, but an individual and his image mostly result from the incalculable game of unforeseen causes, mocking any of the viewer's preconceived notions.

SEVERAN PORTRAITS: THE BEGINNING OF LATE ANTIQUITY (193–235)

The portraits of the Antonine period may be considered as the closing chapter of Roman portraiture. The Severan period opened the gates to Late Antiquity, to the inevitable downfall of men and their realm. More and more, portraits began to turn away from reality and strive for a pure spirituality. The images henceforward become less and less portraits, and the flesh takes its revenge as it turns to pure stone.

74 A girl of the Severan period, clearly from a Roman workshop and Italian blood, presents a sober image. An elaborate hairstyle similar to the wig, but with a heavy chignon, is worn like a helmet. The face reveals a character that seems at first pragmatic to the point of banality. The appearance is slightly misleading: under the detached expression there is a smile which undulates the full lips and lets one feel some intellectual depth and sympathy with the subject.

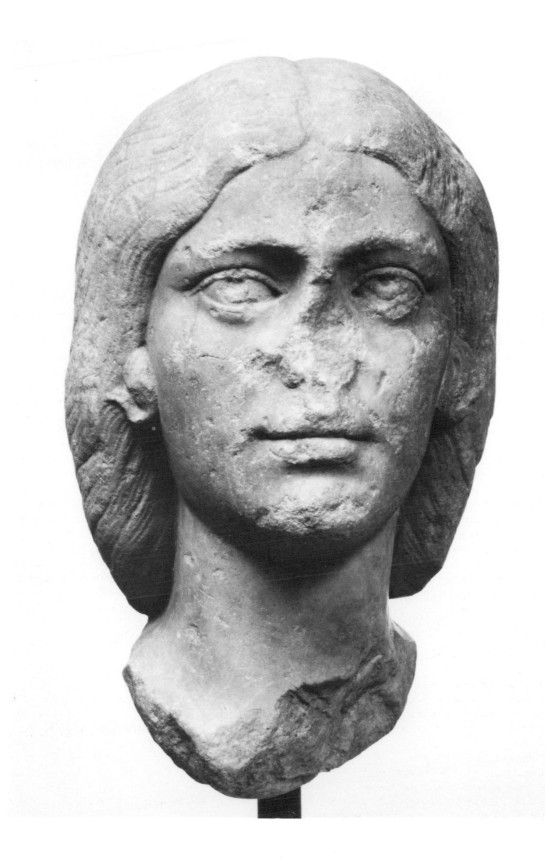

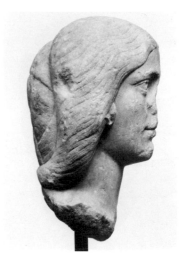

74. Head of a girl

The rather plain sitter is represented with fine psychological analysis. First decade of the third century.

75. Wig

The separately carved hair provided the opportunity to update a lady's portrait with the current fashion. Beginning of the third century A.D.

75 The earliest Severan piece in the collection, which exhibits very little spirituality, is just a simple hair-dress, a wig, unbroken and in nearly perfect condition. As mentioned in the introduction, Roman ladies did not like the thought that their effigies could become dated with the change of fashions in hairstyles. Thus the head and hair could be made separately, making it possible to follow the latest creations of the hairdressers. Our heavy, helmet-like wig is parted in the middle with ribbed waves corresponding exactly to the hairstyle preferred by Julia Domna, wife of Septimius Severus. As the scale is not over life-size, an empress is less probable as the owner than a private lady trying to be up to date with court fashions.

76 After looking at these reflections of Julia Domna, the wife of Septimius Severus, we may turn to her daughter-in-law Plautilla (d. 212), short-term wife of Caracalla (nos. 77–78). The identification is due to Sheldon Nodelman and is based on the fact that there are one or possibly two replicas of this same type. The better preserved one is in Houston. Our example, which suffered from centuries of exposure to sea water, was originally of superior artistic quality. The modeling is soft not only in the face but even in the formation of the hair: we can see this in the waves terminating in the elaborate chignon and in the little curls on the sides of the neck. Plautilla wears her intricate hair style like a crown. A disturbing contradiction exists between the sitter and the style: the girl is clearly oriental with opulent flesh and melancholy eyes, while the fine carving reveals a court sculptor in Rome (or rather an excellent copy after a Roman original). A second dichotomy is deep in the sitter herself. It is not because of her external situation: the official artist would surely eradicate any indication of marital or family strife reflected in her face. Married to the fourteen-year-old Caracalla in 202 to further her father Plautianus's ambitions, she was banished after his murder in 204, and protected by Septimius Severus until his death in 211, when Caracalla had her executed with the rest of her family, going so far as to erase her image from public monuments.

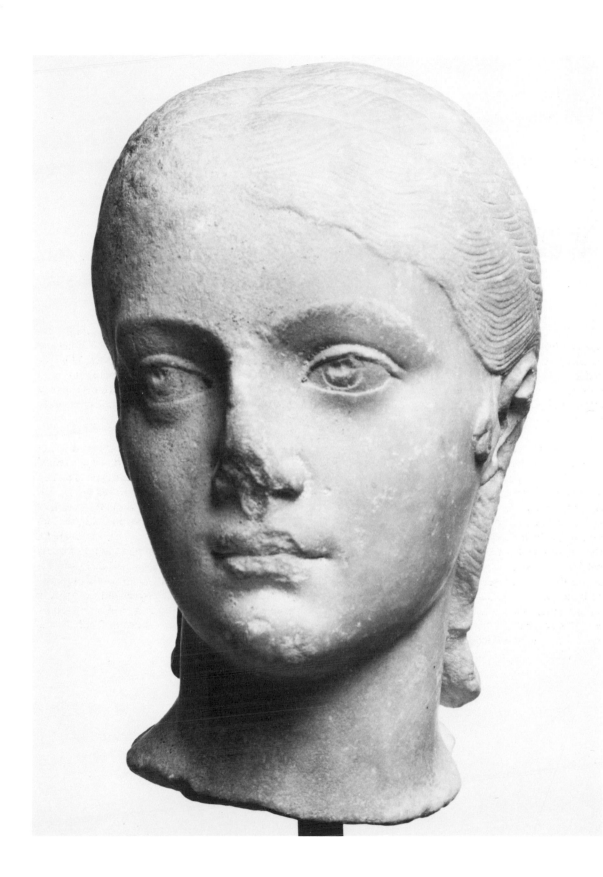

76. Plautilla (d. 212), wife of the emperor Caracalla

The unloved wife of Caracalla, married for political reasons and soon executed by her husband, is represented with the slightly enigmatic charm of an oriental princess. First decade of the third century A.D.

77. Fragmentary head of the young emperor Marcus Aurelius Antoninus, called Caracalla

The earliest type of the sulky boy prince is reproduced with rich modeling in the best tradition of Alexandrian sculpture. End of the second century A.D.

77 The identity of the young Caracalla (b. 188, ruled 211–217) is evident even in this fragment. The quality of the carving is excellent but a little unusual for the standard output in antiquity. Indeed, the sculptor treated the material as if it were a hard stone, giving its surface a shiny and compact appearance. The excellent tradition of Alexandrian sculpture is responsible, as can be seen if we compare this fragment to other sculptures of this origin in the museum's collection (see also nos. 31 and 53). Past the surface, however, lies a richness of modeling which raises this repetition of a rather common type of the precociously promoted prince. The image transcends the normally unpleasant aspect of a rather spoiled, doughy-looking boy into a character study as well as a monumental sculpture.

78 The association of a portrait bust with a shield goes back to early Roman times and seems to have been adopted from Hellenistic traditions. It was used under the Empire not only for portraits of emperors but also for various celebrities of the past, including Greek classics. Our example, carved in Asia Minor marble, must come from this region even though it was formerly considered as Italian work. The rather fluid modeling also points to this region. The features of the young Caracalla do not correspond to the well-established sequence of his iconography, but the representation may be that of his image as newly proclaimed Augustus, heir apparent to Septimius Severus. He is decked with a large fillet, a tradition inherited from Hellenistic princes. The original appearance was enhanced by vividly applied polychromy which may have given the features some more clarity.

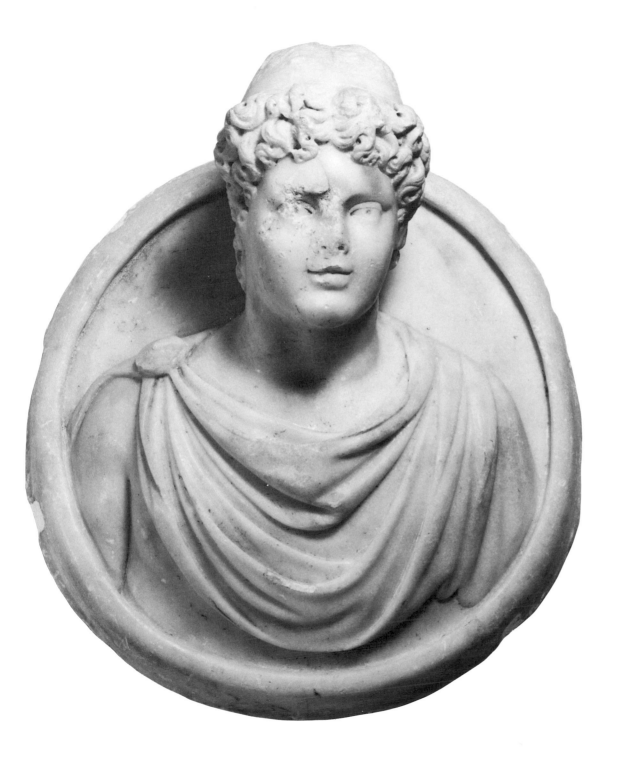

78. Marble shield with the bust of Caracalla as heir apparent.

The face shows few individual characteristics and is due to the work of the local sculptor as it corresponds poorly with the established portrait types of Caracalla. Beginning of the third century A.D.

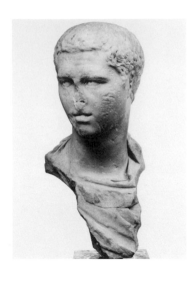 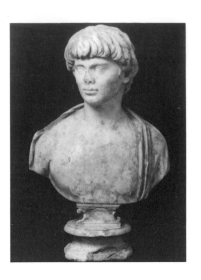

79. Bust of Geta, younger son of Septimius Severus (d. 212)

The face was intentionally mutilated, probably after Caracalla had his brother murdered rather than share the Empire with him.

Figure 16. *This bust of a youth was found together with the Getty bust of a bearded man. The workmanship is from the same atelier if not the same hand, but the styles suggest that the boy dates back from the Antonine period while the man dates to the time of Caracalla. The two portraits must serve as a reminder of the overlapping of portrait styles and of the versatility of portrait sculptors. Minneapolis, The Minneapolis Institute of Arts, 68.9.2.*

79 The appearance of this bust makes it clear that the subject must be a member of an imperial house. The date points to the early Severan period, still in the first decade of the third century. Thus, Caracalla and Geta come to mind. It is notoriously difficult to distinguish them, but the piece itself offers an unexpected key. Looking at its mutilations, it is evident that they were not produced by accident but quite intentionally The sides of the bust were broken off, the nose and ears hammered away, and there are traces of blows on the eyebrows, left cheek, and right side of the chin. Finally, there was an attempt to saw off the head starting at the nape. As is well-known, Caracalla was not content just to have his younger brother murdered but also ordered his memory be officially expunged, together with systematic destruction of Geta's monuments. There is good reason to believe that this bust was found in the Thames. It may have been thrown there as part of the destruction, but the workmanship and the marble point clearly to Italy from where it must have been imported as an official portrait. On the other hand, no exact replicas are known. It is, however, worth mentioning that both sons accompanied Septimius Severus on his last trip to Britain, from which he never returned and soon afterwards the younger brother was killed. The main interest of the portrait is its destruction. It is a unique case. Otherwise as a work of art it is far from being outstanding, but its style and characteristics correspond well to the psychological trend of the time, with accompanying reduction of the correct anatomy. It can be compared well with the brilliant portrait of his sister-in-law Plautilla (no. 76), with which it shares not only style but also a slight oriental cast. Finally, the face is an excellent precursor of later Severan portraiture such as no. 83.

80 The bust of a bearded man is an eloquent example of how private people attempted to emulate the appearance of the emperor. The sculptor gave his subject the short, curly hair fashion of the adult Caracalla and also tried to incorporate the proportions of the emperor's face, even imbuing him with some of the somberness that Caracalla thought imitated the genius of Alexander the Great. The excellent preservation allows us to appreciate the high polish of the marble skin, which contrasts with the rougher textures of hair and drapery. At the same time, both in the drapery folds and the facial features, the organic cohesion is loosening. It is also clear that the tradition of the time emphasizes the spiritual—the sculptor enlarged the eyes and turned their gaze to the heavens—at the expense of individual character. Another interesting original feature is unfortunately lost to the modern viewer. The piece was originally paired with another bust of a youth (fig. 16) today in the Minneapolis Institute of Arts. The two sitters differ in age and personal characteristics, but the two portraits, indisputably carved in the same workshop and even by the same chisel, are of different styles. Isolated, the bust in Minneapolis would be dated a quarter of a century earlier than the one in Malibu: the youth's presentation corresponds to the middle and later Antonine style. Whatever the explanation may be—did our sculptor reproduce an earlier piece?—it demonstrates clearly that the style is significant not only in the frame of portrait evolution but also as an integral part of depicting the individual.

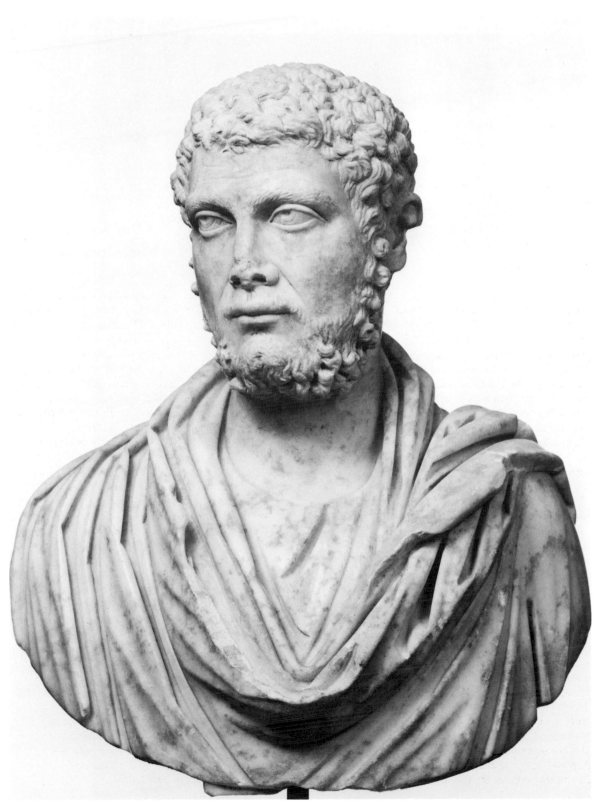

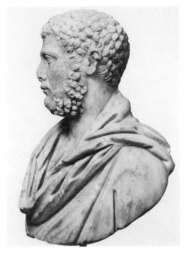

80. Bust of a young man

The sitter and sculptor consciously imitate the mature portrait type of Caracalla. Early second decade of the third century A.D.

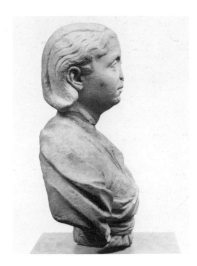
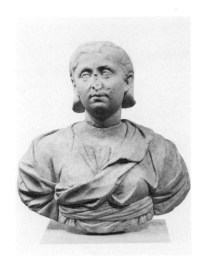

81 As it is displayed today in the Getty Museum, the impressive draped female statue does not seem at first to be a good example of Severan date. It is too successful, too careful, too much *di buona epoca* in the simplistic notion that evolution of Roman art is a history of constant line. When the lady was still in Palazzo Sciarra in Rome and even when she was first on the art market, there was still a powerful even if slightly restored head of an elderly matron inscrted (fig. 17). The portrait must have been influenced by the likeness of Julia Maesa, sister of Julia Domna, a woman from the same strong-willed Syrian family who successively put on the throne the sons of her two daughters. The head is lost now (hopefully only temporarily) but the monumental quality of the statue shows that the classical tradition and excellent craftsmanship were alive and well about 220.

82 The next piece was also originally a statue. Broken in modcrn times, it was reshaped into a bust and the surface of the drapery and the head wcre recut, suffering during the operation. Despite these interventions, the portrait fits well into the fashions set by Julia Mamaea, mother of the young emperor Alexander Severus (222–235). The carving, even in the original, was considerably inferior to the Sciarra statue, but it is still of a good quality. Reflecting the new trends of imperial portraiture, a feminine softness conceals any of the lady's harsh features and subdues the marks of advancing age.

81. Draped statue of a woman

The broken-off head of an elderly lady dates the piece about 220. The statue repeats an early Hellenistic prototype.

Figure 17. The draped statue of a woman before its third century head was removed.

82. Fragmentary statue of a woman

Cut in modern times into a bust. The portrait head dates from the 20s of the third century A.D.

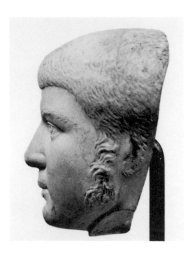

83. Portrait head of a young man

The sitter is not very attractive; the workmanship is accomplished. From about 230.

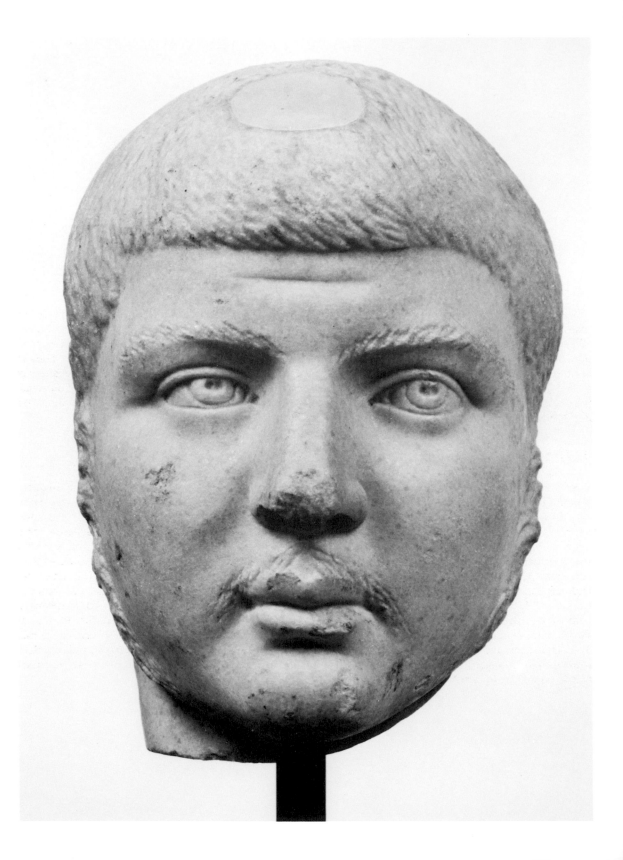

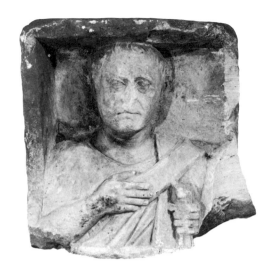

83 One might be tempted to identify an emperor in this perfectly preserved face of a young bearded man, but the sculpture is too late for Elagabalus, not soft enough for Alexander Severus, and perhaps too early for Gordian. It need not represent an emperor at all. At this moment in Roman portraiture, the degree to which a portrait expresses an individual is becoming less important, especially in images of youths. They all seem to lack bones, and not only anatomically. The dreamy aura which began suffusing the countenances of young men in the time of Antinous (no. 45) has become a dominant spiritual note. The carving is of outstanding quality. Here it is clear to be seen that it is not by a decline of craftsmanship that Roman portraiture is losing its *raison d'être*.

THE SOLDIER EMPERORS (235–305)

84 This funerary relief with the bust of a man brings to mind the similar monument from the Augustan period in the Republican tradition (no. 11). Here, too, there was originally a second bust, now missing. Here, too, the emphasis is on the verisimilitude and on the pitiless rendering of age. This monument however must be from the later 30s of the third century and serves as confirmation of an insight. Bernhard Schweitzer explained the trend of this period as a conscious revival of the art of the Roman Republic. One would even like to say of Republican values, for there is some ring of truth in this statement. The leaders of this trend were soldier emperors who emerged, via the army, often from the bottom of society. Their rough short beards and hair and their ferocious expressions may deliberately have attempted to evoke the rustic appearance of the venerable Republicans. It is this approach which seems to be the dominant feature here, but if the man is compared with the Augustan relief (no. 11) or with the cippus head of the rustic provincial (no. 9), we can see how this superficial return to older traditions lacked true roots. Both rugged post-Republicans are at ease in their unattractive skins. They are part of a framework, real or supposed, which is *civism*; their credo is *salus res publicae lex suprema esto*. The man from the third century is a loner lost in the universe; even his face is contorted by a self-destructive anxiety.

84. Funerary relief of a man

The shape of the monument and the expressive face point to a revival of Roman Republican funerary effigies. The hair cut and the style indicate a date in the 30s or 40s of the third century A.D.

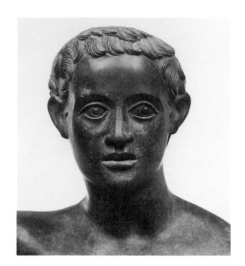 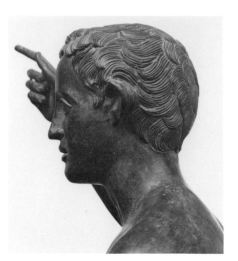 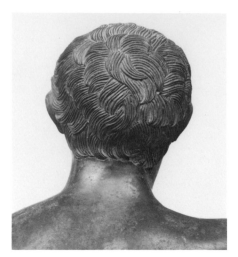

85 The most important things about this bronze statue are that it is complete, well preserved, and that bronze statues are rare. The element of portraiture hardly exists. It does, however, still retain from the tradition of classical sculpture the fact that it really stands both as a work and as an object. The metal casting technique is equally correct. The statue is fashioned from segments, and even in casting these pieces the metal has countless flaws. The level of art is poor. The raised right hand in the gesture of *adlocutio* has a venerable tradition and suggests that the represented person is an imperial prince. The expressionless face and the schematically described anatomy make the chronology difficult, but one should not be tempted to a late dating by the inherent provincialisms. The best place for the piece is in the second quarter of the third century; the young man may be one of the young sons of Philip or Trajan Decius.

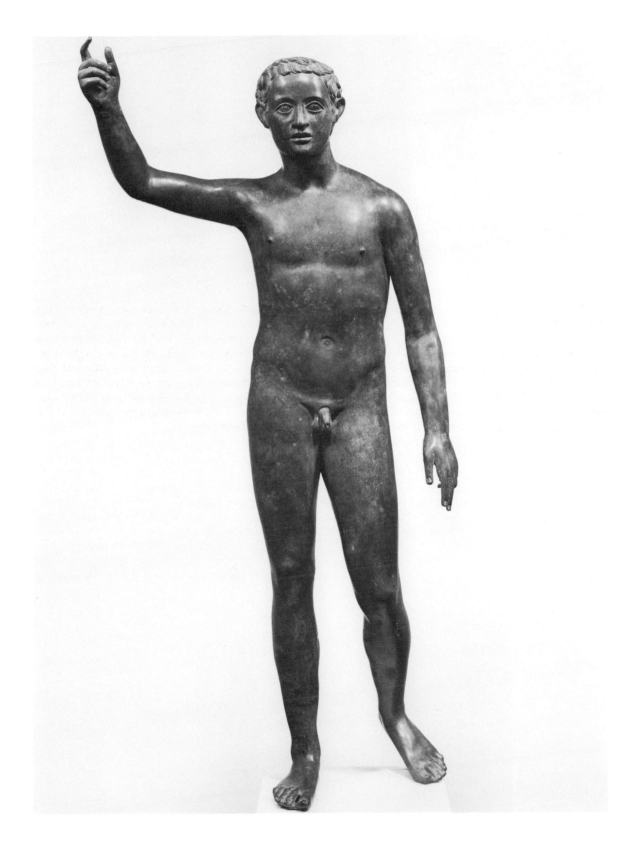

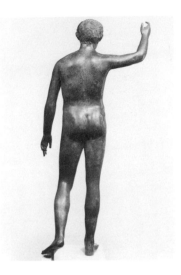

85. Under life-size bronze statue, perhaps of an imperial prince

From Asia Minor. Identification is impossible given the scanty quality of the portrait and of the workmanship in general. From the second quarter of the third century A.D.

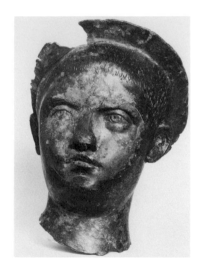

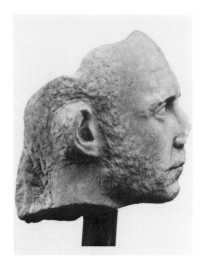

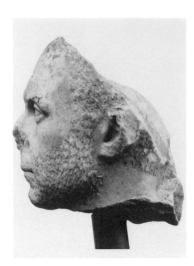

86. Bronze head of Philip the Younger

Son of Philip the Arab (244–249). From Asia Minor. The boy prince is barely recognizeable.

86 This bronze head of a young prince was cast separately and perhaps placed on a body similar to that of the preceding. It too is not of extraordinary quality, but there are many more personal characteristics. The flaccid anatomy is casually modeled, but the face retains a strong character with the capacity of overwhelming the viewer. The possible identification of this portrait as heir apparent is confirmed by the rather strange halo-like edge on the hair, which could have supported a separately-made radiate crown. The features of Philip the Younger (244–249) found on coins of this prince and the not too well documented three-dimensional images of his father (see no. 94) are comparable with this youth's appearance.

87 The head from Asia Minor produces an ambiguous impression, not about its authenticity or its quality but about its date. Does it come from before or after the middle of the third century A.D.? One is at first inclined to the later date, but the reworking of the eyes and mouth noted in the description makes it clear that this anxious man is earlier. The depth of the eye sockets and the rich modeling of the lips was flattened, perhaps in the fifth century, probably to keep the piece on public display after an accident. It is even possible that the head was broken off and replaced on its statue on the same occasion. The head is over life-size, which points to an imperial image. Taking the modifications into account, he may be identified as Trajan Decius (249–251), who attempted in his brief reign to revive some of the past glories of the Empire associated with the good emperors of the second century—hence his assumption of the name Trajan. Decius's only generally acknowledged portrait is of Roman workmanship, and is thus perhaps more individual but also much more stone-like in its modeling than our version, which speaks of personal power as much as of the tensions of the age.

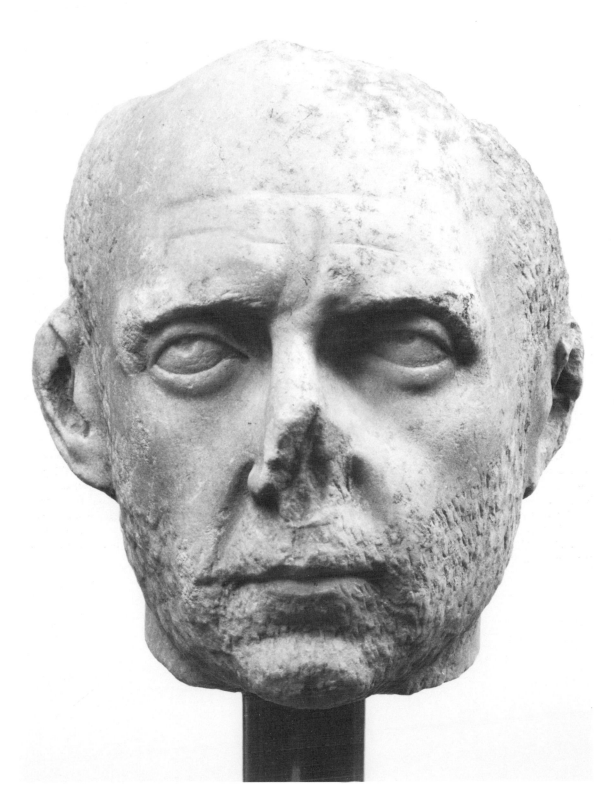

87. Bearded man, perhaps the emperor Trajan Decius (249–251)

From Asia Minor. The ancient recutting makes the identification difficult, but the over life-size scale indicates an emperor. Perhaps from about 250.

105

88. Head of an elderly woman from an imperial family

The realistic rendering of the age is reminiscent of Republican matrons. Second quarter of the third century A.D.

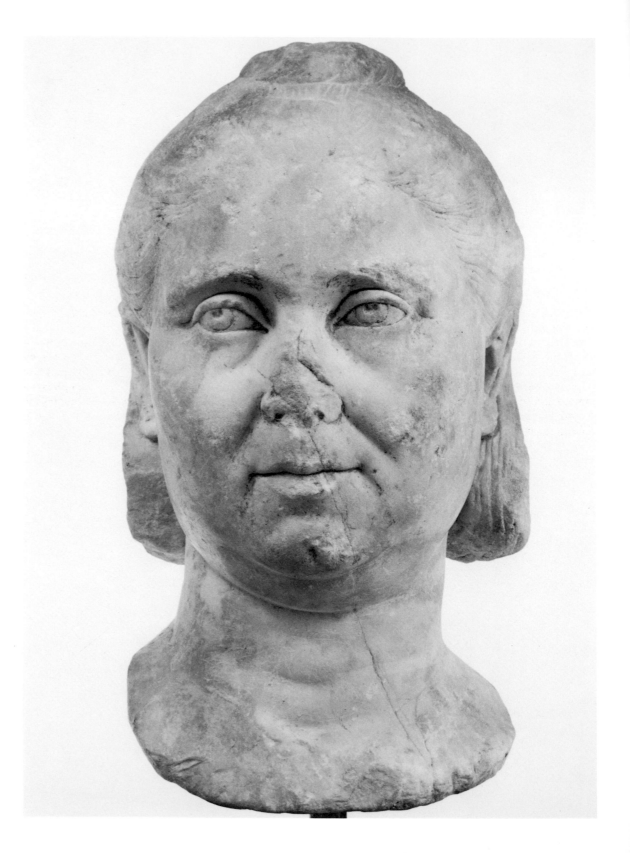

106

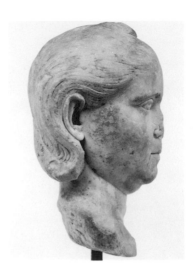

88 Female portraits of the second quarter of the third century also reflect some nostalgia for remote Republican times. This portrait of an elderly lady, probably imperial because she is over life-size, is without any sure iconographic identity. Because of her marked physiognomy, she has been nicknamed "the mother-in-law." The frank statement of her homeliness, however, lacks anything ordinary in it. Like many contemporary imperial portraits, she appears at the same time agitated and thirsty for power. Originally the piece must have been even more striking, but modern cleaning took its toll on the surface. The elaborate physiognomy denies the softness and organic structure of the flesh; and the whole face turns to stone, adding the element of exalted spirituality. At one time the lady was thought to be Herennia Etruscilla, wife of Trajan Decius, but this hypothesis is no longer tenable.

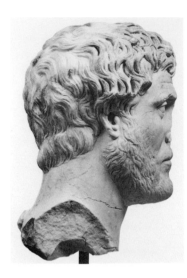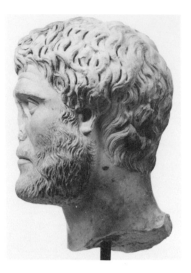

89 Two portraits show men from the same time, breathing the same air but utterly different both in style and personality. They share an emphatic spirituality, with their eyes enlarged and turned heavenwards. The anatomical structure is neglected and the flesh turns to stone, but one man seems to believe in his creed while the other looks as though he wears it under the orders of his emperor, conforming to the fashion of the time. The close cropped beard of this latter corresponds to the fashions of the first soldier emperors who succeeded Alexander Severus, as does the total personality of the man: compare, for example, our miniature Philippus Arabs (no. 94, disregarding as unimportant whether it is ancient or eighteenth century). The pragmatic, hard-driving core of the man is just the opposite of the contemplative spirituality he is apeing. One would like to see him as one of those ambitious officers whose meteoric career culminated in a murderous conspiracy against the ruler, to become, shortly after, a victim of the next pronunciamento. Still, some nostalgia for the great Roman past lingers, and distant echoes of Republican portraiture may be discerned here.

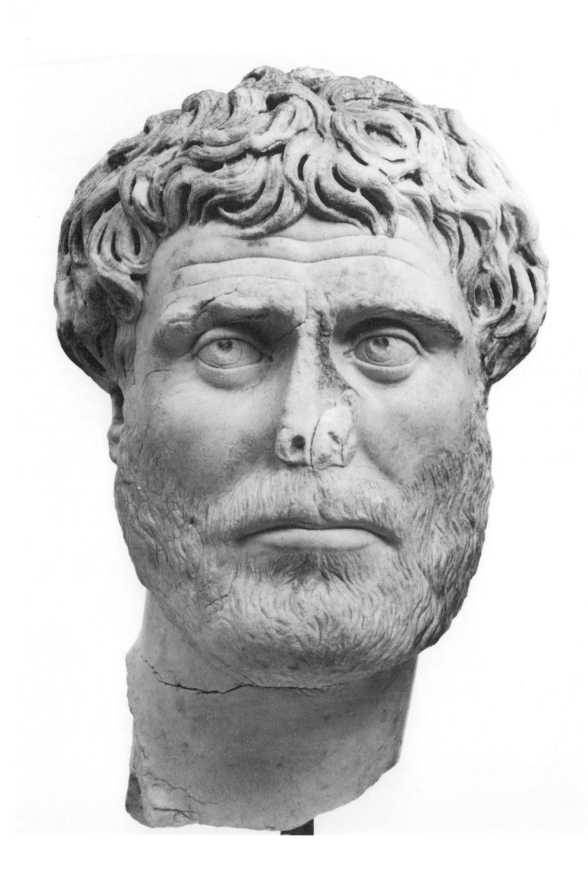

89. Head of a bearded man

The sculptor adapted the active personality of the sitter to the spiritualizing tendency of the times; the resulting ambivalence produces a superb portrait. From the middle of the third century A.D.

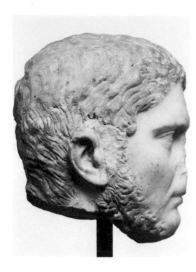

90. Head of a man with a short beard

The portrait is modeled after that of the emperor Gallienus (253–268), with the same attempt to revive something of classical Greek art while the reflection of contemporary Neoplatonic philosophy seems to spiritualize the enlarged eyes. From the third quarter of the third century A.D.

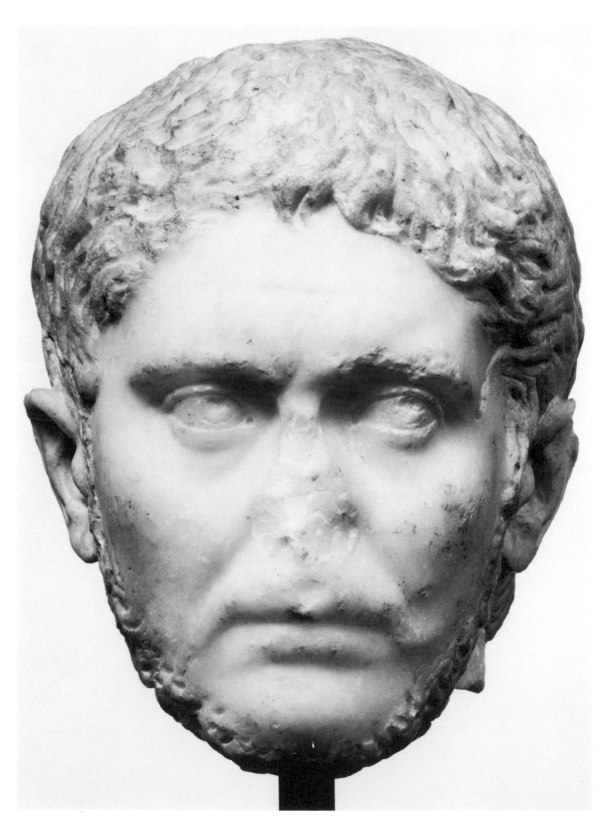

90 The other man also incarnates an illusion, namely the resuscitation of the true Hellenic heritage. To the Neoplatonic movement guided by the great Plotinus corresponds what specialists call the "Gallienic renaissance" in art, fostered by the emperor Gallienus and his wife. But as Plotinus was to Plato, the art of this time assumes just the trappings, the sad leftovers, of the extinct fire that was Greece. Even measured against the pale reflection of classicism that was the "Hadrianic renaissance," like the Antinous (no. 45), our man shows just some reference to traditional proportions and softness of modeling, much as they were inculcated in the image of Gallienus himself. One might even be tempted to label this portrait Gallienus, but in spite of the lessened feeling for precision in portraiture, the features are simply not his. The quality is also vastly superior to even the best replicas of imperial effigies.

91 The front of the sarcophagus is dominated by a simple vertical fluting. At the two sides are surrealistic groups of lions tearing at boars. The central medallion is above two tragic masks and bears the portrait of a lady. She is decidedly homely in her heavy, elaborate hairstyle, as unattractive as the preceding head of an empress (no. 88) but without her imposing power. Both the portrait and the rest of the sarcophagus seem to have been carved at the same time, and the only function of the portrait here is the identification of the deceased, timid and symbolic rather than a true likeness. Both of these two ladies can be compared especially well with the small head of a woman in the late Republican tradition (no. 12), but the superficial affinity reveals much more the abysmal difference in art, portraiture, and social conception of the individual.

91. Sarcophagus with a bust of a woman

The portrait has little pretension to actual likeness, although the lions on either side of the sarcophagus are very fine. Middle to third quarter of the third century A.D.

92. Fragment of a sarcophagus with a portrait bust of a man carried by Erotes inside a shell

The workmanship of the decorative elements of the sarcophagus corresponds to the 50s or 60s of the third century, but the rough carving of the portrait itself is possibly twenty years later.

92 A shell that was in the center of its front face is all that remains of this sarcophagus. On the ground of the ribbed shell are several small Erotes, like hovering angels, supporting the bust of a man with rather rugged features. The portrait is expressive, however clumsy it may appear at first glance. Both the style of the portrait and its workmanship are significantly different from the surviving rest of the piece. The explanation is very simple: the sarcophagus was completed with the exception of the portrait head, which was left as a boss for some fifteen years. The style of the decorative figures thus points to the first decade of the second half of the third century, while the brutal characteristics of the portrait reveal art developments closer to the time of the first Tetrarchy.

93 The sculptor of this imperial portrait paid little attention to individual features or even to the organic articulation of anatomy. The face looks like a carved stone. The individual likeness was not the primary interest and that is why identification of the ruler is difficult. The four emperors—Tetrarchs—of the newly reorganized Empire (ca. 293–305) sought to be identical, mutually replaceable units in the machinery of the government. Their coin and sculptured portraits carry this message of unanimity to the point where one could literally substitute one for another. At first glance, one may be reminded of the shrewd "Republican" (no. 9) because of the heavy jowls and broad cheekbones, but the overall result is utterly different. That head, after all, is open to a dialogue with the viewer; here the massive head imposes itself on the public, gazing above the viewer in direct communication with the heavens. The contracted forehead, the upturned eyes, and the tight mouth emphasize divine inspiration. This is a new type of emperor: he is self-identified with the divinity, his celestial virtues legitimizing his power. The conception came to the late Empire from the Orient and would later be taken over by Christianity for the anointed rulers of early medieval times. The classical portrait thus disappeared, although the art, denying the conquests of the classical heritage, is not without its own impressive achievements.

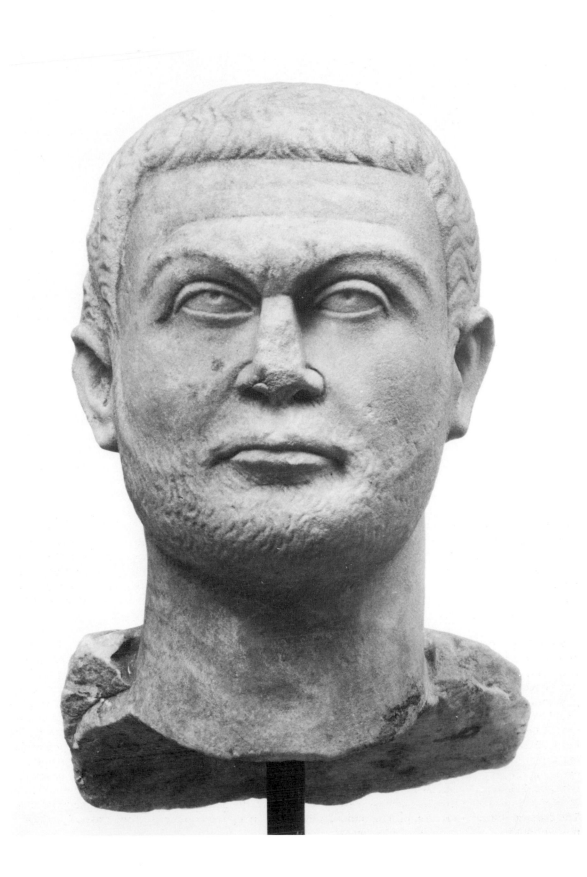

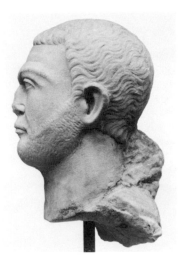

93. Tetrarch

Late imperial iconography stressed the divine inspiration of the men who jointly ruled the Empire. The solid geometry of this head is subtly modeled, but the severe abstraction of the forms and impenetrable expression defy identification. About 295–305.

94. Miniature bust of the emperor Philip the Arab (244–249)

The portrait may be from the emperor's reign, serving possibly as a jeweler's model, or, less probably, may be a recreation of the late eighteenth century. In either case, it is an indisputable masterpiece.

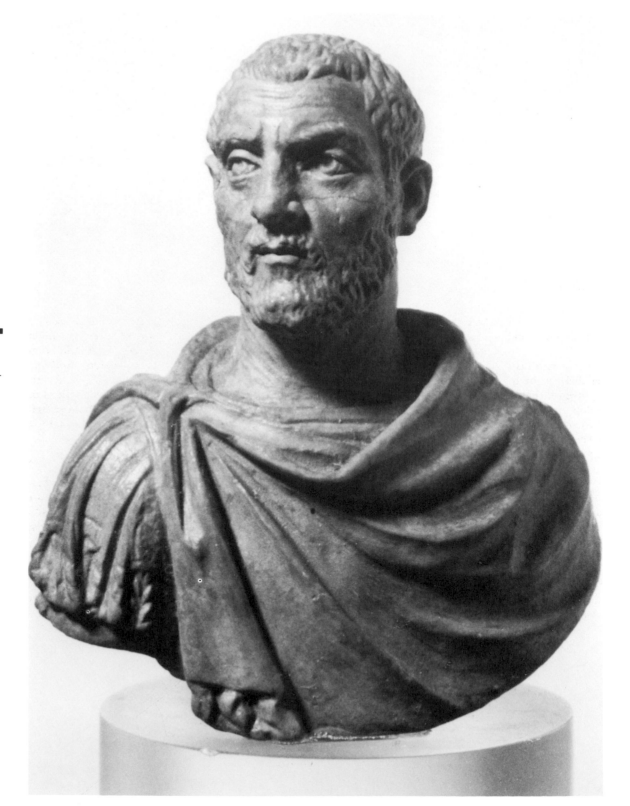

114

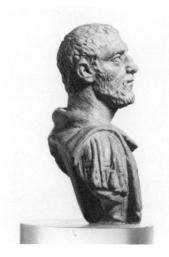

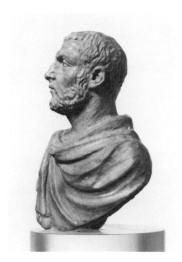

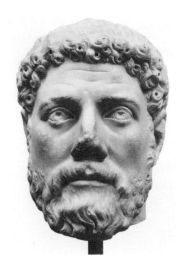

DUBIA

94 What a jewel! And what a difficulty! The shape and presentation are proper for a model to be used by a goldsmith working a miniature bust of an emperor in repoussé—such as a gold Septimius Severus found in Thrace. While the identification with Philip the Arab (244–249) seems to be sufficiently evident in comparison with his coin portraits (fig. 18), the authenticity of the piece remains under discussion. No direct parallel can be quoted, and the surface, especially under magnification, produces a rather impressionist, eighteenth-century Baroque effect. There is a further disquieting circumstance: the two extant portraits of Philip in the Hermitage and the Vatican were both discovered in the later eighteenth century. Both passed through the workshop of the great restorer and imitator of antiquity Batolomeo Cavaceppi, and one is rightly hesitant about the products—life-size, miniatures, gems—of his workshop. But the artistic quality of the small bust is superb and finally tips the balance towards a favorable appreciation.

95 This head of a bearded man offers a problem, one of dating if not authenticity. The possibility of an intentional fake can be discounted. The surface is clearly older than one and a half centuries. Anyhow, the art is incompatible with the neoclassical style of the late eighteenth and early nineteenth centuries. The only clearly modern detail is the plastic indication of the pupils, and that must be a later addition. The rendering of the hair resembles the works of the late first century A.D., but the psychology of the man is later; it is intellectual with some emotional weight from older Roman values. A moderate visionary, one could say, and this points rather to the later third century. A sharp cylindrical hole in both ears may have been destined to hold a metal wreath. This technique is common in imitations of antiquity but rather rare in genuine ancient heads (although see no. 32). With some regret, since the face is not without its attractions, one feels obliged to leave the piece unclassified.

Figure 18. *Bronze sestertius of Philip the Arab. Getty Museum, 79.AI.26.*

95. Head of a bearded man

The portrait may be ancient, but identification is difficult, partly because of modern recutting of the eyes.

96. "Cicero"

Carved by an early sixteenth century Florentine sculptor, the head reproduces the portrait of the great orator created during the Renaissance.

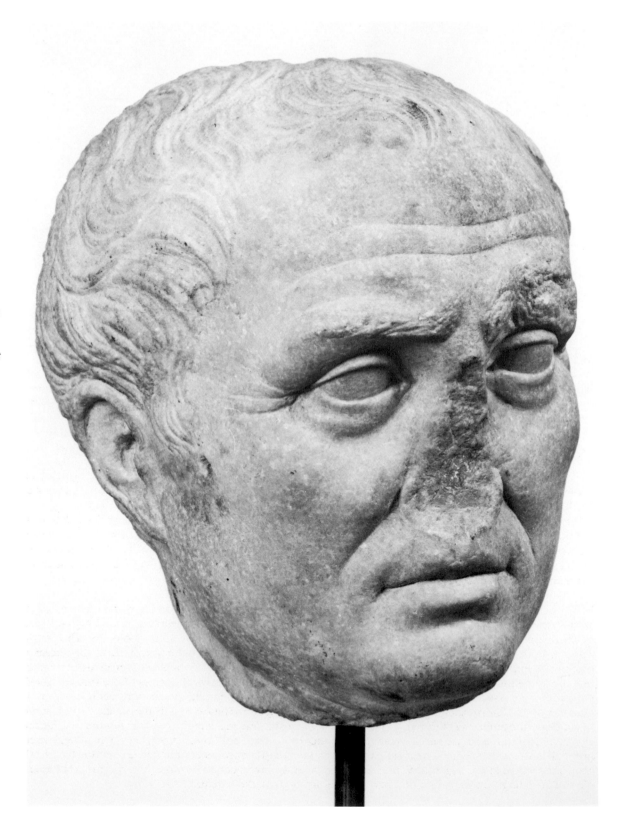

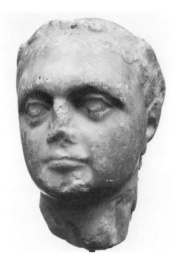

97. **Small alabaster wreath-ed head of Domitian (81–96)**

Late eighteenth century, probably Venetian, work. Created probably as part of a set of Roman emperors.

SPURIA

96 Contrary to the other pieces in this section, the head of "Cicero" is not an intentional forgery. Even though it is not an antiquity, it provides an eloquent image of how the Renaissance was trying to revive the *uomini famosi*, the likeness of great men of the past. In fact, this indisputably fine portrait of Cicero is based on an inscribed bust now in Apsley House, where the core of the head remains to some small extent ancient while the inscription was the creation of sixteenth-century humanism. All the other replicas and variants of the same face must be later, from the Baroque period through the nineteenth century, but the Getty piece is probably a Florentine carving from the very beginning of the sixteenth century.

What makes the piece non-ancient? First, the carving which is very precise and sharp, preferring contours to volumes, and, at the same time, expression to organic cohesion. Next, the single strands of hair are cut into the skill rather than modeled, and their pattern does not grow well from the head. Also, the protrusion of the ears compressed into one plane is contrary to the ancient feeling for this very subtle part. Finally, the presence of the man is very different from the conscious limitations of a true Roman: he must have read Machiavelli's *The Prince*, too subtle for the real Cicero.

It may also be restated here that the present curator, having no opportunity to check the original, fell into the trap of a pleasant photograph and thought the piece was ancient. This event provided constant subject for pleasantries for Mr. Getty, unspoiled even by the later revelation that the piece was of some merit after all. It still provides good testimony of antiquity as the feeding ground not only of Renaissance art but also of contemporary individualism.

97 Several small heads with laurel wreaths, thus intended as images of Roman emperors, belong to the same workshop. They are scattered through several European museums. The features of some of them seem to represent members of the Julio-Claudian dynasty, if not Caesar himself. Ours looks like a Domitian. Another in the museum in Torcello has been recently baptized Balbinus. Others seem to archaeologists to represent members of the Tetrarchy. In itself this could be quite correct. Through all Roman history, but especially in the third century A.D., commemorative coins and medallions with images of the former "good" emperors were issued, and retrospective effigies can be identified among extant portraits (like our third Caesar, no. 7). Unfortunately, this is not the case with this group. The carving of the Malibu head is surely not ancient: the rendering of the hair is like a sharp, schematic drawing, and the modeling of the face, lacking any bony scaffold, is rather flaccid. Also the alabaster-like marble has no exact parallels in genuine, ancient material. It seems then evident to assume that the whole group is a product of the Baroque period by a workshop somewhere in the region of Venice, probably without any intention of forgery. It was just a late example of illustrating Roman history and personalities for dedicated dilettanti.

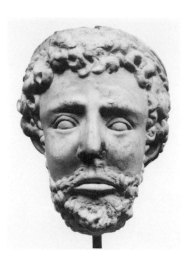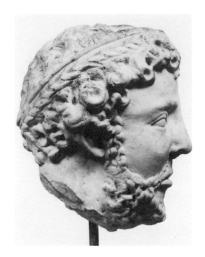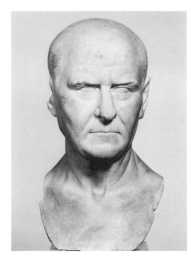

98. Bearded head

A recent forgery unsuccessfully imitating portraits from the third quarter of the second century A.D.

99. Modern bust imitating a Roman portrait

The man's hair style reproduces the fashions of the third century A.D. while the style of the rest vacillates between that period and the time of the Republic.

98 The contorted features of this head reveal a rather poor and frankly incompetent fake. It pretends to give the impression of a man from the Antonine period, with the hair, beard, and perhaps even expression following the example of Marcus Aurelius (no. 61). But it fails miserably even as a simple image of a human face. The anatomical details simply do not hold together, and the carving lacks competence. However, it has its special moments. It comes from a workshop supposedly in the region of ancient Ephesus, whose countless successful products abuse the credulous tourist.

99 The next fake is no less instructive. Here the forger betrays himself, mixing the stylistic elements of two different periods of Roman art. The ruthless depiction of the man's age wants to be Republican, while his picked hair points to the second quarter of the third century. The workmanship of the back is also not ancient, and the back view of the piece generally betrays its modern date (frequently it is in an unusual view of a forgery that a forger betrays himself). The result is a rather ambivalent personality, combining a respectable old-fashioned gentleman with some doubtful if not crooked characteristics.

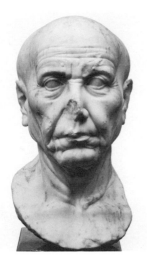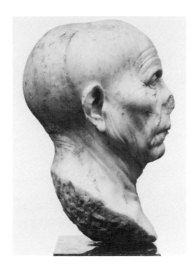

100 Often a fake in some ways provides a more convincing statement than an authentic piece. This venerable Republican appealed not only to Mr. Getty, who purchased him personally just before World War II with the enthusiastic approval of the renowned authority on Roman portraits, Ludwig Curtius, director of the German Archaeological Institute and in his time the authority for Roman portraits, but also to other archaeologists who continue to admire and defend the piece. The forger proceeded methodically. Indeed,the wrinkled, slightly caricatured face reproduces the funerary relief of P. Aiedius and his wife found in Rome after the middle of the last century. The original (fig. 19) dates in the time of Augustus and is a vigorous image in the Republican tradition. The forger has given perhaps a little too much emphasis to the wrinkles, anatomical distortions, and folds of skin. Too much insistence turns them into a stone mask, lifeless in the end. For the nape and back of the head the forger was without a direct model, and here the unorganic appearance clearly denounces the final product. Confrontation of the prototype and the imitation is most eloquent. Some elements of nineteenth-century vision directed the modern chisel, producing some technical peculiarities incompatible with a genuine antiquity, as for example the spherical eyeballs. Also, the shape of the cone for insertion and the surface do not correspond to ancient standards. Overall, the piece is dramatic witness of how the nineteenth and early twentieth centuries could find their own image in the faces of venerable Republican men.

100. Modern imitation of the head of P. Aiedius

Based on a Roman funerary relief in Berlin.

Figure 19. *Detail of the head of P. Aiedius from his funerary relief in Berlin. Photo courtesy of E. Gazda.*

SUPPLEMENTARY INFORMATION

1. Roman General, possibly L. Cornelius Sulla
73.AB.8
Bronze,
H: 0.28 m.

Neck edge made to be fitted to a statue body: viz. rectangular notch that survives on nape. Generally excellent condition. Lips probably originally inlaid with copper but now missing. Some small chips and holes in right ear and in hair. Ancient rectangular repair has fallen out of right side of neck. *JPGM,* cover, p. 37; *Guidebook*, 1980, p. 35 ill.; Vermeule, no. 111.

2. Young man from Asia Minor
74.AA.10
White grained Asia Minor Marble,
H: 0.318 m.

Acquired in Smyrna about 1912/ 13 by Harold W. Bell, where it was seen with a replica. Formerly in the collection of Sir Ashley Clarke. Made for insertion in a statue; the conical lower edge of the neck well preserved. Tip of nose, lower lip and ears broken off. Surface washed by acid during previous restoration. G. M. A. Richter, *The Portraits of the Greeks*, 3, 1955, p. 279, figs. 1979–1981 (as Euthydemos II of Bactria); Christie's, 11 July 1973, no. 200; *Recent Acq.*, no. 19.

3. Terracotta girl
80.AD.142
Presented by Malcolm Wiener
Terracotta,
H: 0.26 m.

Broken off a bust (?). Tip of nose and part of hat chipped. Forehead, lips, and chin abraded. The original polychromy is gone, leaving only the overall red coarse clay. Note the low-set ears, a violent contradiction to the naturalism of the rest of the piece. Christie's, 24 April 1978, no. 478.

4. Terracotta head of a youth
75.AD.103
Anonymous donation
Terracotta,
H: 0.184 m.

Broken into several fragments and restored. The front of the face, including the nose, is well preserved, but sections of the sides of the cheeks in front of both ears are missing and also a triangular section on the top of the head. Much of the original polychromy survives: black on the hair and eyebrows, red on the face and ears (extended onto the modeled hairline), darker red under the eyes and around the nostrils for modeling. The back of the head is painted but far more cursorily modeled than the front. The large ears, pouting mouth, and prominent nose give a strong impression of immediacy. *Unpublished.*

5. The McLendon Caesar
78.AA.266
Presented by Gordon McLendon
White marble with large crystals, probably Thasian,
H: 0.27 m.

Face worn, numerous chips. Nose, mouth, eyes, cheeks and forehead severely battered and encrusted, but careful and elaborate modeling of facial features still evident. Fresh gash along left temple and cheekbone. Richmond, no. 55; UCSC–LMU, no. 2.

6. The Blücher Caesar
75.AA.46
Pentelic marble,
H: 0.365 m.

Made for insertion in a *capite velato* statue, as behind the ears the occiput was not finished and the back of the hair was only roughly indicated. Nose, left cheekbone, part of center of hair, and right ear broken off. Many other chips. Surface bruised and washed. J. Frel, Getty *MJ* 5, 1977, pp. 55–62; *Guidebook*, 1980, p. 39, ill.

7. The Getty Caesar
73.AA.46
White large grained marble from Asia Minor,
H: 0.535 m.

An origin in the northern part of western Asia Minor has been suggested. Ex-collection Breusch.
Made to be inserted in a togate statue, and thus intentionally not finished behind the ears. Over life-size. Nose broken off; lips, chin, ears chipped. Surface cleaned with acid. J. Frel, Getty *MJ*, pp. 55–62; E. Alföldi-Rosenbaum, *XI International Congress of Classical Archeology, Acts*, London, 1978, p. 978; Inan-Rosenbaum 2, pp. 53–55, no. 1, pl. 1, 1–4.

8. Bearded man
78.AA.7
Carrara marble,
H: 0.365 m.

Head made with a rounded neck base for insertion into a draped statue, as there is a fragment of drapery on the back left of the neck. The surface, originally covered with a disfiguring root mark patina, was cleaned by the museum (test patches preserved). A large chip under the left eye has been filled. The tip and bridge of the nose damaged; other scattered chips. Behind the right ear is a deep undercutting, much more than necessary to free the ear from the skull. The back of the head is not as well finished as the rest. The hair is a loose mass of large curls, the locks waved forward on the neck in Augustan style. UCSC–LMU, no. 3.

9. Bust of an elderly man
79.AA.176
Presented by Mr. and Mrs. Milton Gottlieb
Low-grade Carrara marble,
H: 0.323 m.

Bust made for insertion; its shape and treatment point to a *cippus* rather than a statue. Some root marks and traces of incrustation, especially on the bust; water corrosion on the backs of the shoulders. Without a doubt, the portrait was intended to be seen from the front only: the back of the head, neck, shoulders, and rims of the ears are very roughly worked. The missing upper part of the head was worked separately and joined with an iron pin set in lead; half of the metal is still stuck in the rectangular cavity and its rusting has started to split the marble. The concave bottom "cone" is picked for adhesion. The bottom and sides were worked roughly with a pick. Richmond, no. 54; UCSC–LMU, no. 1.

10. Funerary relief of Popillius and Calpurnia
71.AA.260
Italian marble with strong, dark veins,
H: 0.635 m.; W: 0.89 m.;
depth: 0.203 m.

From Rome
Surface weathered, especially on left side; some damage to the edges and the inscriptions. The two figures are in good condition except for the broken noses and some chips, especially on Popillius' toga.
Inscription:

C·POPILLIVS·Ɔ·L CALPVRNIA·Ɔ·ET
SALVIVS OCTAVI·L· NICE

Penn., no. 17; *JPGM*, p. 43; *Cat.*, no. 84; E. K. Gazda, Getty *MJ* 1, 1974, pp. 61–72, fig. 6.

11. Funerary relief of a man
73.AA.56
Italian marble,
H (head): 0.18 m.; H (whole):
0.57 m.

Only the left part of the relief preserved. The face has been badly battered. Carving of the background between the right shoulder and the edge unfinished. Traces of red polychromy preserved on the tunic of the man. *Portraits*, no. 16, ill.; E. K. Gazda, Getty *MJ* 1, 1974, pp. 61–72, fig. 1.

12. Elderly woman
80.AA.73
Carrara marble,
H: 0.205 m.

Yellowish brown patina. Nose and right ear broken off. Many chips on the left side of neck and on the hair; missing knot on back of head. *Unpublished.*

13. Matron, perhaps Atia, mother of Augustus
72.AA.112
Italian marble,
H: 0.30 m.

Head worked separately for insertion into statue (turned to its right). Yellowish patina overall, with some more recent brown spots on the neck; battered. Hair knot broken off in 1980 and reattached by the Conservation department. Fresh chips, especially at front of hair, left side of nose and mouth, front of neck; older small chips and scratches on hair and nape. The same strongly modeled face can be traced to at least four other variants (Arezzo, Smyrna, two on the art market). Ours was found together with a male head now in Munich which is identified as Augustus' father and known in three replicas (D. Ohly, *Münchner Jahrbuch* 22, 1971, pp. 227 f.), the best of which is Ny Carlsberg Glyptotek 600 (V. Poulsen, *Portraits romains* I, pp. 41 ff., no. 2). *Portraits*, no. 17, ill.

14. Augustus
L78.AA.40
Anonymous loan
White Carrara marble,
H: 0.31 m.

Nose once restored (now missing) and the surface repolished. The otherwise apparent good condition is due to some slight recutting, including both ears, eyebrows, upper lip, bridge of the nose, and the lower eyelids. Sotheby's, 3–4 July 1978, no. 98, p. 14.

15. The Nilsson Augustus
78.AA.261
Owned jointly with the Antikenmuseum, Basel
Very fine Pentelic marble,
H: 0.39 m.

From Agnone (Molise), from a Samian-Roman site. Formerly in the Martin Nilsson (Sweden) collection. Carved for insertion. Tip of nose and edges of ears chipped. Some retouching of the surface. Oriented to its right. H. P. L'Orange, *Dragma M. Nilsson*, 1939, pp. 288 ff., figs. 1, 2, 4, 5; Christie's, 10–11 July, 1974, no. 203; *Die Bildnisse des Augustus*, Glyptothek München, 1978, p. 75, no. 6.10.

16. Fragment of a statue of Livia

73.AA.50

Fine grained white marble,

H: 0.535 m.

Said to be from Southern Italy, where it was used in the nineteenth century as the image of the Virgin in a church.

Break across the left shoulder through the center of the breast: oriiginal piece of marble restored and surface partly recarved. The nose restored in marble. Section of the left shoulder and left side of the veil restored in marble and now removed. The eyebrows, eyelids, mouth, and hairline recarved, and the surface washed. *Unpublished.*

17. Bust of Livia

74.AA.36

Presented by Heinz Herzer

White Carrara marble,

H: 0.405 m.

Back of the left side of the head sheared off. The bottom edge originally joined to a stand, possibly with a tablet. The simple, undraped bust, extended to just below the collarbones, is of a type common in the early Empire. Old damage to the lower edge of the bust. The nose and mouth battered, chips scattered on the right cheek and the back of the neck. Only the tips of the earlobes survive.

The coiffure is a variant of the dignified nodus hairstyle in which Livia was more frequently presented to the public (cf. Bartels, *Frauenporträt*, pp. 29–48). V. Poulsen's type D, *Portraits romains* I, p. 68, dates perhaps in the first century B.C. Livia, after the death of Drusus Major, was then nearly 50. The distinction is that the hair is in two waves only at the sides of the head, and the nodus is braided back and over the crown (see Felletti Maj, no. 87 (Terme) and *EA* 3109–11 (Marbury Hall). Richmond, no. 56; UCSC–LMU, no. 4.

18. Bust of an Augustan Lady, perhaps Octavia Minor

72.AA.106

Italian marble,

H: 0.54 m.

Slightly over life-size. The draped bust includes the collarbones and part of the breast. The greater part of the nose and the outer edges of the ears are lost as well as a large chip from the chin. Otherwise, the bust is in excellent condition, the surface marred only by small chips and minor abrasions in the areas of the right eye, mouth and along the outer edges of the draped bust. Head turned slightly to the right. Slight use of drill for the curve of the mouth and eye orbits.

The closest comparison is clearly the portrait bust in the Ny Carlsberg Glyptotek no. 1282 (V. Poulsen, *Portraits romains* I, no. 41). *Cat.*, no. 55 (perhaps Livia or Antonia); *Portraits*, no. 18 (as Octavia Minor); P. K. Erhart, Getty *MJ* 8, 1980, pp. 117–128 (as Octavia Minor?); *Guidebook*, 1980, p. 27, ill.

19. Young woman

72.AA.129

Fine crystalline marble,

H: 0.245 m.

The nose broken; some chips on lips, cheeks and hairline. Knot at base of neck broken off. Drill used in the hair. *Portraits*, no. 20.

20. Small head of a woman

77.AA.74

Presented by Gordon McLendon

Large crystalline Italian marble,

H: 0.128 m.

The flattened bun seems to point to a head from a relief, and it also indicates the precise view of the head, three-quarters from its right. Fine drill work in the part of the mouth and the strands of the hair. *Unpublished.*

21. Fragmentary head of Tiberius

74.AA.35

Presented by Jeanette Brun

White homogenous marble,

H: 0.24 m.

Diagonal cut across left top of head resulting from secondary use in antiquity. The back of head from behind right ear to center left broken off at a later time. Big chips missing from the right side of the chin, left temple and cheek; small chips on both cheeks and in the hair. There were three periods of damage: 1) ancient: crown, nose and left temple; chin and lower lips reworked to minimize damage and attach restoration. Also, the left eye, ear, and left part of hairline recut at same time; 2) break to back of head and ears; 3) modern scattered chipping. White incrustation remains on the left side of the neck, broken back of head and hair.

The portrait corresponds to Polacco's *Imperium Maius* type created in the first part of Tiberius's reign (Polacco, pp. 125 ff., especially Ny Carlsberg Glyptotek 624, *ibid*, pls. 19–20; *Gnomon* 31, 1959, p. 524). Richmond, no. 57; UCSC–LMU, no. 5.

22. The Lansdowne Tiberius

71.AA.275

Pentelic marble,

H: 0.292 m.

Formerly in the Lansdowne collection, attached to a nude statue to which it did not belong (present whereabouts unknown).

The nose, right earlobe, and tip of the chin restored in the eighteenth century, and now removed. Small chips on left eyebrow and right side of forehead. The surface has been slightly overcleaned and recut in places, especially the lips and the lower eyelids. Clarac, 2356 C, pl. 925; Michaelis, p. 444, no. 28 (as Tiberius); J. J. Bernoulli, *Römische Ikonographie* II, 1886, p. 153, no. 49; Reinach, *Rép. stat.*, I, p. 568; *EA* 3054/ 5; Sotheby's, 5 March 1930, no. 111 (Whole statue); Polacco, p. 129, note; Sotheby's, 13 June 1966, no. 178 (whole statue); *Cat.*, no. 56; *Portraits*, no. 19 (bibl.).

23. Germanicus

71.AA.285
Pentelic marble,
H: 0.345 m.

The nose, chin, and left ear were once restored (see fig. 14) but now removed. The head, which after the removal of the restorations looks mutilated, was broken from a draped statue, and the back is unfinished since it was not meant to be seen. At some point the face was washed with acid, causing the partial loss of both moustache and sideburns. The outer corners of the eyes were enlarged by modern recutting. The drill was used to part the lips, in the inner corners of the eyes, and in the separation of the hairline, neck, and veil. Scattered chipping.

The type, with veil, sideburns, and broad modeling, is closest to Corinth Museum 137 (published as Drusus Caesar in Kiss, figs. 499–500) and to Ephesus, Selçuk Museum (Inan-Rosenbaum 1, no. 18). *Catalogue*, Malloy Gallery, New York, 1971, no. 125, cover; *Penn.*, no. 15; *Cat.*, no. 57 (as Caligula?); *Portraits*, no. 20; *UCSC–LMU*, no. 6.

24. Caligula

72.AA.155
White crystalline marble (Thasos?),
H: 0.43 m.

From Asia Minor

The head was made for insertion in a togatus statue, as evidenced by a bit of drapery carved at the left side of the neck. The point of the nose battered; ears partially broken off, and the chin slightly bruised. Rootmarks, especially on left side. Otherwise well preserved. H. Jucker, *Art in Virgina*, 13, 1973, p. 20, fig. 13; *Die Bildnisse die Augustus*, Glyptothek München, 1978, p. 96, no. 10.7 (P. Zanker); Inan-Rosenbaum 2, pp. 69–70, no. 16, pls. 13. 3,4; 14. 2,3 (bibl.).

25. Plaster head of a man

79.AA.114
Plaster,
H: ca. 0.285 m.

Said to be from Southern Italy.

Put together from several pieces; still in the process of conservation. Part of the chin, part of the left eyebrow, and the tip of the nose missing. Chips overall. The plaster itself is aged, guaranteeing authenticity. *Unpublished.*

26. Claudian togatus

76.AA.7
Carrara marble,
H: 1.78 m.

Head broken off and then repaired in antiquity with an iron pin. Another iron pin repaired the right forearm. Left hand missing; numerous chips and breaks on the narrow clavus, and on the lower part of the drapery. At the left side, a large conical support unfinished. Sides of the drapery show traces of the pick. In the chief folds there is clear use of the drill. *Unpublished.*

27. Antonine togatus

79.AA.77
Presented by Bruce McNall
Marble,
H: ca. 1.52 m.

The head, right forearm and hand, and left hand were made separately and are now missing. Broken at the level of ankles and support and put back together. Two large holes due to corrosion (?) at the groin level. Large chip on plinth between feet. Slight damage to edges of drapery overall. *Unpublished.*

28. Seated priestess of Cybele

57.AA.19
Coarse island marble,
H: 1.62 m.

Purchased by Mr. Getty in 1957. During the sixteenth century, in the Mattei collection in Rome; purchased by Gavin Hamilton for the first Marquis of Buckingham, then acquired by the Lonsdale collection, Lowther Castle, in 1848.

In 1975, D. Rinne removed the modern restorations, including the bottom of the cornucopia (non-extant in Clarac, thus done in the nineteenth century), part of the left hand and the nose (probably both eighteenth century restorations), and cleaned the surface. There were two modern (nineteenth century?) additions to the base; the front was removed in 1974, but the back has been kept for stability. Originally, the statue must have stood in a niche, as the back of the throne and the top of the head are only cursorily finished. A large square hole in the back was made in modern times for ease in transport. Clarac, *Musée de Sculpture*, III, 396 A, fig. 664 E; Michaelis, p. 498, no. 68; Reinach, *Rép. stat.*, p. 183, fig. 2; M. Bieber, *The Statue of Cybele in the J. Paul Getty Museum*, 1968; *JPGM*, p. 46; *Cat.*, no. 58; *Guidebook*, 1980, p. 40, ill.

29. Agrippina the Younger

70.AA.101
West Asian marble,
H: 0.32 m.

Purchased by Mr. Getty in 1939.

The head was probably broken off an over life-size statue. The tip of the nose missing; chips on cheeks, forehead and in the right side of hair. On the right side of the head is a rectangular cut, perhaps to anchor a separate headdress, although the left side has no corresponding marks. The drill was used lightly for the nostrils, corners of eyes and mouth, and in the hair.

Many replicas of this type exist. *Collector's choice*, p. 84, 234–238 (found in the tunneling for the Rome underground); C. Vermeule, *Proc. Phil. Soc.*, 108, 1964, p. 106; W. H. Gross, *Julia Augusta*, 1962, pp. 114 f., pl. 23.2; *Cat.*, no. 54; *Portraits*, no. 22 (with previous bibl., wrongly called Agrippina Major.)

30. Nero
L78.AA.6
Anonymous loan
Marble, with large crystals, from
Asia Minor,
H: 0.34 m.

Apparently broken off of a statue. Surface much worn and pitted. The nose and chin severely chipped. *Unpublished.*

31. Man from Alexandria
79.AA.135
Parian marble,
H: 0.28 m.

Ex-collections Fouquet, E. Brummer.
Broken off through the middle of the neck. Nose damaged. The top and back of the head worked flat and pierced by a cut for a large vertical tenon in the neck. *La Collection Fouquet*, Galerie Georges Petit, 12–14 March, 1922, no. 133; *The Ernst Brummer Collection, Ancient Art*, Galerie Koller, 16–19, October 1979, no. 642.

32. Galba
74.AA.37
Presented by Mohammed Yeganeh
White marble, with large crystals,
from Asia Minor,
H: 0.287 m.

A dark vein running through the marble gives a false impression of the jawline. The nose and ears missing; the mouth chipped. This piece was intentionally cut off its background in antiquity, as can be seen from the reverse. A metallic laurel (?) crown was added over the bald skull, held in place by pins in holes above the middle of the forehead and above the nape (in which there is still a piece of metal). Some indications of short hair may have been painted on the skull. E. Bielefeld, *Kunstwerke der Antike, Gallery of Greek, Roman and Byzantine Art*, Frankfurt, n.d., no. 10; *Rec. Acq.*, no. 21; J. Pollini, Getty *MJ* 5, 1977, 63–66; S. Bailey, Getty *MJ* 5, 1977, 107, no. 2.

33. Vitellius
80.AA.156
Presented by Mr. and Mrs. Milton
Gottlieb
Crystalline marble,
H: 0.36 m.

Said to be from Southern Italy.
Made for insertion in a statue. Intentionally mutilated in antiquity. The chin and nose missing; also, hits on the forehead and left eyebrow. The occiput broke following the grain of the marble after a blow at the same time. Other scratches and chips over the surface of both ancient and more recent date. The preserved surface on the left is slightly more weathered. *Unpublished.*

34. Unfinished head of Domitian
75.AA.26
Presented by Bruce McNall
White marble with large crystals,
H: 0.425 m.

Unfinished. The long neck ends in a large cone for insertion into a pre-existing statue body. The technical evidence demonstrates that the manufacture was according to traditional means. First the carver used the pick, traces of which can be seen on the nape and on both sides of the ears (which were left intentionally as bosses to prevent their breaking during the early stages of carving). The claw chisel was then used; its marks survive on the cap of short hair and in traces on the sides of the forehead and on the summary eyeballs. The drill was used only minimally for the exterior eye corners and the corners of the mouth. The central part of the face, vital for the expression, was worked from forehead to chin by flat chisel to give a preliminary suggestion of the muscle structure. Over the centuries, the lips and tip of the nose were damaged, and there are extraneous scratches on cheeks and chin. UCSC–LMU, no. 7.

35. Torso of a cuirass statue
71.AA.436
Pentelic marble,
H: 1.075 m.; W: 0.425 m.

Made to have a portrait head inserted. Lower legs, head, right arm, left elbow, and back of left upper arm were carved separately and inserted with iron pins (removed by the conservation department in 1975). The sword hilt was also attached with an iron pin that rusted and exploded in 1975. The fingers of the left hand broken off. The back of the statue was not fully finished, suggesting it was carved to be displayed in an architectural setting.
The upper pteryges represent (from the back): inverted palmette, five leaf palmette, elaborate palmette, gorgoneion, helmet (?), eagle with rabbit, opposing rams heads, palmette under the edge of the baldric. The lower pteryges: palmette, rosette, palmette, rosette, palmette, large palmette, opposing rams' heads, gorgoneion, gorgoneion, opposing rams' heads, palmette, blank. *JPGM*, p. 48; *Cat.*, no. 60; C. C. Vermeule, *Berytus*, 23, 1975, pp. 12–13, no. 113 B, figs. 1 & 2; K. Stemmer, *Untersuchungen zur Typologie, Chronologie und Ikonographie der Panzerstatuen*, 1978, no. 270.

36. *Julia Titi*
58.AA.1
Italian marble,
H: 0.33 m.

Ex-collection Ludwig Mond. Purchased by Mr. Getty in 1958.
Exceptionally well preserved, including the nose. The restorations were removed in 1973. Some chips on the surface of the hair and the diadem, some damage to the pupil of the right eye. Surface slightly weathered. Metal earrings were originally inserted into the drilled holes of the earlobes. *EA* 5976; G. Daltrop, et. al. *Die Flavier* pp. 116f., pl. 49. a.c.; *Joys*, p. 77, ill.; *JPGM*, p. 47; *Cat.*, no. 59 (bibl.); *Portraits*, no. 23, ill.

37. *Fragment of a statue of a Flavian matron*
72.AA.122
Coarse grained marble with grey veins,
H: 0.83 m.

Major crack from the right upper arm to the left side of the neck; another crack over the right shoulder which is broken off and restored. Other minor cracking to the drapery and across the eyes. Preserved above line of right hip to left elbow in the pose of the Large Herculaneum Woman. Inan-Rosenbaum 2, pp. 329–330, no. 328, pls. 237, 1; 238, 1, 2.

38. *Fragment of a statue of a Flavian girl*
72.AA.123
Coarse grained marble with grey veins,
H: 0.74 m.

Preserved in back above the elbows, in front, above the breasts. Younger relative of the previous statue (?) in same pose (?). Lower part of the nose broken off. Abrasions to the lower lips, right eye, forehead and cheek. Some chips in hair and drapery. The claw chisel was used for the hollow around the neck and the drapery folds. Inan-Rosenbaum 2, pp. 330–331, no. 329, pls. 237, 2; 238, 3,4.

39. *Bust of a Flavian woman*
73.AA.13
Fine grained, yellowish Carrara marble,
H: 0.68 m.

Exceptionally well preserved, including ancient socle. The head broken off in a diagonal line across the neck and restored. Bust includes shoulders and breasts with tablet on drum base. The tip of the nose, and the edges of the lips battered. Traces of red polychromy in hair. Drill used for drapery folds, curls, hairline, nostrils, and the corners of the mouth. *Portraits*, no. 24.

40. *Woman*
73.AA.57
White Italian marble with small crystals,
H: 0.28 m.

The sculpture has suffered badly; not only the chin and nose but also part of the left side of the coiffure is lost. Broken at the neck; the chin, left ear, lips and nose broken off. *Portraits*, no. 25.

41. *Trajanic woman*
73.AA.35
Carrara marble,
H: 0.365 m.

The nose formerly restored and now removed. Broken edge of neck trimmed and smoothed at the same time restoration made. Large chips missing from left side of hair knot, right side of front coiffure. Small chips above right eye, on both cheeks, and in the elaborate coiffure. Parke-Bernet, 24–25 April 1970, no. 215, ill. p. 104; *Portraits*, no. 27; UCSC–LMU, no. 8.

42. *Plotina*
73.AA.129
Presented by Jeannette Brun
Gray Carrara marble with large grains,
H: 0.305 m.

Originally from a statue. Surface overcleaned at some time. The nose, upper lip, and ears broken off. Many scattered chips. The drill was used for the parting of the lips, nostrils, contours of the eyes, eye sockets, and around the hairline. Very strong chisel strokes indicate the strands of the band of hair above the forehead. The puntello at the back proves that this is a replica of an official type. Richmond, no. 60; UCSC–LMU, no. 9.

43. *Sabina*
70.AA.117
White medium crystalline (Carrara?) marble,
H: 0.405 m.

Purchased by Mr. Getty in 1953.
Head and veil made for insertion in a statue as evidenced by the rounded neck edge. Restored back of head removed in 1974. Lower left edge of mantle broken and reattached. Surface badly weathered. The nose and chin battered and slightly sugary. Chips on the forehead, lips, and left cheek. Drill used for the nostrils, inner ears, earring holes, and holes on sides of veil to attach metal crown. *Cat.*, no. 37; *Portraits*, no. 31; F. Yegül, Getty *MJ* 9, 1981 forthcoming, fig. 5.

44. *Bust of Sabina with diadem*
70.AA.100
West Asian marble,
H: 0.43 m.

Bought by Mr. Getty in October 1939 from Barsanti (Rome).
Surface once washed with acid and then waxed; in 1973 the wax was removed. Severe acid damage to the left side of the forehead, right cheek, and the center of hair. Chips on edge of the diadem and on drapery. Drill used for the nostrils, corners of mouth and eyes, inner ears, and knot of hair at the back of the head. J. P. Getty, *The History of the Oil Business of G. F. & J. P. Getty*, 1941, pp. 488–492; A. Carandini, *Vibia Sabina*, 1969, pp. 185–186, no. 51, figs. 226–7; *Cat.*, no. 64; *Portraits*, no. 30 (bibl.); *JPGM*, p. 59.

45. *Antinous*
71.AA.440
White large grained marble from Asia Minor, H: 0.343 m.

Broken off at the top of the neck, so that only the head remains. The nose, earlobes, and chin missing; many chips and bruises scattered over the surface, but particularly serious on the lips, eyebrows, and curls of hair. *Cat.*, no. 71.

46. *Boy*
55.AA.8
Coarse Asia Minor marble,
H: 0.273 m.

Restored in 1955, when both cheeks and chin were patched with a fill of plaster and marble powder. Recently the restoration was replaced with more discreet plastic, but it is still hard to visualize the original surface. A brownish stain further disfigures the hair. *Joys*, p. 73, ill.; *Cat.*, no. 66; Inan-Rosenbaum 2, p. 329, no. 327, pls. 236.3, 4 (the last before cheeks were restored).

47. *Bearded man*
71.AA.286
Yellowish marble with small crystals, probably Pentelic,
H: 0.33 m.

The nose and beard are partly missing; a crack runs from the chin through the mouth to the left cheek, distorting the expression. The face is badly chipped, including the eyebrows, forehead, and both ears. The back of the head is less finished than the front. Penn., no. 16; *Cat.*, no. 63 (as philosopher); *Portraits*, no. 28.

48. *Barbarian*
70.AA.123
Carrara marble with dark veins,
H: 0.46 m.

Head made for insertion into a statue. The tip of the nose missing; back of head left rough. Surface, with the exception of the back of the head, recut in modern times. Drill used for the curls, sideburns, corners of eyes, nostrils, and parting of lips. *Cat.*, no. 62.

49. *Sarcophagus of a boy with Erotes and griffins*
74.AA.25
Gray crystalline marble,
H: 0.45 m. (including the lid),
L: 1.16m.

Lid does not fit perfectly, but nevertheless belongs. *Recent Acq.*, no. 13.

50. *Lid of a sarcophagus with a reclining girl*
73.AA.11
Marble,
H: 0.37 m.; W: 1.41 m.;
Depth: 0.47 m.

Chips on right shoulder of tunic and at hem. Otherwise in very good condition. Gold earring originally in earlobe preserved separately. Robin Symes, *Ancient Art*, 1971, p. 17, ill. (head only); *JPGM*, p. 43, ill.

51. *Statue of a Hadrianic lady*
72.AA.94
White fine crystalline marble,
H: 1.143 m.

Statue preserved from mid-thigh up. Left hand missing, right elbow and hand broken off; otherwise only some old chips on the edges of the drapery. The head was worked separately from finer marble and inserted. The face was overcleaned. Nose and ears lost; marks of the pick or plow that unearthed the sculpture can be seen on the left cheek. Minneapolis, no. 9; *JPGM*, p. 57; *Cat.*, no. 61; *Portraits*, no. 29, ill.; Inan-Rosenbaum 2, p. 331, no. 330, pls. 237.3; 239; Nagle, p. 317, ill.; Vermeule, no. 265.

52. Statue of Faustina the Elder
70.AA.113
Asia Minor marble,
H: 2.09 m.

Bought by Mr. Getty from Spink in 1952. Ex-collection Wilton House, possibly via purchase from the Arundel collection in 1678 (the method of restoration seems to correspond to this date).
Restored parts, including the nose, chin (lower part of chin in plastic), right index finger, and hair knot were removed in 1975. The attribute held in the right hand broken away. Two puntelli remain on the left side. Another puntello supports the end of the drapery on the left flank. The plinth has the sides carved with a pick. Modern inscription between the feet: FAUSTINA SENIOR. The hole midway between feet may be ancient, corresponding perhaps to a metal extremity of the attribute once held in the left hand. The surface of the face has been slightly repolished, especially on the right side. The lower eyelids, especially the right one, recut. Michaelis, pp. 671–3, no. 1d, no. 3; Wegner, *Antonines,* p. 166; *JPGM,* p. 62; *Cat.,* no. 68; M. Bieber, *Ancient Copies,* 1977, p. 151, 160, figs. 697–698; Inan-Rosenbaum 2, pp. 106–7, no. 55, pl. 49.

53. Bust of a matron
79.AA.118
Marble,
0.53 m.

Said to be from Alexandria.
Both sides of the bust were broken off in antiquity, but the rear strut is largely intact. Old damage to the nose, upper lip, left eye, and ears. Several small fresh chips in the hair and drapery. Otherwise in very good condition. *Unpublished.*

54. Antonine woman on modern bust
71.AA.265
Carrara marble of two different kinds,
H: 0.66 m.

Ex-collection Lonsdale, Lowther Castle.
All of the bust, most of the knot of hair, and the tip of the nose are eighteenth-century restorations. The hair and bust were worked in different marble than the portrait; but the tip of the nose was restored in the same marble, probably taken from inside the neck. The surface was entirely reworked; even the strands of hair were recut. The engraved eyebrows are gone, the lips are thinner than originally, and the chin is more pointed. Both irises and pupils are indicated. The drum pedestal dates from the eighteenth century. Sotheby's, 1 July 1969, no. 263; *Cat.,* no. 67; *Portraits,* no. 34.

55. Antonine woman
72.AA.117
Carrara marble with medium crystals,
H: 0.275 m.

Head made separately for insertion. The tip of the nose is broken, but otherwise well preserved. Yellow-brown patina and rootmarks overall. The surface is slightly weathered, especially on right side. The knot of hair was worked from a separate piece of marble and attached. The drill was used for the nostrils, pupils, inner ears, parting of the lips, and upper eyelids. The occiput was worked separately in antiquity. *JPGM,* p. 65; *Cat.,* no. 70; *Portraits,* no. 37 (ill. by mistake as no. 34); Vermeule, no. 277 (as probably Faustina Minor).

56. Woman
78.AA.332
Presented by Mr. and Mrs. Milton Gottlieb
Marble,
H: 0.273 m.

Ex-collection Alphonse Kahn.
Excellent condition except for the abraded tip of the nose and tiny scratches on the chin and face. Christie's, 14 June 1978, no. 333.

57. Diva Faustina
79.AA.57
White coarse-grained marble,
H: 0.275 m.

From Asia Minor.
The head was probably broken off of a draped statue as evidenced by the edge of a mantle on the left neck edge. The knot of hair seems to have been the top of an Asia Minor-style neck support. The surface is polished and somewhat better preserved on the right side. The nose, cheeks, chin, and right eyebrow broken; the mouth battered. Large fresh chips on the right side of the hair knot. Incrustation slightly cleaned from face, but remains heavy especially on the left side of the hair. Ten centimeters above the knot is a puntello, indicating that this is a replica of an official portrait type. Richmond, no. 62; UCSC–LMU, no. 11.

58. Antoninus Pius
76.AA.18
Presented by Mohammed Yeganeh
Marble,
H: 0.325 m.

Very battered. The left eye, nose, and right side of the chin seriously chipped. The surface is severely weathered all over. *Unpublished.*

59. Small bust of a bearded man
78.AA.269
Presented by Gordon McLendon
White Carrara marble,
H: 0.255 m.

Ex-collection Count von Blücher, Geneva.
The nose is missing. The left eyebrow is battered close to the center. The surface is covered with fine root-marks and some concretions. *Unpublished.*

60. Youth from a relief
76.AA.73
Anonymous donation
White, grained Thasian marble,
H: 0.235 m.

Ex-collection Count von Blücher, Geneva.
The nose is missing and there are scattered chips; otherwise the piece is perfectly preserved. A small attachment to the background can be seen under the right ear. *Unpublished.*

61. Fragment of a head of Marcus Aurelius
74.AA.38
Anonymous donation
Carrara marble,
H: 0.19 m.

The upper and lower parts of the head are broken off; only the eyes, battered nose, and most of the forehead remain. Only two curls of hair on the right temple, part of the left side of the moustache, and some beard hair on the left side of the jaw survive. There are small chips to the mouth, nose, and forehead above the left eye. The head was intended to be seen from three-quarters left.
The type is closest to the first imperial portrait type from A.D. 161, type of Terme 726 (Daltrop) with curly hair, well modeled flesh areas, and feathery beard. The eyes are somewhat larger and more opened, as in the Dresden bust after the same type. Richmond, no. 61; UCSC–LMU, no. 10.

62. Lucius Verus
73.AB.100
Bronze,
H: ca. 0.355 m.

Said to be from Bubon.
The current appearance of the head is the result of careful restoration. The head was discovered completely flattened and the modeling has suffered. There are numerous fills on the forehead, the hair above it, right cheek, and lips. Several rectangular plugs are visible on left cheek and eye. *Life,* 3 December 1971, 83–84 (with photos of the restoration); *Recent Acq.,* no. 22; Inan-Rosenbaum 2, pp. 107–108, no. 57, pl. 50.1 (bibl.); C. C. Vermeule, *Eikones,* 1980, 190, no. E; J. Inan, *IM* 27/28 (1977–78), p. 274.

63. Commodus
L78.AA.5
Anonymous loan
Carrara marble,
H: 0.327 m.

The nose and right eyebrow broken. The head arrived in the museum covered with concrete, as the result of its reuse as masonry material. Careful conservation has preserved the surface, but weathering has destroyed the original high polish. *Conservation of Antiquities,* JPGM pamphlet, May-July 1978, no. 3.

64. Septimius Severus
77.AA.8
Presented by Nicholas Koutoulakis
in memory of J. Paul Getty
Grained marble, probably
Thasian,
H: 0.34 m.

The nose, lips, left eye and cheekbone, brow ridges, and left earlobe damaged. Many small chips in the hair and beard. The drill was used extensively for undercutting and for emphasizing the curls and the hair strands on the front of the head, the beard, the parting of the lips, contours, and pupils of the eyes.
The type corresponds to A. M. McCann's Serapis type (type IX), cf. especially her catalogue no. 47 (Ny Carlsberg Glyptotek) and no. 49 (Newby Hall). Richmond, no. 63 (ill. as no. 64); UCSC–LMU, no. 13.

65. Bust of a priest of Serapis
71.AA.453
Large grained grayish marble
(Asia Minor?)
H: 0.759 m.

Ex-collections George William Crofther, John Hewitt, Hans Callmann, Christopher Powner, and G. F. Williams (Brighton).
From Egypt.
Excellent condition. Some small chips scattered on the tip of the nose and in the beard. Remains of the once extensive gilding survive on the diadem and seven-pointed star or rosette. Traces of colors: eyes (blue), lips (pink), hair and beard (brownish). The drill was used for the nostrils, pupils, ears, and accents in the hair and beard. For the subject, cf. Berlin R99 and art market, *Apollo,* November 1980, Suppl. p. 142. Sotheby's, 18 June 1968, no. 147; Sotheby's, 12 July 1971, no. 134; *Joys,* p. 12; Minneapolis, no. 12; *JPGM,* p. 64; *Cat.,* no. 75; *Portraits,* no. 42; Bergmann, p. 172, pl. 51.3.

66. Funerary relief
71.AA.282
Limestone,
H: 0.79 m.; W: 0.673 m.;
depth: 0.255 m.

From Syria.
Surface of stele battered. The heads, protected by the niche, are in good albeit weathered condition except for the lost noses.
Inscription:

ΞΑΝΘΙΩΝ ΧΡΗ ΞΑΝΘΕ
ΣΤΕ ΦΙΛΟΠΑΤΡΙ

Sotheby's, 1 July 1969, no. 166, ill. (no. 165 is pair); Penn., no. 20, ill.; *Cat.*, no. 87; K. Parlasca, *Proceedings Xth International Congress on Archaeology*, Ankara, 1978, pp. 305–309, pls. 82–84; idem, Getty *MJ* 8, 1980, pp. 141–146.

67. Man
71.AA.272
Limestone,
H: 0.29 m.

From Syria.
Only a small section of the neck is preserved. The surface is much weathered. In the back, part of the supporting pillar survives. Originally part of a standing funerary statue. The right side of the mouth, forehead, chin, and both earlobes are chipped away. There is a hole in the left top of the head and another in the left side of the head. The pupils are deeply drilled. Penn., no. 19; *Cat.*, no. 89; *Portraits*, no. 40; Sotheby's, 1 July 1969, no. 248; K. Parlasca, Getty *MJ* 8, 1980, pp. 141–146.

68. Bust of an African
71.AA.437
Medium crystalled white marble,
H: 0.445 m.

At the base, a marble plug for insertion in a socle. Heavy yellow-brown patina. The left shoulder was broken off in antiquity. The nose, lips, and curls over the forehead are missing. Considerably chipped on the right shoulder, right temple, and left cheekbone. The surface, especially of the bust, is worn. The drill was used for the hair, pupils, ears, and corners of the eyes. *Cat.*, no. 73; *Portraits*, no. 36, ill.

69. Negro Boy
71.AA.462
White Italian fine grained marble,
H: 0.22 m.

The surface is well preserved, including the porcelain-like finish of flesh areas, especially on the right side of the face. The nose and mouth are slightly battered; there are many chips in the hair. The top back of the head was cut away in a flat plane for a modern repair. Minneapolis, no. 12; *Cat.*, no. 72; *Portraits*, no. 39; UCSC–LMU, no. 12.

70. Bust of a youth
72.AA.116
Italian marble,
H: 0.41 m.

The right half of the bust was cut away or perhaps made separately. There are numerous chips on the cheeks and lips; the nose is missing. Some images of Antonine princes may be comparable (J. Charbonneaux, *Mon. Piot.* 44, 1950, p. 80, pl. 8), but none has the artistic delicacy of this bust. *Cat.*, no. 69; *Portraits*, no. 35, ill.

71. Severan bearded man
72.AA.111
White marble, probably Italian,
H: 0.23 m.

The nose and both ears are missing. There are chips on the left eyebrow, beard, and hair. *Portraits*, no. 38, ill.; *JPGM*, p. 63.

72. Funerary relief of Agrippina
71.AA.456
White Italian marble, slightly grained,
H: 0.775 m.
(H (head and socle): 0.335m.

Nose and lips are damaged; the surface overall slightly worn. There was drill work in the ears.
Inscription:

 Θ X
ΑΓΡΙΠΠΕΙΝΗ·ΘΥΓΑΤΡΙ
ΖΗCΑCΗ·ΕΤΗ·Γ·ΜΗ·Α·ΗΜ·ΚΖ
ΓΟΝΕΙC·ΕΠΟΗCΑΝ·ΜΝΗΜΗC
ΧΑΡΙΝ

Minneapolis, no. 10; *JPGM*, p. 61; *Cat.*, no. 85; *Portraits*, no. 33.

73. Boy
78.AA.44
White marble, probably Carrara,
H: 0.18 m.

The nose was restored in plaster and is now removed. There are countless small abrasions over the surface, especially on the lips and eyes. The surface, particularly of the eyes, was overcleaned and partially altered by restoration in the nineteenth century. Parke-Bernet, 20–23 April 1949, no. 156; Minneapolis, no. 11; Del Chiaro, *Roman*, no. 4; *Portraits*, no. 26 (bibl.).

74. Girl
73.AA.51
Carrara marble,
H: 0.29 m.

The neck ends in a cone (broken on the right side) for insertion into a statue body. The back of the head, less finished, was probably not meant to be seen. The right side of the head is more weathered than the left. There are old abrasions to the broken nose, left eye, lips, and chin, and small, fresher scratches over the whole surface plus a recent, large chip in the hair on the right side. The drill was used for the parting of the lips, the inside corners of the eyes, pupils, line of the eyelids, and the separation of the hair from the neck. The head is turned delicately to her right.

Compare two private women's portraits in Florence: Meischner, nos. 17 and 18. Inan-Rosenbaum 2, pp. 331–332, no. 331, pl. 240.1 (wrongly said to be from Asia Minor); UCSC–LMU, no. 16.

75. Wig
Anonymous loan
Grayish large grained marble,
H: 0.235 m.

The surface has been discolored by fire damage. The top of the head is somewhat weathered. One bad crack almost splits the upper left side. There are large flat chips, especially on the back of the head. The inside of the wig is picked for adhesion to the face. Concretions near the inside edge, small areas carved very smooth, and some hair strands cut in a different technique must be traces of reworking to make the head and wig fit together.

In the style favored by Julia Domna, Dresden type, the hair is dressed in a center part with tightly crimped waves of hair pulled back and a spiral braided knot on the back of the head. *Unpublished.*

76. Plautilla
72.AA.118
Slightly crystalline grayish marble,
Italian but not Carrara,
H: 0.305 m.

Traces of a mantle on the right side of the neck indicate that the head was probably cut from a statue. The surface is much worn, especially on the right side of the head where even the hair strands have disappeared. Some rootmarks and accretions. Areas of greenish color are due to long immersion under water, as is some partial deterioration of the marble on the right temple and left side of the neck. The tip of the nose and the lips bruised; some chips on the chin, left cheek, and forehead. The head is turned gently to its right and was meant to be seen from about seven-eighths left. *Cat.*, no. 74 (as perhaps Julia Paula); *Portraits*, no. 41; Inan-Rosenbaum 2, pp. 333–334 no. 333 (said wrongly to be from Asia Minor), pl. 240. 3, 4; UCSC–LMU, no. 15; F. Yegül, Getty *MJ* 9, 1981, forthcoming, figs. 8–10.

77. Fragmentary head of the young Caracalla
80.AA.78
Anonymous donation
White, medium grained Asia Minor marble,
H: 0.215 m.

Probably from Alexandria.
Only the right eye, ear and side of the hair and forehead survive, but they are in almost perfect condition. There is deep, interrupted drill work in the locks of the hair. In spite of the fragmentary nature, the sulky face of the young Caracalla is easily identifiable. *Unpublished.*

78. Imago clipeata of Caracalla as heir apparent
73.AA.113
White Asia Minor marble with large crystals,
Diam: 0.55 m.

Ex-collection Hoffman.
The nose is missing. Chips on the right eyebrow, eye, and mouth. The pupils are indicated. *Collection H. Hoffman,* Hôtel Drouot, Paris, May 15, 1899, 146, no. 622, pl. XLI (said to be from Rome).

79. Bust of Geta
78.AA.265
Presented by Gordon McLendon
White marble, probably Thasian,
H: 0.55 m.

Found in the Thames River.
Both sides of the bust are broken; the nose and ears are missing. The surface is partially damaged and uniformly softened by its long immersion in water. Drill work was used for the parting of the lips, nostrils, eye contours and pupils, ear channels, accents in the hair, and folds of the drapery.

The bust was intentionally mutilated in antiquity. There are traces of hammering on the forehead and right chin; the nose, both lips, and the ears were broken off as well as the sides of the bust. There are also some ancient scratches on the left cheek, and there was an ancient attempt to saw off the head starting at the nape. All are evidence of a systematic, official destruction of the monument. Christie's, 12 July 1977, no. 207; Richmond, no. 64 (ill. as no. 63); UCSC–LMU, no. 14).

80. Bust of a bearded man
73.AA.42
Marble, possibly Pentelic,
H: 0.61 m.

The vertical strut of the bust is broken in back. The right edge of the front is missing. The tip of the nose is abraded; scattered chips on the hair, beard, and cheeks. Part of the left ear and part of major drapery fold broken off. Inan-Rosenbaum 2, pp. 332–333, no. 332, pls. 241, 242.1, 2.

81. Draped statue of a woman
72.AA.153
White, large crystalled marble,
H: 1.91 m.

Ex-collection Sciarra, Rome.
The original portrait head (see fig. 17) was broken off while the statue was on the art market in recent years. The right arm, including the shoulder and drapery on the hip, the left arm below the elbow, and folds of drapery were broken off and restored in marble in Baroque times. The right shoulder section is still attached, supporting an ancient piece of elbow. The smooth surface and dowel holes from the restoration are prominent on the right hip. The statue was of exceptional quality, wearing a nearly diaphanous chiton under a mantle draped over the left shoulder: a tassel on one corner of the mantle is clearly indicated on the left thigh and a second tassel once touched the outer left knee. The original shape of the plinth, oval with a flattened front, may survive. F. Matz-F. von Duhn, *Antike Bildwerke in Rom* I, 1882, p. 410, no. 1421; *EA* 5022 (still with ancient head unbroken).

82. Fragment of a statue of a woman
77.AA.125
Presented by Sidney Port
Carrara marble, H: 0.56 m.

The statue was cut above the waist, the arms taken off, and the back hollowed out and shaped into a central support, imitating a bust. The head was broken off and replaced. The surface was washed with acid but not recut. The restored nose has been removed and the large chip in the left temple has been filled. *Unpublished.*

83. Severan youth
76.AA.14
Whitish-grey, large crystalled marble,
H: 0.245 m.

Mr. Getty's last purchase for the museum.
Broken at the neck very close to the chin. The back of the head and left ear restored in the nineteenth century and now removed. The head is in excellent condition, with only a large oval chip on the crown, and small nicks and abrasions on the tip of the nose, the right cheek, right eyebrow, right upper lip, left lower lip, left upper eyelid, and the left side of the chin. *Unpublished.*

84. Funerary relief, bust of a man
L80.AA.59
Carrara marble of lower quality,
H: 0.59 m.

The frame is well preserved on the top, bottom, and right side. There was at least one other bust to the man's left. The surface is worn, and the nose missing. *Unpublished.*

85. Under life-size portrait statue of a prince
71.AB.454
Bronze,
H: 1.20 m.; H (of head): 0.16 m.

Said to be from near Iconium.
The casting was done in several parts: head, body to navel, lower torso, legs to mid-calf, feet, and arms. The technique is adequate and with many ancient repairs, especially along the joins, of very thin metal.
The conventional body is modeled roughly after Polykleitos' Doryphoros, but the upraised arm in the gesture of *adlocutio* identifies the subject as a youthful ruler. The portrait qualities of the face are limited, but the general style is comparable to a bronze head in the Allard Pierson Museum, Amsterdam (no. 517, *Algemene Gids*, 1956, p. 57. C. Vermeule, *Polykleitos*, 1969, pp. 42, 45, 48; *Portraits*, no. 44, ill. (bibl.); *JPGM*, p. 56; Inan Rosenbaum 2, pp. 334–335, no. 334, pl. 243.

86. Philip the Younger
79.AB.120
Bronze,
H: ca. 0.22 m.

The "halo" of bronze around the head was for anchoring another, probably more elaborate, crown and the top of the head. Several breaks and minor holes in the center of the face. The missing parts were restored with plastic. The head was cast in one piece, probably to be fixed on a standard-type body. The casting is summary, as is the chasing of the hair and eyebrows. In the middle of the forehead is a rectangular ancient repair. The piece was deliberately mutilated in antiquity by a blow to the base of the nose, perhaps in connection with the tearing down of the outdated imperial image. The round halo of bronze seems to have been the support for a *corona radiata*, even though there are no visible holes: the rays may have been glued or affixed to the top. *Unpublished.*

87. Bearded man
Anonymous loan
Asia Minor marble,
H: 0.34 m.

Slightly over life-size. The head was broken from a standing statue. The lump of raw stone at the nape points to an Asia Minor origin. The top, most of the back of the head, and the tip of the nose are broken off. There are chips on the ear helixes and eyebrows. The surface is worn but otherwise intact. Ancient damage to the lips and eyebrows was repaired, making the chronology of the head somewhat ambiguous. The drill was used deeply for the eye sockets, ears, parting of the lips, corners of the mouth, nostrils, labial lines, and wrinkles in the forehead. *Unpublished.*

88. Elderly woman
73.AA.47
Fine grained greyish marble,
H: 0.37

The head was made for insertion into a statue. The surface was weathered and then washed with acid. The patina, especially on the right side, suffered damages. The nose and the left eyebrow are battered. There are abrasions on the chin, mouth, and left cheek; and on the right side of the hair and collarbone. The head was turned slightly to her right and was meant to be seen from her left. M. Bergmann, 1977, pls. 26, 5–6 (on art market).

89. Bearded man
73.AA.7
Italian marble,
H: 0.35 m.

Although the nose is broken, the head is otherwise well preserved. The marble has been burned, which accentuates the porcelain-like quality of the polished facial surface. Crackelure from fire mars the whole surface: there are severe cracks on the right cheek, eye socket, and across the neck. The drill was used copiously in the hair. The socket for the arm of a herm(?) survives in the broken right side. The head preserves the orientation of a seated statue. *Portraits*, no. 43, ill.; Nagle, p. 385, ill.; Vermeule, no. 308.

90. Gallienic man
75.AA.52
White fine grained Italian marble,
H: 0.26 m.

The underside of the neck was hollowed out with a claw chisel for setting on a statue. The nose was broken, and the left eyebrow chipped. The hair, beard, and irises were roughly carved with a chisel and show slight use of the drill. The face was highly polished and was so washed with acid in modern times that the moustache has almost disappeared. The luminous appearance of the face is due partly to this and partly to the original intent. *Unpublished.*

91. Sarcophagus with portrait medallion of a woman
77.AA.65
Presented by Gordon McLendon
White marble with large grains,
H: 0.555 m.; L: 1.70 m.

Four joined fragments of an oval sarcophagus survive. Small bits of the bottom are missing. On the upper rim are holes for secondary clamps. Only half of the sides and nothing of the bottom is preserved. The left and right sides show lions attacking boars. Ten flutings are on each side of a central medallion, containing a bust of a lady wearing a tunic and a mantle, turned slightly to her right. Her nose is missing; the eyes are drilled. Under her, two tragic masks with high wigs look outwards. *Unpublished.*

92. Fragment of a sarcophagus with a bust of a man
73.AA.48
Marble,
H: 0.43 m.; W: 0.445 m.

The back was cut flat in modern times, but the top rim is preserved. A shell with a portrait of the deceased was held on both sides by figures whose hands survive on the edges of the top and sides of the shell. They must have been sea centaurs. Under the shell is the head of an Eros. Two other Erotes fly on either side of the bust inside. The man holds a *volumen* in his left hand and wears tunic and mantle. The bust extends below his waist. Both the back of the portrait head and its sides are unfinished. Although much drill work was used on the sarcophagus, the portrait is mostly the result of the chisel, further evidence that the head was carved by a different artist than the sarcophagus. *Unpublished.*

93. Tetrarch
78.AA.8
White grained homogenous (Thasian?) marble,
H: 0.35 m.

Broken from a standing *togate* statue, as the folds of a mantle survive on the back and shoulders. Surface weathered more on the left side; otherwise the head is in good condition. Tip of nose battered. Large chip on the right side of back of head. Chips on the right side of neck and right beardline. Small abrasions over the surface. The drill was used extensively for the parting of the lips, nose, contours and pupils of the eyes, and the ears, but its traces are discreetly masked to intensify the pronounced geometric modeling. The rectangular support at the nape betrays the Asia Minor origin. UCSC–LMU, no. 17.

94. Miniature bust of the emperor Philip the Arab
72.AA.292
Presented by Gordon McLendon
Limestone,
H: 0.038 m.

In pristine condition. *Unpublished.*

95. Head of a bearded man
74.AA.63
Anonymous donation
White marble, probably Italian,
H: 0.24 m.

The tip of the nose lost; small chips scattered overall. Otherwise it is well preserved. *Portraits*, no. 45.

96. "Cicero"
73.AA.142
Fine Carrara marble with
sugary crystals,
H: 0.235 m.

The neck is broken off just below the chin but the turn of the head to the left is still clear. The back of the head is less finely finished than the rest. The left earlobe may be slightly recarved. The left eyebrow is battered. On the top of the head is a rectangular secondary cavity for supporting it on a pin against the wall. The nose was restored in the later nineteenth (?) century and has been removed. Parke-Benet, 7 December 1973, no. 100; *Recent Acq.*, no. 20; UCSC–LMU, no. 20.

97. Miniature head of an "emperor"
79.AK.191
Presented by R. M. Harlick
Alabaster-like marble,
H: 0.145

The nose and part of the neck are broken off; the chin and other details chipped. Compare the other members of the group published in E. Paul, *Die Falsche Göttin*, 1962, pp. 56–58, figs. 19/ 20 (in Berlin, Oslo, Leipzig) and G. Traversari, *Rivista di Archeologia*, 1, 1977, pp. 89f., fig. (Torcello). *Unpublished.*

98. Bearded man said to be from Ephesos
75.AK.25
Anonymous donation
Marble,
H: 0.265 m.

The head is perfectly preserved except for small chips in the hair and on left nostril. The surface has artificially induced rust spots. *Unpublished.*

99. Forgery of a Republican man
70.AK.121
Rather homogenous Carrara
marble,
H: 0.40 m.

The head is on a rectangular bust that extends about 10 cm. below the collar bones. There is a slot cut in the right shoulder. The helixes of both ears were restored and are now lost. The surface is roughened in the center of the face due to washing with acid. The tip of the nose and the eyebrows are somewhat battered, and there are scrapes and chips on the left shoulder. A deep, round hole in the occiput served to fix the piece to a wall in modern times. Del Chiaro, *Roman* no. 3 (ill. by mistake); UCSC–LMU, no. 19.

100. Forgery after the funerary relief of P. Aiedius
78.AA.55
Carrara marble,
H: 0.33 m.

Bought by Mr. Getty from Gallerie Barberini (Rome) in 1952.
Very well preserved except for the right side of the nose. There are chips on the right cheek, above the left eye, and on the right side of the mouth. The discolored surface was cleaned after entering the museum. The ears are solidly attached to the sides of the head. For the relief of P. Aiedius on which the head is based, see C. Blümel, *Römische Bildnisse*, 1933, no. R7, pl. 4. Del Chiaro, *Roman* no. 3 (discussed—wrong ill.); S. Howard, *CalStClassAnt* 3, 1970. pp. 99–113 (as example of late Hellenistic Attic portraiture); *Portraits*, no. 15 (as modern); S. Howard, *CalStClassAnt* 7, 1974, p. 168, no. 11 (as modern); E. Gazda, *Roman Portraiture*, Ann Arbor, 1977, pp. 34–35, no. 13 (as based on Aiedius relief); UCSC–LMU, no. 18.

ABBREVIATIONS

(H.) Bartels: *Studien zum Frauenporträt der augusteichen Zeit*, 1964.

(M.) Bergmann: *Studien zum römischen Porträts des 3. Jahr. n. Chr.*, 1977.

(*Die*) *Bildnisse des Augustus*: Glyptothek München, December 1978–March 1979, (K. Vierneisel and P. Zanker).

CalStClassAnt: California Studies in Classical Antiquity

(R.) Calza, *Iconografia Roman Imperiale I: da Carausio a Giuliano*, 1972

Cat: C. Vermeule and N. Neuerburg, *Catalogue of the Ancient Art in the J. Paul Getty Museum*, 1973.

(C.) Clarac, *Musée de Sculpture*, 1826–1853, 2 vols.

Collector's Choice: J. P. Getty and E. Le Vane, *Collector's Choice*, 1955.

(M. A.) Del Chiaro, *Roman Art in West Coast Collections*, The Art Galleries, University of California at Santa Barbara, March 28–May 13, 1973.

EA: P. Arndt, W. Amelung and G. Lippold, *Photographische Einzelaufnahmen antiker Skulpturen*, 1893.

(B. M.) Felleti Maj, *Ritratti: Museo Nazionale Romano, i Ritratti* , 1953.

(J.) Frel: "Caesar," Getty *MJ* 5, 1977, pp. 55–62.

(E.) Gazda: *Roman Portraiture*, The Kelsey Museum of Archaeology, January 28–April 15, 1977.

Getty *MJ: The J. Paul Getty Museum Journal*, 1–, 1974–.

Guidebook: The J. Paul Getty Museum Guidebook, fifth edition, 1980.

IM: Istanbuler Mitteilungen

(J.) Inan-(E.) Rosenbaum 1: *Roman and early Byzantine portrait sculpture in Asia Minor*, 1966.

(J.) Inan-(E.) Rosenbaum 2: *Römische und frühbyzantinische Porträtplastik aus der Turkei*, 1979.

Joys: J. P. Getty, *The Joys of Collecting*, 1965 (antiquities text by J. Charbonneaux).

JPGM: B. B. Fredericksen et al., *The J. Paul Getty Museum*, 1975.

(H. P.) L'Orange: *Art Forms and Civic Life in the Late Roman Empire*, 1965.

(A. M.) McCann: *The Portraits of Septimius Severus, Memoirs of the American Academy in Rome* 30, 1968.

(J.) Meischner: *Das Frauenporträt der Severerzeit*, 1964.

(A.) Michaelis: *Ancient Marbles in Great Britain*, 1882.

Minneapolis: *The J. Paul Getty Collection*, The Minneapolis Institute of Arts, June 29–September 3, 1972.

(O. B.) Nagle: *The Ancient World*, 1979.

Penn.: *Selected works from the Ancient Art Collection of the John [sic] Paul Getty Museum*, State University of Pennsylvania, May 29–June 20, 1971.

(L.) Polacco: *Il Volto di Tiberio*, 1955.

Portraits: Greek and Roman Portraits in the J. Paul Getty Museum, California State University at Northridge, October 16–November 11, 1975, (J. Frel and E. Buckley).

(V. H.) Poulsen: *Les portraits romains du Ny Carlsberg Glyptotek*, vol. 1, *République et dynastie julienne*, 1973; vol. 2, *de Vespasien à la basse Antiquité*, 1974.

Proc.Phil.Soc.: Proceedings of the American Philosophical Society

Recent Acq.: Recent Acquisitions. Ancient Art. The J. Paul Getty Museum, Washington State University, Fine Arts Gallery, October 9–30, 1974. and the J. Paul Getty Museum, December 15, 1974–February 1, 1975.

(S.) Reinach: *Répertoire de la statuaire greque et romaine*, I-IV, 1897–1910.

Richmond: *Ancient Portraiture; the Sculptor's Art in Coins and Marble*, Virginia Museum of Fine Arts, April 29-July 20, 1980 (M. Jentoft-Nilsen).

(G. M. A.) Richter, *Roman Portraits*. The Metropolitan Museum of Art, 1948.

(B.) Schweitzer: *Die Bildniskunst der römischen Republik*, 1948.

UCSC–LMU: *Roman Portraits; Aspects of Self and Society*, Sesnon Art Gallery, University of California, Santa Cruz, February 20–April 9, 1980, and Loyola Marymount University Art Gallery, October 14–November 11, 1980 (P. Erhart, J. Frel, S. Morgan, and S. Nodelman).

(C.C.) Vermeule: *Greek and Roman Sculpture in America*, 1981 forthcoming.

(M.) Wegner, *Antonine: Die Herrscherbildnisse in Antoninischer Zeit. Das römische Herrscherbild* II.2, 1939.

(M.) Wegner, *Flavier: Die Flavier. Das Römische Herrscherbild* II.I, 1966.

(M.) Wegner, *Hadrian: Hadrian. Das römische Herrscherbild* II.3, 1956.

(H. B.) Wiggers: and (M.) Wegner, *Caracalla bis Balbinus. Das römische Herrscherbild* III.1, 1971.

INDEX BY ACCESSION NUMBERS